Thames & Hudson world of art

This famous series provides the widest available
range of illustrated books on art in all its aspects.

If you would like to receive a complete list
of titles in print please write to:

THAMES & HUDSON
181A High Holborn
London WC1V 7QX

In the United States please write to:

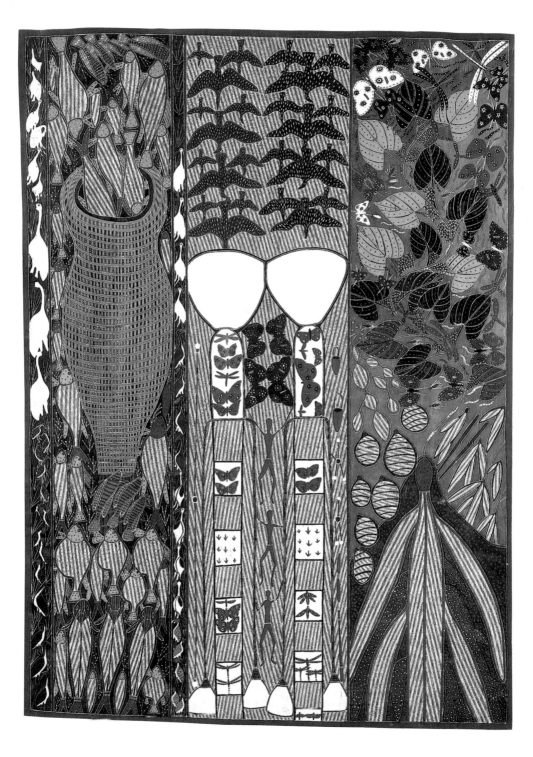

Wally Caruana

Aboriginal Art

New edition

206 illustrations, 67 in colour

 Thames & Hudson world of art

Frontispiece:
1. Jack Wunuwun, *Barnumbirr the Morning Star*, 1987

The publishers wish to express their gratitude for the cooperation of the National Gallery of Australia in the preparation of this volume.

First published in the United Kingdom in 1993 by
Thames & Hudson Ltd, 181A High Holborn, London WC1V 7QX

www.thamesandhudson.com

New edition 2003

British Library Cataloguing-in-Publication Data
A catalogue record for this book is available from the British Library

ISBN 0 500 20366-0

Printed and bound in Singapore by C.S. Graphics

Contents

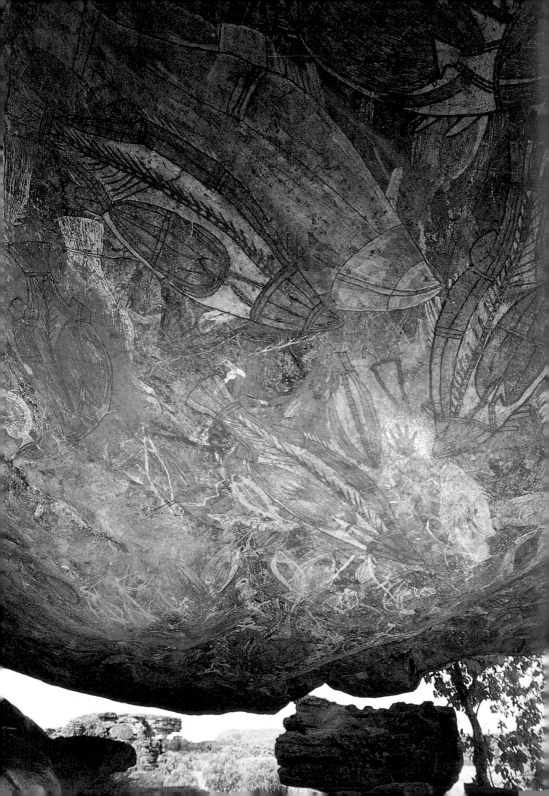

Chapter 1: Introduction

The art of Aboriginal Australia is the last great tradition of art to be appreciated by the world at large. Despite being one of the longest continuous traditions of art in the world, dating back at least fifty millennia, it remained relatively unknown until the second half of the twentieth century. The Surrealist map of the world, published in 1929 by the Parisian avant-garde, depicted the size of each country proportionate to the degree of artistic creativity, with the recently discovered riches of the Pacific islands looming large. Australia barely featured.

The often ephemeral materials of Aboriginal art make it difficult to determine the antiquity of the majority of the forms of art practised today. The most durable forms are the multitudes of rock engravings and rock paintings which are found across the 4,2 continent. In the Arnhem Land escarpment, evidence suggests 3 that paintings were being made fifty thousand years ago, antedating the Palaeolithic rock paintings of Altamira and Lascaux in Europe. Engraved designs found in South Australia have been dated to at least thirty thousand years before the present. More recent dates for engravings and paintings at these and other art sites indicate continuous artistic activity over the millennia.

The first inhabitants of the continent arrived from the north and spread across the land to populate a range of environments, which today include the tropical regions of the north and the temperate climates of the south, harsh deserts and fertile river lands. With little contact from the rest of the world, cultural practices spread across the country, developing a diversity which is reflected in the variety of religious beliefs, ceremonies, social structures, languages (in pre-European times over two hundred distinct languages and many more dialects were spoken, although only about fifty are in daily use now), and in particular, in the range of artistic practices and idioms.

Art is central to Aboriginal life. Whether it is made for political, social, utilitarian or didactic purposes – and these functions constantly overlap – art is inherently connected to the spiritual domain.

Art is a means by which the present is connected with the past and human beings with the supernatural world. Art activates the

2. Rock painting, Kakadu, Northern Territory

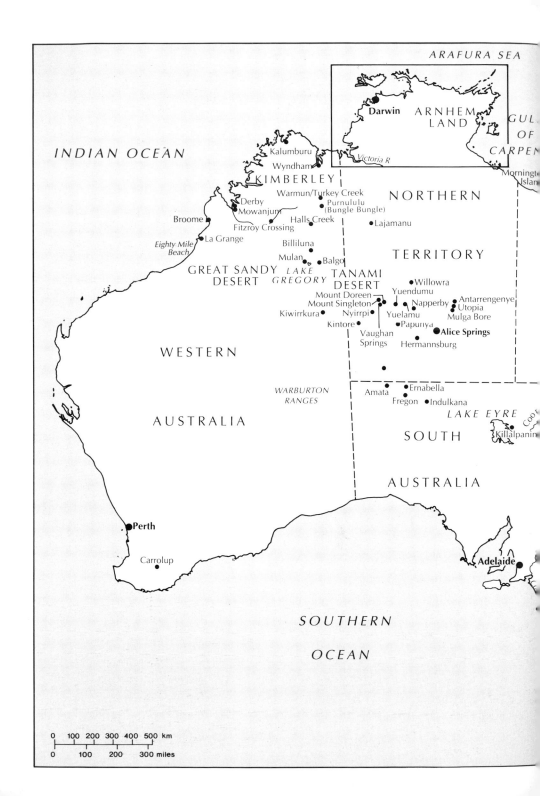

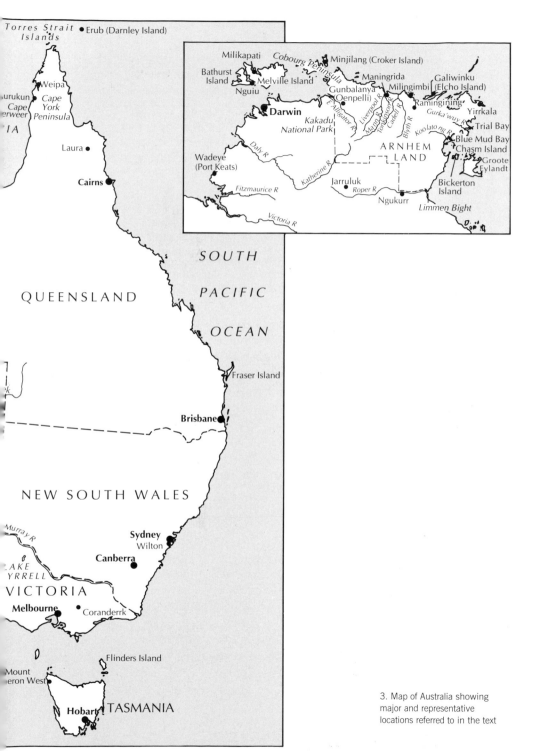

Torres Strait
Islands
● Erub (Darnley Island)

Milikapati
Bathurst
Island
Cobourg Peninsula
Minjilang (Croker Island)
Nguiu
Melville Island
Maningrida
Galiwinku
(Elcho Island)
Gunbalanya
(Oenpelli)
Milingimbi
Ramingining
Darwin
Kakadu
National Park
Yirrkala
Trial Bay
Wadeye
(Port Keats)
ARNHEM
LAND
Blue Mud Bay
Chasm Island
Groote
Eylandt
Fitzmaurice R
Jarruluk
Roper R
Ngukurr
Bickerton
Island
Victoria R
Limmen Bight

Daly R
E. Alligator R
Katherine R
Liverpool R
Mann R
Tomkinson R
Cadell R
Blyth R
Gurka'wuy R
Koolatong R

● Weipa
Cape
York
Peninsula
urukun
Cape
erweer
IA

Laura ●

Cairns ●

SOUTH

PACIFIC

OCEAN

QUEENSLAND

Fraser Island

Brisbane ●

NEW SOUTH WALES

Murray R
Sydney ●
Wilton
Canberra ●

LAKE
TYRRELL
VICTORIA

Melbourne ●
Coranderrk ●

Flinders Island

Mount
eron West

Hobart ● TASMANIA

3. Map of Australia showing
major and representative
locations referred to in the text

9

powers of the ancestral beings. Art expresses individual and group identity, and the relationships between people and the land.

Until the arrival of Europeans in Australia in the eighteenth century, Aboriginal art was made purely to fulfil traditional cultural needs, and this has remained the case in varying degrees since. In the ceremonial sphere, art may only be created and viewed by those initiated to the proper level of awareness. However, in modern times, a significant body of art has emerged which is intended for the wider, public domain.

The Dreaming
The spiritual life of Aboriginal people centres on the Dreaming. The Dreaming is a European term used by Aborigines to describe the spiritual, natural and moral order of the cosmos. It relates to the period from the genesis of the universe to a time beyond living memory. The term does not refer to the state of dreams or unreality, but rather to a state of a reality beyond the mundane. The Dreaming focuses on the activities and epic deeds of the supernatural beings and creator ancestors such as the Rainbow Serpents, the Lightning Men, the Wagilag Sisters, the Tingari 5 and Wandjina, who, in both human and non-human form, travelled across the unshaped world, creating everything in it and laying down the laws of social and religious behaviour. The Dreaming is not, however, merely a guide for living, an agent of social control, or simply a chronicle of creation, restricted in time to a definable past. The Dreaming provides the ideological framework by which human society retains a harmonious equilibrium with the universe – a charter and mandate that has been sanctified over time.

The continent of Australia is covered by an intricate web of Dreamings. Some relate to a particular place or region and belong to those who reside there, other Dreamings travel over vast distances and connect those whose lands they cover. Thus people may be connected to several Dreamings. The all-pervasive powers of the ancestral beings of the Dreamings are present in the land and in natural species, and also reside within individuals. They are activated by ceremony and art to nourish generation after generation of human descendants. An individual's links with the ancestral beings in the Dreaming, and his or her spiritual identity, are expressed through totemic associations with natural species and phenomena, ritual songs, dances, objects and graphic designs. The events of the Dreaming provide the great themes of Aboriginal art.

Visual art and meaning

Aboriginal visual art takes many forms, from the enduring rock 4–9 engravings and paintings to the more ephemeral arts of body decoration, bark and ground paintings and ceremonial sculpture in wood. Ritual and utilitarian objects are made from stone, wood, paint, woven fibre and feathers, and jewelry is also made from bone, shell and seeds. Regional variations abound; in Arnhem Land paintings on flattened sheets of bark are common, whereas ground paintings are made in the desert. Although most traditional forms, ground paintings for example, continue to be largely restricted to ceremonial use, others, such as painting on bark and wood sculpture readily fulfil ritual functions and are made for the public domain as well. Recent years have witnessed the flourishing of some art forms and the demise of others. The adoption of new technologies and materials such as canvas and synthetic paints has led to the creation of new art forms which often complement rather than replace existing ones.

Aboriginal Australia embraces a number of distinct classical or long-established artistic traditions within which conventional

4. Rock engraving, c. AD 500,
Mount Cameron West, Tasmania

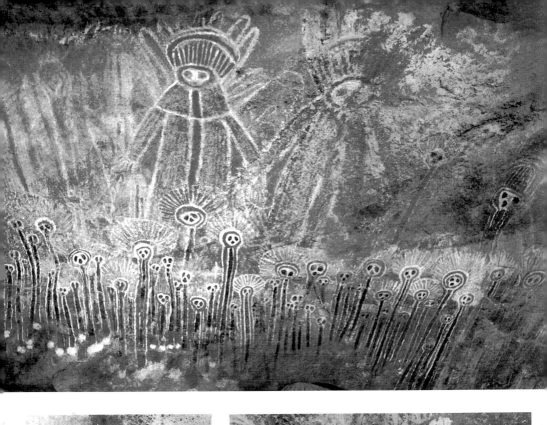

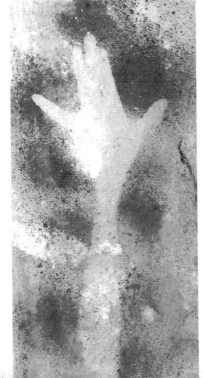

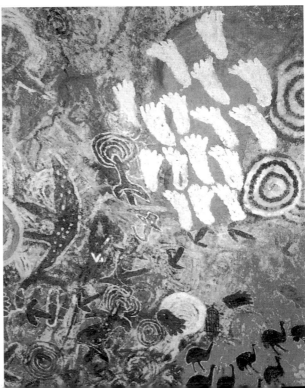

5. (*opposite, above*) Rock painting of Lightning Brothers and lightning figures, Katherine River, Northern Territory

6. (*opposite, below left*) Rock art hand stencil, Kakadu, Northern Territory, 9–20,000 years before the present

7. (*opposite, below right*) Narrative rock painting, Musgrave Ranges, South Australia

8. (*right*) Gwion Gwion, rock painting, the Kimberley, *c.* 3,000 years before the present

9. (*below*) Rock drawing of kangaroos, Wilton, New South Wales

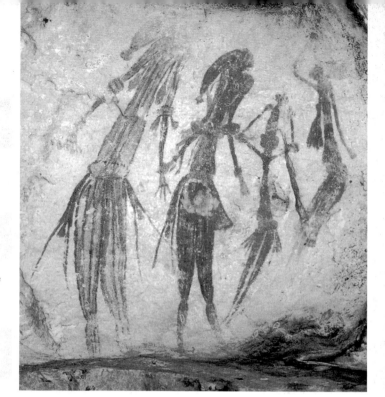

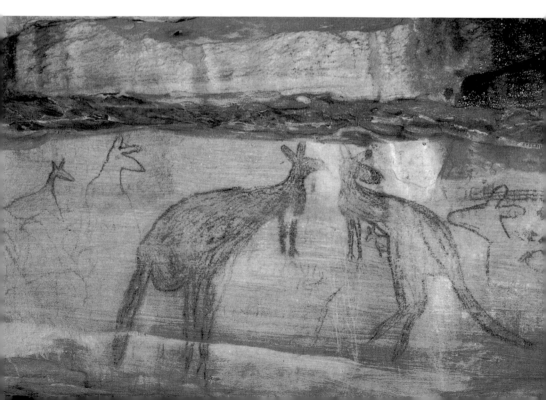

graphic designs and representational symbols are the most potent, but far from exclusive, carriers of meaning. Each artistic idiom contains a lexicon of designs and symbols which may be used in a multitude of combinations and contexts. Unlike prose, the interpretation of Aboriginal designs and images is not a one-to-one equivalence. Rather, like poetry with all its inherent complexities, multiple references and intended ambiguities, each symbol or icon within a work may encapsulate a variety of meanings.

Each set of designs is interpreted according to the ritual, social and political situations in which it is presented. The levels of interpretation of an image or design depend on the ritual knowledge of both artist and viewer, and on an understanding of the ancestral landscape. Thus a ritually senior man will have access to a broad range of meanings of a particular image. He may elaborate on these in describing works created for ceremony, whereas in a work made for the education of an uninitiated youth, or for public display, he will confine his account to the appropriate level or levels of interpretation. Today it is common practice for artists to provide a description of their work, and the many levels of interpretation permit artists to present their art to an often culturally untutored public without compromising its religious nature. Artists talk of two broad levels of interpretation, the 'inside' stories which are restricted to those of the appropriate ritual standing, and the 'outside' stories which are open to all.

Meaning is elaborated in terms of spiritual power. Religious images and designs, when applied to any surface, whether the body of a participant in ritual or the surface of a shield or a carrying bag, have the power to transform the nature of the thing from a mundane state to an extraordinary one, from the profane to the sacred. In ceremony, people's bodies and objects are taken from a dull state to one of brilliance by the application of paint and designs. The concept of brightness often carries through into art intended for the public domain: not only does it evoke the radiant presence of supernatural power but it also provides a means by which artists explore concepts beyond the tangible qualities of life.

Art and authority
It is by the acquisition of knowledge, not material possessions, that one attains status in Aboriginal culture. Art is an expression of knowledge, and hence a statement of authority. Through the

use of ancestrally inherited designs, artists assert their identity, and their rights and responsibilities. They also define the relationships between individuals and groups, and affirm their connections to the land and the Ancestral Realm.

Traditional Aboriginal society is structured by a number of systems that organize all aspects of life and perceptions, and, indeed, by which the universe is ordered. The systems vary in detail from society to society but include kin groups and 'moieties'. An individual is placed in one of up to eight kinship groups, while people and all the phenomena of the natural and spiritual worlds are classed as belonging to one or other of two complementary groups, the moieties. Jointly these affiliations determine a person's conduct in every aspect of social and religious behaviour. Marriage, for example, is customarily conducted between members of specific kinship groups belonging to opposite moieties. In art, moiety affiliation plays an important role in determining the subjects to which an artist has access and, in many cases, the manner in which they are depicted.

Individuals inherit through their parents both direct and indirect rights and responsibilities to land, ceremonies and Dreamings, as well as their connections to the ancestral and supernatural beings. Those with direct rights in a ceremony or Dreaming – today mostly derived through patrilineal inheritance – are termed the owners. They, however, do not activate or control the ritual but work in conjunction with those of the opposite moiety who have secondary or indirect rights in the ceremony, derived through matrilineal descent. Members of the latter group are often called the managers or workers, and they create ritual art in negotiation with and under the supervision of the owners. The roles of individuals vary according to the ceremony being performed. Thus ceremonial activity (including art) requires cooperation between the two groups in a specified relationship to each other.

The regulations which apply to the ownership of and rights to land and Dreamings in traditional societies are, with varying degrees of modification, carried over into the making of art for the public domain. An individual artist to whom a work is attributed will be the owner of, or have other rights to depict the subject. In this way, the prerogatives of artists to use sacred designs and to depict religious subjects are regulated. Ownership of the designs is akin to copyright over them; the use of designs belonging to others without the appropriate permission constitutes a major breach of Aboriginal law. This issue assumes

greater significance in a world where the designs are broadcast much more widely than ever before.

As a statement of authority, the aesthetic in art is often articulated in terms of ritual knowledge. Through art, individuals express their authority and knowledge of a subject, the land and the Ancestral Realm, and artists will use their authority to introduce change and innovation. It is their authority that artists bring to bear in their relationships with the world at large. Through art, they express the relevance of their culture to a world that has neglected or attempted to undermine Aboriginal values.

The last two centuries

In addition to the cultural differences between Aboriginal groups, Aboriginal society today encompasses people with vastly different historic experiences, particularly over the last two centuries. While Aboriginal cultures across the country possess uniting principles and common features, they are neither homogenous nor static; they have been and continue to be dynamic societies, capable of responding to both internal and external influences. These include dramatic environmental changes over the millennia as well as the great trauma induced by the recent settlement of Australia by Europeans.

Despite the fact that the Aboriginal population probably numbered about a million in 1788, the continent of Australia was declared *terra nullius*, the empty land, by the early British settlers, thus sidestepping claims to sovereignty by Aboriginal people and permitting the wholesale takeover of the country. With few exceptions, Aboriginal people, their beliefs, customs and land were treated with scant respect by the invaders. In many parts of the continent, the original inhabitants were forced from their homes, denied access to natural resources, and witnessed the dismemberment of their society. While the British met with a great degree of resistance in the form of battles and guerilla warfare, the cultural and social dispossession of the Aboriginal people had commenced. The nineteenth century saw the settlement of large parts of the continent.

In the first years of the twentieth century, Australia's newly formed federal government introduced institutionalized racism under the policies of assimilation. In essence, assimilation declared the discrete Aboriginal culture redundant, and sought to submerge Aboriginal Australians in what was considered to be, in the Darwinian sense, the dominant society.

Nevertheless, Aboriginal people across Australia have striven to maintain their identity. In the 1930s Aboriginal people began to organize themselves politically, and through demonstrations and petitions demanded equality and the social and political rights that had been denied them. By the 1960s, the Aboriginal struggle gained momentum with the first concerted land rights claims and the establishment of organizations for social advancement. Official recognition of rights to land was high on the Aboriginal agenda, the centrality of land to Aboriginal social and spiritual life being paramount.

In 1963, North East Arnhem Land people used art as a means of expressing to the world the nature of their attachment to the land; bark paintings were submitted as evidence of legal title to their land to the Australian Government in constitutional procedures concerning Aboriginal land rights. It was not until 1976, however, that land rights legislation in any form was finally enacted in the Northern Territory.

In 1967 universal suffrage for Aboriginal people became a reality and in 1972 the Aboriginal campaign brought about fundamental changes in official government policy; the assimilation policies were revoked in recognition of the demands for self-determination for Aboriginal people. For the first time in two centuries Aboriginal people had a voice in the running of their own affairs. With increased political freedoms came the gradual acknowledgment of some Aboriginal rights to land, and the opening-up of social and economic opportunities. These advances, however, are yet to manifest themselves in every aspect of social and political life across the country. Genuine social justice and equality are still far from a reality, and the struggle continues. Nonetheless, as people expressed pride in their culture, and many resumed a fuller traditional and ceremonial life, art again began to flourish. The strength of Aboriginal culture today is testimony to the resilience and determination of the Aboriginal people.

Art in the public domain
The achievements of Aboriginal artists are now well regarded, but European attitudes were not always so sympathetic. The first European visitors to the shores of Australia made note of the cultural artefacts they encountered; their paintings, drawings and engravings of the period illustrate Aboriginal weapons and implements, and show people with their bodies covered in painted designs. In Tasmania in 1802, the Baudin expedition 10

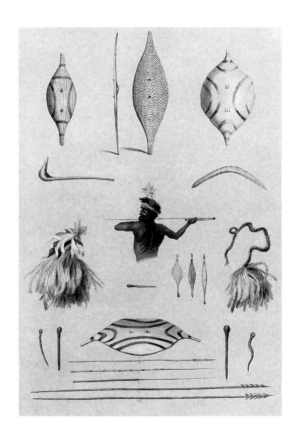

10. George French Angus, *Native weapons and implements*, 1847

found a shelter of bark sheets decorated with designs scratched into their blackened surfaces. The British saw mortuary structures on Melville Island in 1824. Rock-art sites were also recorded. These manifestations of Aboriginal culture were not seen as art, however, but as ethnographic evidence. Nineteenth-century attitudes placed Aboriginal Australians on the lowest rung of the evolutionary ladder, and they were regarded as a people without art.

Aboriginal artefacts had been collected by many of the early explorers and settlers and, indeed, some collections were sent to scientific museums in Europe. A number of those that remained in Australia were eventually housed in local museums of natural history, where they shared the space with geological, plant and animal specimens, reflecting contemporary attitudes. Colonial governments also made collections intended for the great International Exhibitions of Europe, where Aboriginal artefacts were used either for decoration or as examples of the curious

manufacture of a colonized culture. It was only in the latter half of the century, with the beginning of serious anthropological interest, that Aboriginal people began to be seen to have complex religious structures around which their societies were built, and their cultural products to possess intrinsic merit as expressions of their perceptions of the universe.

A notable step was the first exhibition of Aboriginal art, *Dawn of Art*, held in Adelaide in the late 1880s. It contained drawings on paper made by Aboriginal prisoners, and possibly staff, at Palmerston Jail in what is now the city of Darwin. The subjects of these drawings are naturalistically rendered animals with bodies decorated in a similar manner to the rock art of northern Australia.

The first major exhibition to feature Aboriginal art, *Primitive Art*, was organized in 1929 by the National Museum of Victoria. The exhibition included bark paintings collected in 1912 by Baldwin Spencer, a former director of the Museum, whose collections and writings did much to promote Aboriginal art.

In 1941 and 1942, the exhibition *Art of Australia 1788–1941* was the first to present Aboriginal art in an artistic context internationally, touring the United States and Canada, although the inclusion of three drawings by Tommy McRae and eleven Northern Territory bark paintings was intended to represent the local forerunners to art in the European tradition in Australia.

Also in 1941, an exhibition in Sydney featured Aboriginal artefacts along with the work of non-Aboriginal painters and decorative artists using Aboriginal designs or depicting Aboriginal subjects. It heralded a growing awareness of Aboriginal art, although it misguidedly proclaimed its appropriation to foster a unique Australian artistic identity.

After World War II, the growth of anthropological studies and an increasing interest in some quarters of the Australian art world led to a greater appreciation of Aboriginal art. Items from the ethnologist Charles Mountford's major government-sponsored field collection of 1948 in Arnhem Land were later distributed among the state art museums. In 1957–58, Mountford organized an exhibition of bark paintings which toured Europe.

Among the exhibitions of the 1950s, *The Art of Arnhem Land*, curated by the anthropologists Ronald and Catherine Berndt in 1957, was significant in that it was the first to situate identified artists within stylistic traditions. By 1959 the Art Gallery of New South Wales actively pursued the acquisition of a collection of contemporary works through the efforts of the assistant

director at the Gallery, Tony Tuckson, who was also an artist, and the private collector Stuart Scougall. This collection toured Australia in the following year, and signalled the beginnings of the wider acceptance of Aboriginal art. Aboriginal art is now an integral part of the collections of the national and state art museums of the country.

The present level of awareness of Aboriginal art also owes significantly to the efforts of those non-Aboriginal people who have lived and worked in communities and promoted the understanding of Aboriginal culture further afield. The genuine interest in art shown by a number of missionaries, schoolteachers, social workers and government officials – from Pastor Johann Reuther at Lake Eyre in 1903 to Geoffrey Bardon at Papunya in 1971–72, and many others in more recent times – has encouraged artists to produce work for an outside audience.

The interest in Aboriginal art which began in the 1960s has created new opportunities for Aboriginal artists, as their work leaves the communities to be shown in cities and towns across Australia and overseas. Today Aboriginal art is represented with increasing regularity in major exhibitions and hangs in public and private collections both locally and internationally. Meanwhile, the imperatives to produce art for traditional purposes continue, and the expanded environment in which Aboriginal art operates has created further compelling reasons for Aboriginal artists to express the values of their culture to the wider world in which they live.

The following chapters are organized along regional lines to introduce the scope and variety of Aboriginal visual art across the country. They survey the major art areas of Aboriginal Australia, looking back to some of the early and more recent examples of art, and examine the continuing and evolving traditions as they are seen today in all their diversity, from the bark paintings of Arnhem Land, the canvases of the desert and the Kimberley, the sculptures of northern Queensland, to the variety of media and techniques used by artists from cities and towns, and more besides.

Chapter 2: Patterns of power:
Arnhem Land and its surrounds

In the tropical north, Arnhem Land and the adjacent areas represent one of the richest art-producing regions of the country. Covering an area of approximately 50,000 square kilometres, Arnhem Land encompasses a range of environments, from the great sandstone plateau in the west with its thousands of galleries of magnificent rock paintings, to countless rivers, freshwater lagoons, monsoon jungles, open forests, rugged stone areas, mud-flats, coastal lands and islands.

Of the portable arts, Arnhem Land is renowned for bark painting, sculptures and weaving, with a variation in emphasis and styles across the region. In general the paintings of the west tend towards the figurative, and as one moves east, geometric designs become more prominent. On Groote Eylandt, bark paintings are characterized by the black grounds against which the images are set, while around Ngukurr, artists today prefer to use bright acrylic paints on canvas to relate the Dreamings. The Tiwi of Bathurst and Melville Islands produce vigorous sculptures in ironwood, while the art of Wadeye and the surrounding region displays influences of desert culture.

Apart from the traditional communications between groups in and adjacent to Arnhem Land, the earliest evidence of regular external contact in the region dates back four or five centuries to Macassan fishermen from Sulawesi in Indonesia who came in search of trepang (sea cucumber), a highly prized delicacy in China. While they did not settle, the Macassans had some influence on the cosmology and technology of the local peoples.

Sustained contact with Europeans began with tentative attempts by the British to settle on Melville Island in 1824, and on the nearby mainland in the following years. The first permanent settlement, Palmerston (later Darwin), was founded in the second half of the nineteenth century. Over the next one hundred years settlements and missions were established in Arnhem Land which was declared a reserve for Aboriginal people in 1931. In recent decades, these settlements have become Aboriginal towns and service centres for the many people who

have moved back to live on their clan lands. This so-called home-lands or outstation movement has stimulated an increase in cere-monial and traditional activity, while a drive for a degree of economic independence has accelerated the production of art for the public domain. The towns have developed artists' coopera-tives or art centres which have become conduits for the move-ment of art from the region to the outside world.

While several distinct languages are spoken across Arnhem Land, each as different from the other as say, French is from Russian, the peoples of the region have similar forms of social organization and hold many religious beliefs and ceremonies in common.

The complex social structures which organize religious and secular life and articulate the relationships to ancestral beings, ceremonies and Dreamings are reflected in art. Many Dreaming stories originate in one area and travel across the region, assum-ing a wider significance as they link clans who are associated with them. Especially prominent among these are the Dreamings con-cerning the ancestral beings Yingarna and Ngalyod the Rainbow Serpents, the Wagilag Sisters, the Djang'kawu, and Barama and Lany'tjung, all of whom figure in major ceremonial cycles.

17, 20

36, 45

53

The immense sandstone plateau which rises above the sur-rounding lowlands in western Arnhem Land contains galleries of spectacular rock art. Archaeological evidence suggests that paintings were being made some fifty thousand years ago. The oldest paintings in existence are believed to be at least eighteen thousand years old, created during the Ice Age when the sea was well below its present level. Studies of the environmental changes that have occurred since this period, and the changes in styles and motifs, along with the sequences of superimposed images, have enabled archaeologists to broadly determine the temporal sequence in this art. The earliest images are imprints of hands, plants and bundles of string thrown against the wall. These were followed by naturalistic monochrome images of ani-mals and humans in animated postures in a style previously known as 'mimi', after the spirit figures they represent, and now commonly called the 'dynamic style' of rock painting.

Nearly ten thousand years ago, as the sea level rose and the coastal environment came closer to the escarpment, marine creatures began to feature in rock paintings. Rainbow Serpents, creator-beings associated with water, made their appearance. It is estimated that polychrome figures with internal anatomical details visible, in what is now known as the 'x-ray style', were

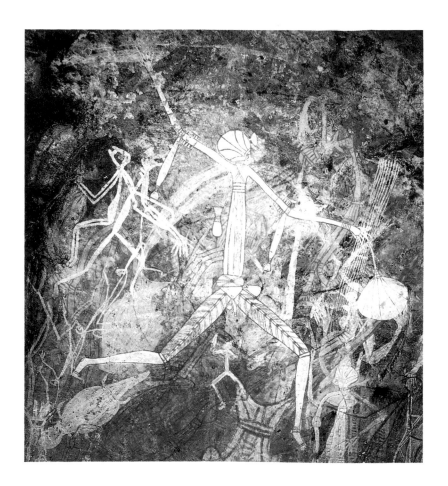

11. Najombolmi, *Hunter*, rock painting, 1960s

introduced in the last three thousand years. The most recent periods of rock painting portray scenes and images relating to contact with the Macassans and later with Europeans.

The rock-art tradition has continued into the twentieth century. One of the most prolific and well-known Kakadu rock painters of the modern era was Najombolmi, also known as Barramundi Charlie, whose elaborate animated *mimi* spirit figure is depicted here throwing a spear. Ritual ornaments hang from his elbows and neck. Working in the last years of his life, Najombolmi has superimposed this image over earlier paintings.

Characteristically, artists like Najombolmi work in more than one medium, although some artists are renowned as specialists in a particular form. The establishment of a market for art outside the communities has encouraged artists to specialize. Since

the early 1900s the demands of anthropologists, researchers and collectors for portable works of art have stimulated the production of bark paintings, although the entire Arnhem Land region is also rich in other forms of art including painted wood sculpture and dyed and woven natural fibres which often incorporate feathers.

Bark is a perishable material and the antiquity of the tradition of bark painting is difficult to establish. The practice of painting on large sheets of bark used for the walls of shelters was seen when the Europeans first arrived, and the earliest recorded bark paintings were collected on Essington Island between 1838 and 1878.

Bark is peeled from the trunks of stringybark trees (*Eucalyptus tetradonta*) during the wet season when the sap is rising and the bark is easy to remove. The curved sheet of bark is cured and made pliable, then flattened under weights for a few days while it dries. Next, the rough outer layer is removed and the inner surface rubbed smooth in readiness for painting. The colours used by bark painters in Arnhem Land are a range of red and yellow ochres, white from kaolin or pipeclay, and black which is usually obtained from charcoal or, on Groote Eylandt, from manganese nodules. The sites at which ochres are quarried are often of important ritual and political significance. Colours and the substances from which they are made are symbolic in themselves. White clay is used in mourning, red ochre is associated with the blood of the ancestor-beings who now reside in the earth. For the artist Narritjin Maymuru, the colours expressed the personal nature of his work. White represented his bones, red his blood, yellow his body fat and black his skin. 60

A range of brushes are made from a variety of fibres and sticks, the ends of which are either frayed by chewing or have hairs or feathers attached. Broad areas of background colour are often blocked in using the hands. A particularly fine brush made of several long hairs attached to a stick (called *marwat*, meaning 'hair', in eastern Arnhem Land) is used to paint intricate cross-hatched patterns. In recent years commercially available brushes have been used, and these are modified to suit the specific needs of the artist.

The traditional fixatives used to bind the pigments include wax, the yolk of birds' eggs, resins and the sap of orchid plants. Since the 1960s, these binding agents have been largely replaced by more readily available and easier-to-handle synthetic wood-glues. The results are generally similar to those achieved with traditional binders, although some artists prefer to use a more

concentrated mixture of glue and pigment to produce a glazed surface on their work. The durable properties of commercial binders make them suitable for the production of art intended for the outside world. Until this became a consideration, the permanence of bark paintings was apparently not important to artists. Paintings made for particular purposes were either destroyed or discarded once their secular or ritual function was fulfilled. As elsewhere in Aboriginal Australia, the process of making art was often more important than the finished product.

Paintings are executed with the bark lying flat, either on the ground or on the artist's lap. As the painting is composed the bark is rotated, and the finished product may have no fixed viewing orientation. As paintings express the relationships between things on social, spiritual and physical planes, the placement of elements in relation to the cardinal points of the compass is often significant. However, the position of dominant images may also indicate a preferred orientation. Narritjin Maymuru's painting *Nyapililngu at Djarrakpi* has both types of reference. 60

The systems of visual communication in Arnhem Land feature figurative or schematic images and conventional and geometric designs, either separately or more usually in combination. Paintings fall into a number of regional stylistic categories. In West Arnhem Land, bark paintings tend to feature naturalistic images against a plain ground, while the use of geometric designs covering the entire painting surface is more prevalent towards the east. In practice the question of style is more complex than a single regional division would suggest. In Arnhem Land, people distinguish between styles according to a number of related criteria, including the type of country artists occupy – freshwater, saltwater, forest or rocky – and most importantly, the subject of the work and the artists' clan and language-group affiliation. A further influential factor is an artist's moiety affiliation; that is, to which of the two complementary social groups he or she belongs. In much of Arnhem Land the moieties are known as Dhuwa and Yirritja. Moiety membership, inherited patrilineally, determines an artist's rights to use particular designs and patterns.

The use of cross-hatched patterns is a feature of Arnhem Land paintings. The patterns are prescribed designs which identify clans. In the western half of Arnhem Land the cross-hatching is referred to as *rarrk*, while towards the east the patterns are known as *miny'tji* and *dhulang*. The clan designs were handed down by the ancestors and are used in a variety of circumstances, from the making of bark paintings in the public domain to body

painting in ceremony. They impart a notion of brightness which signifies the presence of ancestral or spiritual power in a work. Today, artists often elaborate on these designs as they seek to give their paintings vibrancy.

In painting, the major ancestral dramas such as the Wagilag and the Djang'kawu are usually depicted in established compositional structures which include specific iconographic elements arranged in prescribed ways – much as tradition influences the depiction of biblical themes in European art. Here, too, the structures are flexible enough to allow scope for variation, innovation and artistic individuality.

Arnhem Land's range of art styles can be divided broadly by region into four main groups: those of the Kunwinjku and Kuninjku language groups of the west, those of the Rembarrgna and related groups of the centre, the styles of the Yolngu people of the central and north-east regions, and lastly, the disparate styles of the peoples who live in Arnhem Land's environs.

Figures of transformation: West Arnhem Land

The West Arnhem Land region extends roughly from the East 3 Alligator River which marks the boundary between Kakadu National Park and Arnhem Land, to the Liverpool and Mann Rivers, taking in the Cobourg Peninsula and a number of islands to the north. Among languages, Kunwinjku in the west, around the town of Gunbalanya (formerly Oenpelli), and Kuninjku in the east towards Maningrida are the main dialects spoken in the region. Minor cultural differences distinguish the two groups.

The paintings on the cave and rock walls of the Arnhem escarpment and bark paintings, the most common form of contemporary art in the area, share many pictorial characteristics, and artists in the region today acknowledge a relationship between their work and the rock art. Figurative images predominate in rock art and also appear in bark painting, but non-figura- 2 tive designs of the type generally restricted to ceremony appear more frequently on barks.

The figures in West Arnhem Land painting are usually set against monochrome backgrounds, which until the 1970s were often a wash of red ochre. In more recent times, white, yellow and occasionally black grounds have been used. The interiors of the drawn images may be divided into sections, and they are highly decorated with designs similar to those painted on to ritual objects and people's bodies in ceremony. The cross-hatched patterns or *rarrk* identify clans and imbue the object onto which

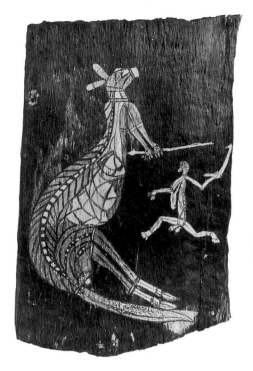

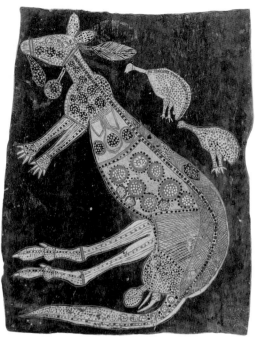

12. Unknown artist, *Mimi spearing a kangaroo*, 1912

13. Jimmy Midjaw Midjaw, *Nadulmi in his kangaroo manifestation, as Wubarr leader*, 1950

they are painted with the power of supernatural beings. In bark painting artists elaborate on these designs and patterns for visual effects and to enhance the notion of ancestral power. As in the rock paintings, the dynamic and x-ray styles of painting are common. *Mimi* spirits are regarded as having taught the ancestors of the present-day Kunwinjku the art of painting. Not regarded as creator beings, *mimi* can be both benevolent and malevolent. They are held responsible for making the earliest rock paintings in the region. 2, 12

Mimi spearing a kangaroo, a bark collected by Spencer in Gunbalanya in 1912, has been regarded as an archetypal image of West Arnhem Land paintings. The kangaroo and the hunter are shown in x-ray style: the kangaroo's backbone and internal organs are clearly visible. The kangaroo is drawn much larger than the hunter to emphasize the main subject of the work. Similar paintings appear on the walls of both bark and rock shelters, and their purpose is often didactic, illustrating the parts of the animal's anatomy and the method of butchering.

Similar images may be painted to express concepts of deeper significance. The posture of the kangaroo in Jimmy Midjaw

Midjaw's *Nadulmi in his kangaroo manifestation, as Wubarr leader* 13
is like that in *Mimi spearing*, but this subject belongs to the relig-
ious sphere. The human ancestor Nadulmi is the creator of the
Wubarr primary male initiation ceremony. Characteristic of
ancestral beings, Nadulmi has the power of transforming his
physical shape. Midjaw Midjaw has depicted Nadulmi in x-ray
style, but the designs on the kangaroo's body correspond to body
paintings used in the Wubarr. To emphasize the connection with
ceremony, Nadulmi is shown wearing white crane feathers and
with a ritual dilly bag suspended around his neck. The painting
expresses the spiritual or inner nature of the subject.

In West Arnhem Land painting, styles spread through the
close family groups or communities in which people live. In the
1950s and 1960s Midjaw Midjaw lived on the island of Minjilang, 3
where a number of artists from different backgrounds worked in
close proximity and influenced one other. Initially stimulated by
collectors and anthropologists, the group included the prolific
bark painter Yirawala (1903–76), a great ritual leader with a 14
wealth of religious knowledge which gave him access to the
entire range of Kuninjku iconography, from simple secular
images of animals through to the images of the great creation
stories, and designs for sacred ceremonies and magic.

Paintings made for purposes of sorcery (a practice allegedly
discontinued following the interventions of missionaries) are
found on the rock walls of the region as well as on sheets of
bark. They proliferated in the atmosphere of uncertainty on
Minjilang, where missionary influence was strong, and where
until the 1960s Aboriginal people of 'mixed blood' had been
resettled. A significant body of bark paintings was produced in
response to the interest in the subject shown by the anthropolo-
gists Ronald and Catherine Berndt and the Czech artist, ethnol-
ogist and collector Karel Kupka.

Aboriginal people recognize two main forms of magical activ-
ity. One is regarded as beneficial and is practised to produce posi-
tive results. A painting of a human figure may be intended to
encourage affection in another, or an image of a pregnant woman
to promote fertility. The other form, sorcery, is undertaken for
negative or malevolent purposes and is often employed in rela-
tion to offences of a sexual nature, where a jilted lover seeks
revenge, for example, or in retribution for a personal slight.
Sorcery images have a number of distinguishing features: the
figure may be drawn with multiple limbs and distended organs,
and the body contorted in unnatural positions. Occasionally

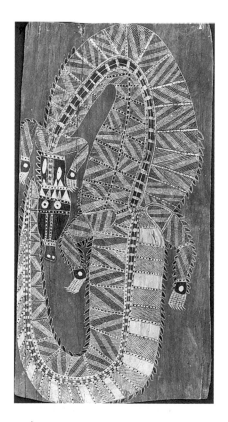

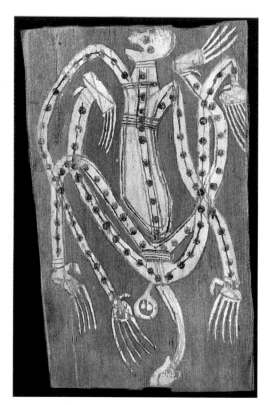

14. Yirawala, *Namanjwarre, the Mardayin Crocodile*, c. 1973

15. Paddy Compass Namatbara, *Maam spirit*, c. 1963

limbs and body orifices are shown pierced by sting-ray barbs which are intended to inflict great pain or death on the victim.

In *Maam spirit*, Paddy Compass Namatbara expresses disfig- 15 urement by adding two legs, and exaggerates the penis to suggest sexual misconduct. *Maam*, a name given to the non-sacred aspect of the soul, is a malevolent entity said to remain with the bones of the dead person, while the sacred aspect of the soul makes the journey to a sacred place in the land of the deceased.

The school of art which developed at Minjilang is replicated today in the family groups who live together on the mainland. The Nganjmirras, a family of Kunwinjku people belonging to the Djalama clan, are some of the most renowned artists. The brothers Peter Nganjmirra (1927–87), Jimmy Nakkurridjidjilmi Nganjmirra (1917–82) and Bobby Barrdjaray Nganjmirra were prolific artists from the 1950s on. Bobby Nganjmirra has painted 16 on rock and produced a large body of bark paintings. The work illustrated recalls the hunting scene in the painting collected by

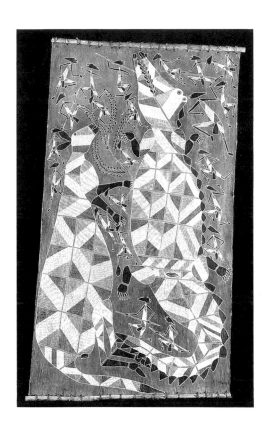

16. Bobby Barrdjaray Nganjmirra, *Kangaroo and crocodile*, 1984

17. Bruce Nabekeyo, *Yingarna, the Rainbow Serpent*, 1989, from the series *The story of the yam*

18. Robin Nganjmirra, *Likanaya*, 1989

Spencer in 1912. A feature of Bobby Nganjmirra's work, however, is his elaboration on the patterns of *rarrk*, which influenced a number of younger Kunwinjku artists.

In *Yingarna, the Rainbow Serpent*, one of Bobby Nganjmirra's 17 protégés, Bruce Nabekeyo, depicts Yingarna as the creator, the First Mother of the Kunwinjku. Nabekeyo has painted Yingarna with waterlilies on its back to indicate its presence in the waterhole which is its home. The Serpent is depicted swallowing people whom it will regurgitate later, in a transformed state, as features of the landscape. The theme of swallowing and regurgitation is commonly used through much of Aboriginal Australia as a metaphor for the transition from one metaphysical state of being to another. It is a feature of many ancestral stories concerning the genesis of the world, and it is employed in ceremony to effect the transformation of initiates to a higher spiritual level.

Another artist taught by Bobby Nganjmirra, Robin, the son of Jimmy Nganjmirra, is typical of a number of painters of his generation in elaborating and inventing patterns of *rarrk* which

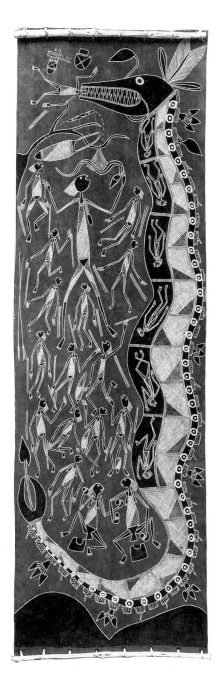
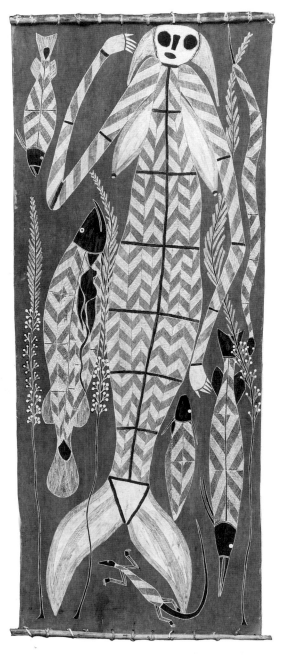

go beyond the prescribed clan patterns. He uses the device in *Likanaya* to suggest images seen through the surface of water. 18 Likanaya and her sister Marayka are two daughters of Yingarna who escaped the advances of the giant Luma Luma by jumping into a waterhole and growing fish-tails.

Not all Kunwinjku accord Yingarna the role of the original creator. The artist Djawida also belongs to the Djalama clan, but his country, Kudjekbinj, lies away from that of the Nganjmirra family, and he paints Nawura as the principal ancestral being. Nawura travelled through the rocky landscape creating sacred sites and giving people the attributes of culture. He taught men how to catch freshwater fish, while his wives taught women how to make food-collecting bags with loops so that they could be carried around their necks, leaving their hands free for wielding digging sticks. As with Yingarna and Ngalyod, Nawura's powers of physical transformation are expressed by the combination of characteristics of different species. In *Nawura, Dreamtime* 19 *ancestor spirit*, his head has a long pointed snout and curved jaw similar to that of the crocodile depicted to his right. Djawida emphasizes the non-human nature of his figures by giving Nawura and his wives six fingers on each hand. The various species in the painting feature prominently in the Nawura epic.

The art of the Kuninjku in the eastern part of the region also features Yingarna, here called Yinarnga. While Yinarnga is regarded as the all-pervasive principal ancestral being, one of her Rainbow Serpent offspring, Ngalyod, is associated with specific sites.

In Peter Marralwanga's *Ngalyod, the Rainbow Serpent* the 20 Snake is shown at Manabinbala on the Liverpool River, where great tides create a dangerous whirlpool, suggested in the painting by the swirling curve of the figure. In pushing the form of the crocodile-headed serpent to the edges of the bark to create a field of *rarrk*, Marralwanga expresses his dominant concern with spiritual forces. Marralwanga was taught by his uncle Yirawala to paint the *rarrk* designs which were to become the hallmark of his later work. Marralwanga did not begin to produce paintings for sale until he was over fifty, when his senior position gave him the authority to develop many unorthodox *rarrk* patterns through varying combinations of ochres and angles of lines, to produce areas of unusual colour and stimulating visual effects.

The device of drawing figures to the extremities of the bark is also a feature of the art of John Mawurndjul who was profoundly 22 influenced by Marralwanga's paintings. *Rainbow Serpent's*

19. Djawida, *Nawura, Dreamtime ancestor spirit*, 1985

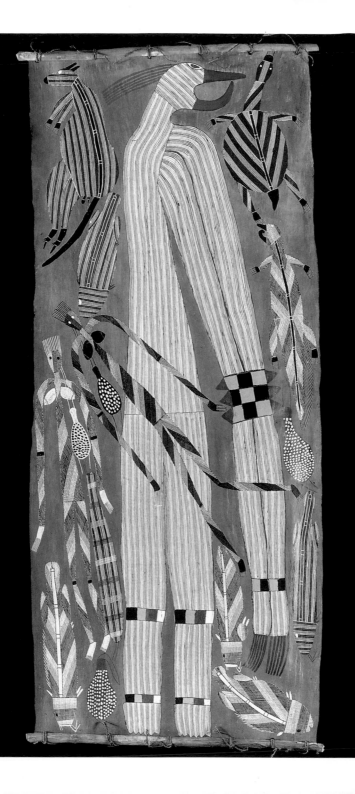

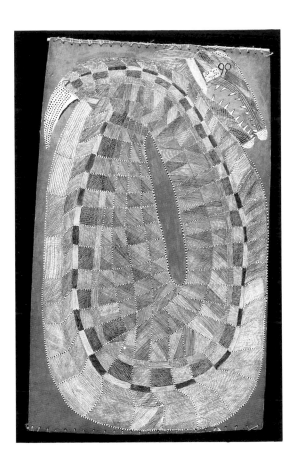

20. Peter Marralwanga, *Ngalyod, the Rainbow Serpent*, 1981

21. Crusoe Kuningbal, *Mimi spirits*, 1979

Overleaf:
22. John Mawurndjul, *Rainbow Serpent's antilopine kangaroo*, 1991

23. Mick Kubarkku, *Dird*, 1991

antilopine kangaroo shows a horned Yinarnga giving birth to the Rainbow Serpent Djangkarla in the guise of a kangaroo. Djangkarla's kangaroo head can be seen in the top left-hand corner of the painting, and Yinarnga's to the right. The protrusions on the upper chests of Djangkarla and Yinarnga represent the gullet of emus in which they store the food they will later regurgitate and swallow again. The detail reinforces the concept of transition through the process of swallowing and regurgitation, comparable to the effects of initiation ceremonies. The painting is dominated by Mawurndjul's sweeping patterns of *rarrk*, which place the subject in the realm of the metaphysical.

In the cosmology of the Kuninjku the moon possessed human form. The Moon ancestor dies, but unlike humans, he is capable of reappearing in the same physical form. Mick Kubarkku's *Dird* 23 shows the full moon dying and becoming the crescent of the new

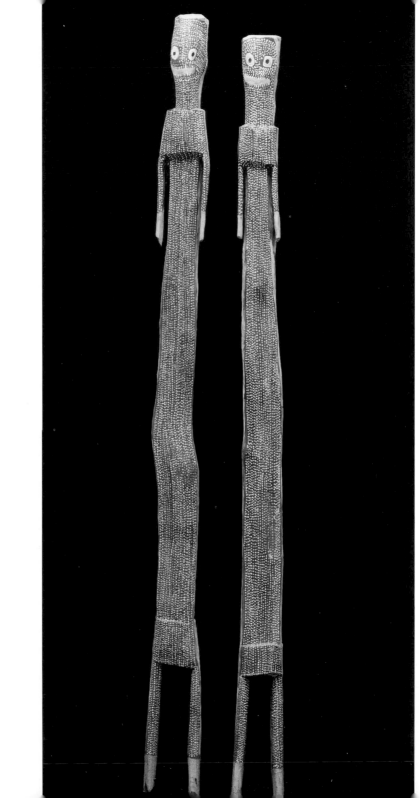

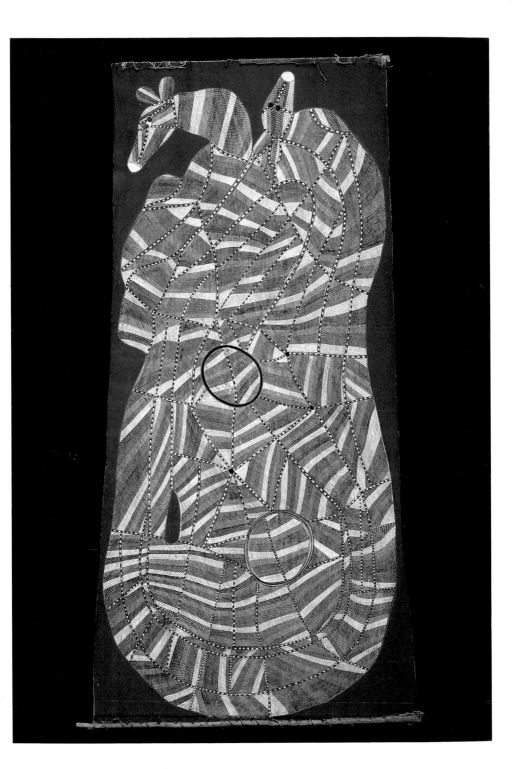

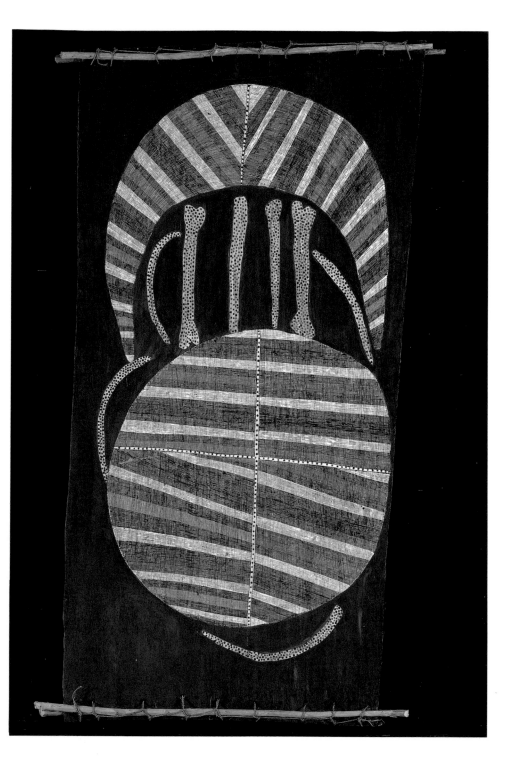

moon. The human aspect of Dird is expressed through the depiction of his bones. Typical of Kubarkku's work, *Dird* adheres to older, less elaborate styles of *rarrk* in preference to the innovations favoured by many contemporary Kuninjku painters.

There is wide scope for invention in sculpture as well as in painting among Kuninjku artists. Crusoe Kuningbal has created 21 innovative sculptures of *mimi* figures for ceremonial purposes and similar ones for sale. In contrast to the animated painted *mimi* images, Kuningbal's sculpted figures are static. They are painted with a red ground and decorated with rows of white dots. Such figures are used in exchange ceremonies called Mamurrng, performed to celebrate the birth of a male child, where they watch over the wrapping of carved wooden bones. They are related to *djuandjuan* figures made of paperbark covered in bush string, known from the 1940s, which were used as grave-markers. In the last ten years of his life Kuningbal was a prolific carver of *mimi* figures. Since his death in 1984, the tradition has continued with his son Crusoe Kurddal (born 1964), who often makes figures up to three or four metres high.

Sacred digging sticks and dilly bags: Central Arnhem Land
The region of Central Arnhem Land, between the Liverpool and Mann Rivers, and the Blyth River towards the town of Ramingining, is occupied by a number of language groups who share ceremonies, customs and beliefs with the Kuninjku. These groups include the Dangbon, Kurrkoni, Gunardba, and Rembarrnga who also possess vast areas of land concentrated in southern Arnhem Land and beyond to Jarruluk. The styles of graphic art in the region mark a transition from the figurative images of the west to the more conventionalized designs and complex compositions found in the east.

That there is no hard and fast division between east and west can be seen from the work of Wally Mandarrk, who like Kubarkku maintained the use of traditional techniques in producing bark paintings for sale, including the use of natural fixatives to bind the pigments well after the introduction of synthetic glues. Mandarrk lived in the rock country of the upper reaches of the Tonkinson and Cadell Rivers. His affiliations to the Kune and the Kuninjku on the Liverpool River to the west are evident in his style of painting, illustrating how cultural and artistic influences travel along river systems. The figures in *Narrangem and Ngaldaluk, Lightning Spirits* are also similar to 24 those found in the rock paintings of the region, and indeed,

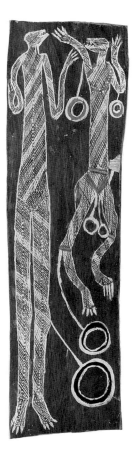

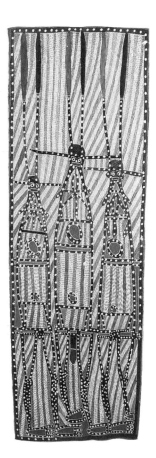

24. Wally Mandarrk, *Narrangem and Ngaldaluk, Lightning Spirits*, 1986

25. Ronnie Djambardi, *Wandurk and his two wives*, 1981

Mandarrk often painted on rock walls. This painting depicts spirits responsible for creating the spectacular curtains of lightning which accompany the drenching rains of the wet season. Narrangem, on the right, wears at his waist a stone axe to make thunder, while the lines emanating from the figures are streaks of lightning and the circles represent smooth stones made by lightning striking the ground.

Ronnie Djambardi's rendering of figures in *Wandurk and his two wives* is similar to Mandarrk's. The figures are shown in full and front-on to the picture plane. The *rarrk* is restricted to clearly defined sections of the torso, in the manner of ritual body painting in a major Kurrkoni ceremony featuring Wandurk for which Djambardi is responsible. Djambardi, however, has used the entire painting surface, in keeping with styles prevalent here and to the east.

39

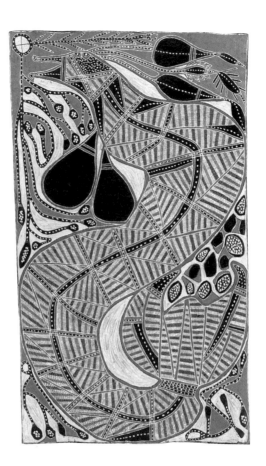

26. England Banggala, *Modj (Rainbow Serpent)*, 1988

In *Modj (Rainbow Serpent)* England Banggala shows the 26 creator-snake as part of the land. The dynamic curve of its body expresses its sheer strength, while simultaneously representing the course of the Cadell River which is its domain. Modj's supernatural powers are contained in the black ceremonial bags around its neck, while eggs, indicative of its procreative energies, appear above the tail on the right. Its home is shown both as the white crescent in the lower half of the painting indicating a rock in the water, and as the white circle at the top left representing a hole on the riverbank.

At Gochan Jiny-Jirra on the Cadell River, Banggala, a Yirritja man, was the ceremonial leader for a group of families which include his daughter, the artist Dorothy Galaledba, and her husband Les Mirrikkuriya.

Galaledba's apprenticeship as a painter began when she was twenty. Under the guidance of Mirrikkuriya, she at first filled in

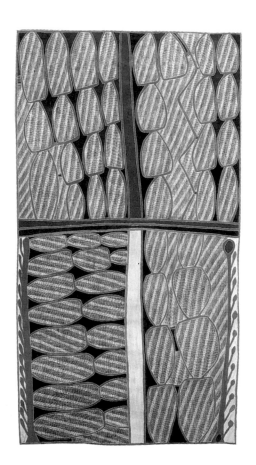

27. Dorothy Galaledba,
*Jin-gubardabiya (triangular
pandanus skirt)*, 1989

the *rarrk* in his paintings, the usual method of teaching the art of painting, and later learned to paint Mirrikkuriya's themes. Recognizing her ability as a painter, Banggala encouraged Galaledba to paint and taught her his stories. As moiety affiliation is patrilineally inherited, Galaledba is Yirritja like her father. Under the marriage rule her husband is Dhuwa, as customarily marriages are made between members of the opposite moieties. Galaledba's experience demonstrates one way in which an artist may gain rights to paint the themes belonging to the opposite moiety.

The main motif in *Jin-gubardabiya (triangular pandanus skirt)* 27 is the skirt woven from pandanus fibres and worn like an apron, symbolic of Gun-nartpa women. In the top right section a meander represents the waterweed *gapalma*, depicted again to either side in the bottom register to illustrate how it can trap unwary people. The waterweed once snared the ancestral Jin-gubardabiya

skirt at a place which is now the underwater sacred site at Nanga-nambirri. While the painting is in the genre of her father's work, and indeed he painted this subject often, Galaledba has developed a personal approach enhanced by her distinctive use of *rarrk*.

The fibre arts continue to be one of the major forms of artistic expression for the women of Arnhem Land, although men also weave items for ceremonial and daily use. Artists emphasize the textural qualities of weavings. As in bark painting and sculpture, the scope of fibre objects is continually enhanced through innovation in style and experimentation with new dyes, materials and techniques of weaving. Lena Djamarrayku's *Djerrh, bush string* 28 *carrying bag* incorporates lines of feathered string. The *djerrh* is used by both men and women as a collecting bag or to hold personal possessions, and it can be used in ritual. Lena Yarinkura has extended woven forms to create tableaux of animals, human beings and spirit creatures, such as the Yawk Yawk female water 29 spirits. This image of the Yawk Yawk is a localized version of the narrative referred to in Robin Nganjmirra's painting of Likanaya. 18 The various types of string and pandanus-fibre bags, skirts, mats and nets form part of the symbolic imagery used to express the daily and the religious experience.

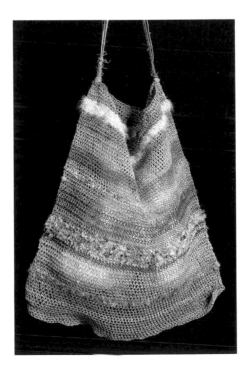

28. Lena Djamarrayku, *Djerrh, bush string carrying bag*, 1989

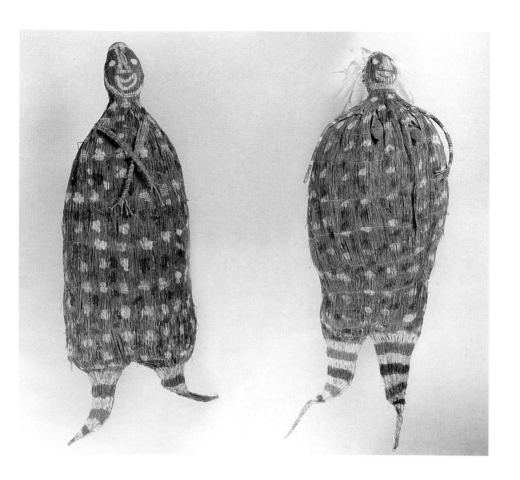

29. Lena Yarinkura, *Yawk Yawk Spirits*, 1998

Objects made of woven fibres play prominent roles in ancestral events. Kunmatj, the sacred dilly bag, was carried by one of the major totemic beings of the Balngnarra clan of the Rembarrnga people, Balangu the Shark. Balangu emerged in eastern Arnhem Land, and his creative exploits link the Murrungun/Djinang and Djambarrpuyngu groups to the Balngnarra. The ancestral Shark (depicted as two sharks in Jack Kala Kala's painting) gave people the humanizing elements of ceremony and law. As Balangu travelled from the east in the wet season, the river waters rose and he was washed far inland to a waterhole where his spirit resides (at Ngangalala on the Glyde River beyond Rembarrnga country). Here Balangu entered the ground, to resurface at other inland lagoons. Red ochre deposits found at these sites were created by Balangu as his body struck the earth.

30

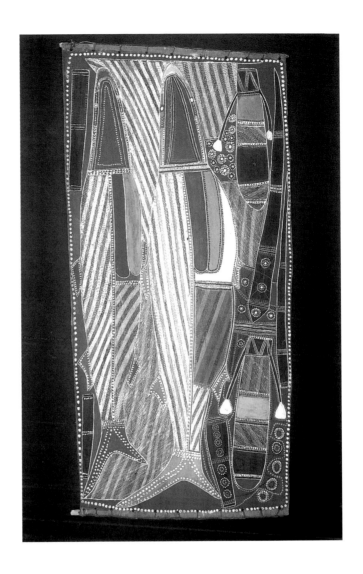

30. Jack Kala Kala, *Balangu, two sharks*, 1986

31. Les Mirrikkuriya, *Digging sticks and sacred dilly bag at Ginajangga*, 1988

Kunmatj the dilly bag appears as the custodian of the water-hole in *Digging sticks and sacred dilly bag at Ginajangga* by Kala 31 Kala's younger brother, Les Mirrikkuriya, who emerged as an artist after Kala Kala's death in 1987. The painting portrays the ancestral digging sticks named Gungarnin walking through the country and plunging into the earth to create the waterholes which are depicted as circles along the base of the bark. The elements are painted as though they are seen under water, an effect achieved by the innovative combinations of *rarrk* patterns and wide range of colour. Mirrikkuriya mixes ochres, charcoal and

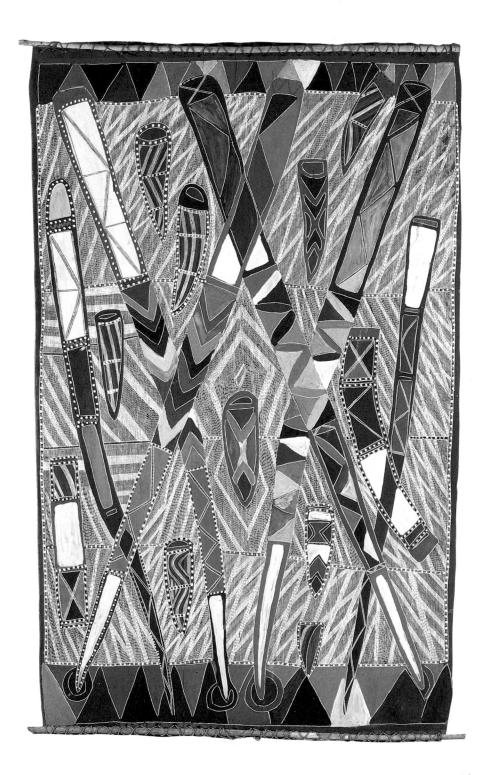

45

pipeclay to make pinks, oranges and greens in a manner rare in bark painting.

The diversity of approach to painting among the Rembarrnga is illustrated in the work of Paddy Fordham Wainburranga from Jarruluk in the south, who favours expressionistic and dynamic figurative images and shuns the use of *rarrk*, although he creates a similar luminosity through the use of dots. While much of his work concerns *balanyjarrnngalany* spirits and the ancestral events which resulted in the creation of his country, Wainburranga's work reveals the scope of bark painting to provide Aboriginal perspectives on historical events.

How World War II began (through the eyes of the Rembarrnga) 32 records an event concerning the Japanese pearl divers who used to work the north coast of Australia. The bottom right panel shows an exchange involving Aboriginal women – the Japanese are identified by the short trousers they wear. The lower central panel shows a pearl diver leading a woman to the boats. In 1941 an incident developed between the local people and the Japanese which led to the latter retreating to Darwin, where they were then expelled by government officials (seen in the top right panel, wearing cowboy hats and guns). A few months later, in 1942, Japanese aeroplanes (shown in the left of the painting) bombed the northern coast of Australia. The Rembarrnga, on whom the war was to have far-reaching social effects as many were recruited to work on military installations, felt they had contributed to the start of hostilities.

32. Paddy Fordham Wainburranga, *How World War II began (through the eyes of the Rembarrnga)*, 1990

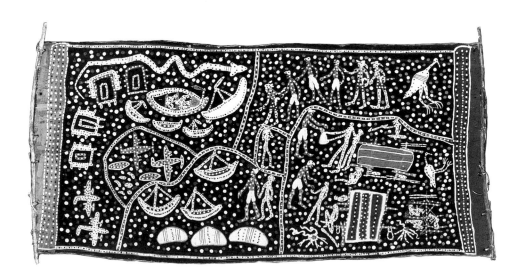

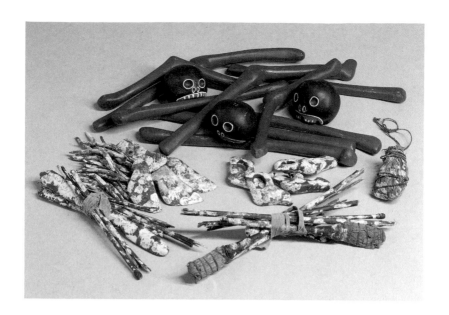

33. Brian Nyinawanga, *Bones*, 1982

Like Crusoe Kuningbal before him, Brian Nyinawanga, a Rembarrnga artist, developed sculptural types for use in ritual but also for sale. Nyinawanga carves and paints animal and human figures in wood which are then wrapped in paperbark bundles. Often these composite sculptures represent human skeletons; in some cases the bundles are displayed unwrapped and with the contents laid out, or they may be presented wrapped or partially open. *Bones* is made up of three sculpted 33 skeletons; the bones are of a father and his two daughters who were killed for failing to uphold customary marriage promises. The work relates ancient events and is didactic in nature. Parcels of carved and painted bones are used in Mamurrng exchange ceremonies along with carved *mimi* figures such as those by Kuningbal. The *mimi* watch over the wrapping of the bundle, 21 which is carried throughout the ceremony.

Rites of passage of the Yolngu: Central Arnhem Land

A second main cultural group in Central Arnhem Land is made up of the clans whose country lies from Maningrida east to 3 Ramingining and the adjacent islands including Milingimbi. The clans have ties with the Rembarrnga and related groups but are more closely affiliated to, and share ceremonies and Dreamings with the clans in North East Arnhem Land. The people in this part of Central Arnhem Land and further to the

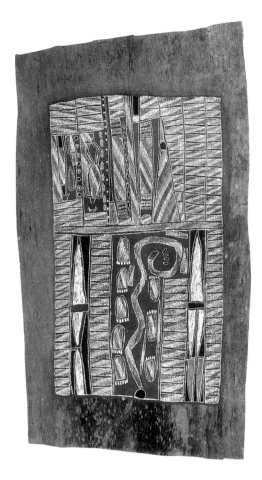

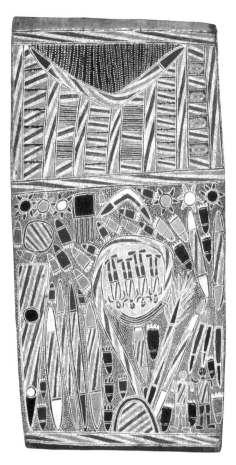

34. Tjam (Sam) Yilkari Kitani,
Wagilag, 1937

35. Dawidi Djulwarak, *Wagilag religious story*, 1965

east refer to themselves by the generic term 'Yolngu', meaning 'Aboriginal people'. Here, while clans own land, ceremonies, ritual objects and Dreamings, art styles are generally perceived to be associated with the broader language groups and moiety affiliation.

Among the most important Dhuwa moiety themes in Central Arnhem Land is that of Wititj the Great Python and the Wagilag Sisters. This chronicles the creative acts of the ancestral sisters as they travelled from south-eastern Arnhem Land, culminating in an epic encounter with Wititj. 34–36

The two Wagilag Sisters have children through incestuous relationships with their clansmen, forcing them to leave their inland country and journey north and then west towards the sea.

As they travel, they come across animals, plants and country on which they confer names, and by so doing, bring them into being. They make camp at Mirarrmina waterhole in Liyagalawumirri country, unaware this is the sacred home of Wititj, the Python. Wititj is angered by their presence. Sucking in the waters of the lagoon, he rears erect in the sky and spits to form the rain clouds of the first monsoon season. The Sisters perform songs and dances to avert the deluge and thunderstorm which follow, and take shelter in a bark hut they have made. Wititj suddenly descends and swallows the women, their children and all their belongings. As Wititj raises himself again into the sky, flood-waters cover the earth.

Wititj explains his actions to other ancestral pythons and is made to realize that he has erred in swallowing those who share the same moiety affiliation. The Python sickens and crashes to the ground, leaving the impression of his body in the earth. He vomits out the women and the children, and creates a strong wind which causes the floodwaters to abate. The action of swallowing and vomiting is repeated, but now Wititj regurgitates only the women, who become two large boulders at Mirarrmina.

The songs and dances performed by the women to stop the rain are revealed to the Wagilag men who had followed. The men are instructed to return home and teach these rites to others to guarantee the continuation of the cycles of nature. Although this is just one aspect of the purpose of the ritual, the Wagilag story emphasizes the importance of religious ceremony, a major function of which is to take an individual from one level of spiritual being to a higher one. The acts of swallowing and regurgitation, as seen in the paintings of Nabekeyo and Mawurndjul in West Arnhem Land, once again provide the metaphor for spiritual transformation.

The Wagilag theme presents the opportunity to study the development in a genre of painting over a period of half a century in the work of three artists of an equivalent ritual status, and with a similar level of access to the myriad meanings associated with the subject. The earliest attributable painting of this theme is by Tjam (Sam) Yilkari Kitani and dates from 1937. In part, the 34 painting is descriptive of the events that occurred at Mirarrmina. It is composed around the image of Wititj, whose meandering form emerges from the circular waterhole along the bottom edge of the painting to coil around four shapes indicating the Wagilag women and their children, whose footprints are also depicted. The engulfing image of Wititj indicates the process of

swallowing, and is the basic structural element which identifies the Wagilag theme in painting. In the upper section the figure of one of the Sisters is seen, upside down in this orientation. The triangular shape seen in the upper right is that made by Wititj's body as it hit the earth. Yilkari indicates the ritual associations of the event through images which are found in ceremonial ground-sculptures, such as the triangle and the meandering line of the serpent. The composition is divided into two sections, both of which contain images relating to the narrative and to the ritual.

The Wagilag story is the focus of the major Dhuwa ceremonies where deeper levels of religious knowledge are revealed to initiates. The rituals, the Kunapipi in particular, have been of great importance in sustaining traditional beliefs since the advent of Christianity in the region.

When Dawidi Djulwarak inherited his position as leader of the Liyagalawumirri in 1956, he did not have the ritual status to exercise his responsibilities, and his ceremonial duties were assumed initially by his uncle Yilkari and later by Tom Djawa. By 1963, however, Dawidi was entitled to paint the entire Wagilag repertoire. Many of the elements of Yilkari's painting are also recognizable in Dawidi's *Wagilag religious story* of 1965. 35 Here again the painting is divided into two sections, isolating the figuratively depicted narrative and ritual elements from a conventional depiction of the landscape where the Wagilag events occurred. In the lower section, the curling form of Wititj appears again as the dominant image. The upper section is composed of repeated rectangles with cross-hatched designs, the curved shape of the monsoon cloud, lines of dots signifying rain and vertical bands of lightning and thunder, combined to depict the rains of the first monsoon fertilizing the ground. These designs refer to the powers of the ancestral beings invoked, metaphorically drenching the land.

Like Dawidi, Paddy Dhathangu was guided in the art of painting by Yilkari. In *The Wagilag Sisters story* Dhathangu highlights 36 the flora and fauna described in the narrative, but he has transformed the conventional structure for depicting the Wagilag. Instead of meandering from the waterhole, the coiled shape of the python dominates the picture, and its contours imply the waterhole at Mirarrmina. The triangular ceremonial ground is omitted, but the formal arrangement of the footprints, the prominence of a cabbage palm painted with clan designs to the left in the painting and the ritual objects shown to the right, all emphasize the ceremonial aspects of the story.

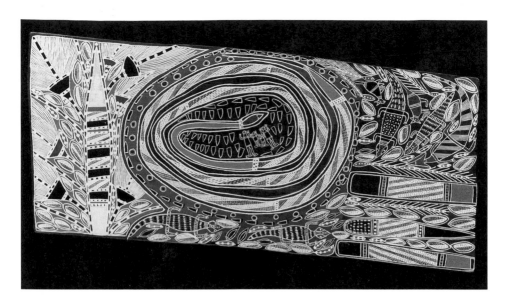

36. Paddy Dhathangu, *The Wagilag Sisters story*, 1983

Comparison of the three artists' treatment of the Wagilag theme yields an insight into the individuality of approach and artistic expression to be seen in bark paintings. While the compositions differ, each work adheres to the pictorial structures which identify the theme.

While the Wagilag Sisters' story is associated with the inland freshwater country, one of the other major Dhuwa sagas, the Djang'kawu, belongs to coastal saltwater clans. The Djang'kawu are commonly described as two sisters and their brother who came from the east, giving birth to the clans and creating sacred sites. Peter Bandjuldjul's *Djang'kawu creator ancestors and Gachalan the goanna at Mewirnbi* is essentially a figurative rendition of events. In the upper section, the Djang'kawu ancestors are shown under a bark shelter. To each side they are depicted carrying their children. Above them is a detail of the conventional ritual design used to identify the Djang'kawu: the cross-like form of rounded shapes representing the freshwater lagoons and the lines joining them indicating the routes the Djang'kawu travelled. (This design is elaborated in a painting by Daypurryun.) Bandjuldjul also illustrates the connection between the Djang'kawu and another ancestral being, Gachalan the goanna, where the paths of the two Dreamings cross at Mewirnbi. The goannas are depicted surrounding a hollow log in the lower

37. Peter Bandjuldjul,
*Djang'kawu creator ancestors
and Gachalan the goanna at
Mewirnbi*, 1982

register of the painting. The circular shape in the middle of the painting represents the waterhole at Mewirnbi.

Details of the creation stories are painted with particular reference to the locality in which events occurred. Tom Djawa's *Crabs*, for instance, depicts a site in Liyagawumirri country [38] opposite Galiwin'ku (Elcho Island) where the Djang'kawu created fish and crabs in the mangrove swamps. The artist, a senior Yirritja moiety man, had the right to paint Dhuwa Djang'kawu images through his matrilineally inherited connection with this Dreaming.

The Djang'kawu ancestors are also among the personal totems of David Malangi, but his predominant subjects derive from the story of Gunmirringgu, the Great Hunter, at Ngur-

38. Tom Djawa, *Crabs*, 1969

runguwa, a site in Malangi's country. The saga of Gunmirringgu concerns death, mortuary rituals and beliefs about the soul.

The Great Hunter camped under a white berry tree and began to cook a kangaroo he had killed when a poisonous King Brown snake bit him, causing his death. *Gunmirringgu* shows the Hunter's body decorated with clan designs and surrounded by ritual dancers in the centre left of the painting. The ceremony involves the killing and eating of kangaroos, an act which refers to the death of a person, while the dissection of the carcass symbolizes the exhumation of human bones in readiness for the reburial ceremony when the bones are placed in a hollow-log coffin (p. 75). According to the Manharrngu, the pelican shown in the tree guides the soul to the land of the dead. The flowering

39

stringybark tree in the upper register of the painting is analogous with the Morning Star pole to which are attached the several morning stars, symbolized by the white berries.

For the Dhuwa moiety the morning star is an important element in post-funeral ceremonies. The religious stories and ritual associated with the morning star are, like the Wagilag story, symbolic of the passage of the soul from one state of being to another – in this case, from the inner spirit world prior to birth, through the physical phase of life, and at death to the land of dead. On one level the Morning Star story relates the transition from night to day. The spirits of the dead keep the Barnumbirr, the Morning Star, in a dilly bag and send it out into the night sky. The Star is attached to a long string, by which it is retrieved and returned to its bag as the sun rises.

Barnumbirr the Morning Star by Jack Wunuwun is layered [1] with metaphorical allusions to the cycle of life and symbolic references to the natural world. In the central panel, the onset of the monsoon rains which fertilize the earth is suggested by a flock of ibis. Below, the ceremonial Morning Star poles are symbolic of procreation. The form of the poles, where the large feathered fans on top and attached to the strings represent the Morning Star, is repeated in the right-hand panel in the forms of the tubers of the yam plant. The yam flowers during Mayaltha, from January to March late in the wet season, the period of growth. In the season of Midawarr, at the end of the wet period, the swollen rivers carry great numbers of fish which are caught in traps, as depicted in the panel on the left. The fish-trap is symbolic of a container of souls. The complex relationships between different realms of experience are succinctly expressed in this painting.

During the second half of the dry period, in Rrarrandhar (August to September), wild bees' nests full of honey are common. The treatment of the subject of honey in art illustrates the relationship between moiety affiliation and graphic representation. Yolngu (as the Aboriginal peoples of the region refer to themselves) identify four types of honey, the main ones being *yarrpany* which belongs to the Dhuwa moiety, and *nimuda* which is Yirritja. *Yarrpany* is usually depicted in a figurative and relatively naturalistic manner. Don Gundinga's *Honey Dreaming at* [42] *Walkumbimirri* is densely packed with images – human and spirit figures, ceremonial objects, animals and insects, tools, collecting bags and drops of honey. The surface is highly animated with different coloured outlines, the bustling juxtaposition of images and the play of areas of cross-hatching which belie the images they

39. David Malangi, *Gunmirringgu*, 1967

40. Clara Wubugwubuk, *Walmi grass – munyigani edible tuber*, 1990

41. Johnny Bulun Bulun, *Sacred waterholes surrounded by totemic animals of the artist's clan*, 1981

decorate. The dynamic nature of the image conveys the presence of the animating spirit of the Honey Ancestor in the land.

In contrast, *Niwuda, Yirritja native honey* by Jimmy Wululu is an elaboration on the conventional method of representing Yirritja honey in painting. The diamond pattern indicates full and empty cells, while the dots represent the bees and pollen-balls of the host tree. The powers of the Honey Spirit are evoked by this pattern, which is also painted on to the chests of participants in the related ceremony, and on the bodies of the deceased members of the Yirritja moiety who are connected to the Honey Ancestor.

One of the most prolific Yirritja painters of the contemporary era was George Milpurrurru. Milpurrurru possessed a range of subjects commensurate with his high ritual standing as a ceremonial leader of the Ganalbingu, and his paintings are characterized by vibrant surfaces enhanced by the serial repetition of motifs. In *Fire and Water Dreaming*, sets of ritual emblems are formally arranged in two sections of the painting, while the upper register depicts a river. Milpurrurru uses intricate cross-hatched clan patterns to create an optical shimmer which suggests the forces of the ancestral Fire and Water Dreamings that imbue his country at Ngalyindi.

The concept of painting the land held by Yolngu artists is that it establishes an individual's or group's relationship to the country. In *Walmi grass – munyigani edible tuber*, Clara Wubugwubuk, one of a number of women who are making their mark as bark painters around Ramingining, depicts a landscape of running water and grass. The edible tuber depicted in the lower section of the painting is the artist's personal totem, and serves to reaffirm her link with the country and the rights and responsibilities she enjoys.

Freshwater lagoons are considered by the Yolngu to be the repositories of the souls of the unborn, and the places to which the souls of the dead will return. The pivotal role of the waterhole is evident in the composition of *Sacred waterholes surrounded by totemic animals of the artist's clan* by Johnny Bulun Bulun. Bulun Bulun makes the circular clan-wells the foci of the composition. Among the surrounding images of flora and fauna are magpie-geese, the major totem of the Gurrumba Gurrumba, the artist's clan. Characteristically for Central Arnhem Land paintings, the compositional structure of Bulun Bulun's bark reinforces the thematic content of the work.

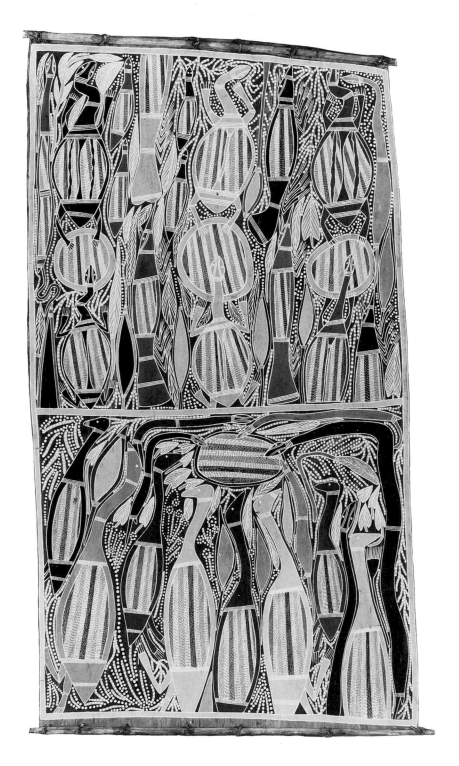

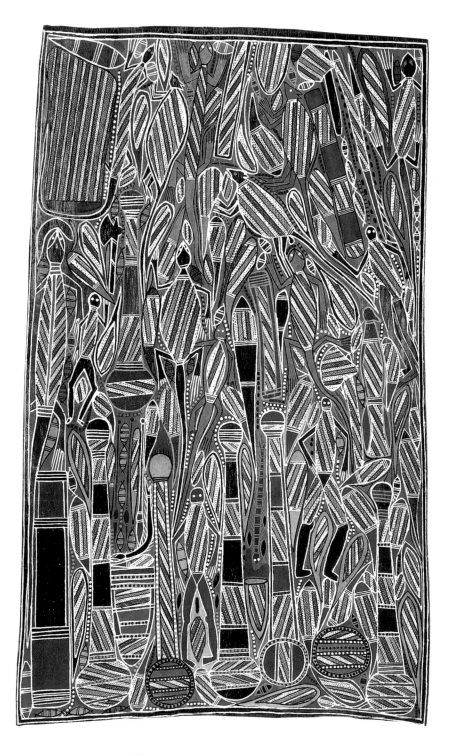

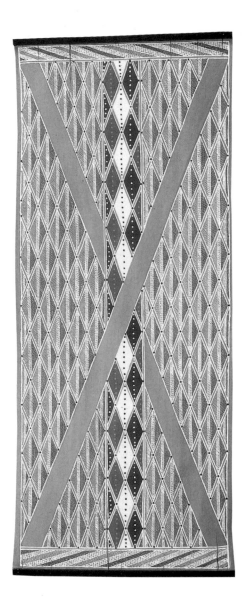

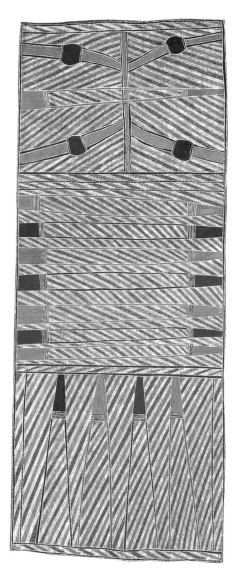

42. (*opposite*) Don Gundinga,
*Honey Dreaming at
Walkumbimirri*, 1984

43. Jimmy Wululu, *Niwuda,
Yirritja native honey*, 1986

44. George Milpurrurru, *Fire and
Water Dreaming*, 1989

Ancestral maps of the Yolngu: North East Arnhem Land

In North East Arnhem Land, from the island of Galiwin'ku to Yirrkala and south along the coast, the influence of clan membership is paramount. In painting, the underlying compositional structures, or templates, identify each clan and act as a conceptualized map of the clan's land. The structures encode sets of relationships between people, their country and ancestral beings. The emphasis here is on formal designs and prescribed compositions. As the market for Aboriginal art began to flourish in the 1960s, artists became concerned that some of the purely conventionalized designs, as painted on to objects in ceremony, were too sacred in nature to be seen by outsiders. Since each geometric design carries many layers of meaning, and there is a range of figurative versions to represent each of these, artists were able to de-sanctify paintings by introducing figurative images. In this way paintings retain deeper meanings to the Yolngu themselves but are made suitable for public display.

A fundamental concern among artists in North East Arnhem Land is to take paintings from a rough, dull state to one of brightness and brilliance. This is achieved through the visual density of the *miny'tji* or cross-hatched clan designs, and the build-up of layers of colour culminating in the use of white cross-hatching. The effect aimed for is one of visual shimmer, which accords with concepts of painting in the ceremonial context. In ritual, paintings on bodies, sculptures, coffins and objects are not intended to be static images requiring studied contemplation. Rather, since designs embody the power of the supernatural beings, they are intended to be sensed more than viewed. The patterns of *miny'tji* are derived from ancestral events: for example, a diamond pattern was burned into the back of the ancestral crocodile while the waves of the sea left patterns on the body of another ancestor.

Among the major Dhuwa themes in the art of North East Arnhem Land are the Djang'kawu ancestors. As with the natu- 45–46 ralistic and conventional forms for rendering episodes of the Wagilag story (called Wagilak or Wawilak in North East Arnhem Land), depictions of this theme take on various pictorial forms.

The Djang'kawu Brother and Sisters encountered various creatures on their voyage to Yalangbara on the eastern shore of Arnhem Land, where they made their first camp. They carried with them dilly bags elaborately decorated with feathers, conical mats, and large digging sticks, all of which were to have important roles in their creative actions. As they travelled west across

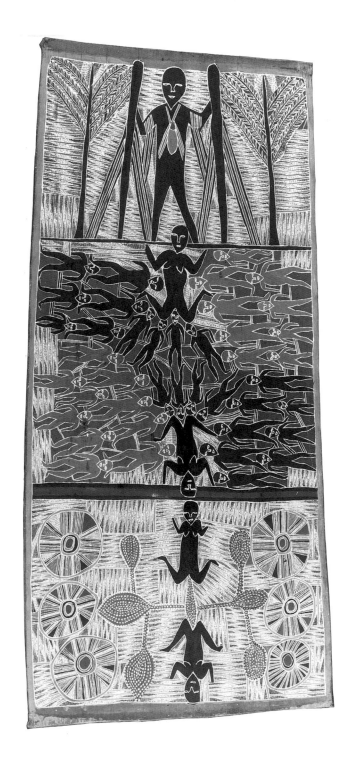

45. Wandjuk Marika, *The birth of the Djang'kawu children at Yalanghara*, 1982

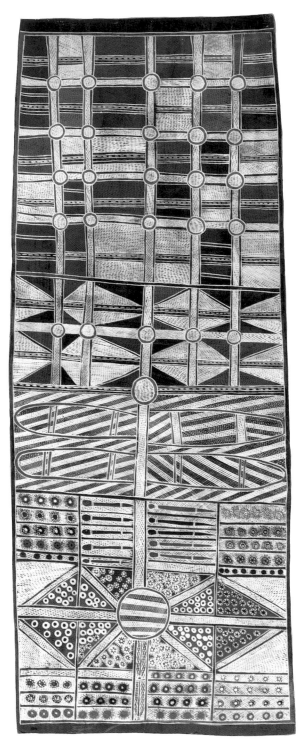

46. Mick Daypurryun, *Sacred waterholes – the Djang'kawu*, 1988

47. Mandjuwi with Kallie
Yalkarrawuy, *The Morning Star
ceremony*, 1979, installation

the land, the Djang'kawu named and created all manner of natural species. At every place they camped they made bodies of freshwater by driving their digging sticks into the ground. The sticks themselves became trees. The Sisters would crouch under the pandanus mats and give birth to sacred objects, and to the ancestors of the clans who would inhabit that country.

In the upper panel of *The birth of the Djang'kawu children at 45 Yalanghara* by Wandjuk Marika, the Djang'kawu Brother is depicted with a dilly bag around his neck and holding two large digging sticks. To either side is the transformation of the digging stick into a casuarina tree. The central panel shows, in schematic form, the two Djang'kawu Sisters giving birth to the clans.

The Rirratjingu clan design which forms the ground of the painting also reads as the pattern of shifting sands on the beach at Yalangbara. The subject of the lower panel is identical but here the event is rendered symbolically. The dotted forms represent the afterbirths, and the clans to which the Sisters gave birth are represented as the six round shapes of the conical mats of the Djang'kawu.

The conventional Djang'kawu pattern is shown in Mick Daypurryun's *Sacred waterholes – the Djang'kawu*. The Djang'kawu's 46 digging sticks and dilly bags along with jellyfish are shown in the lower half of the painting. The painting relates to the Djang'kawu in Liyagawumirri land on Galiwin'ku. The regularity of the design suggests the ordered nature of the creation of the land.

A similar grid structure is found in Mandjuwi's paintings of *The Morning Star ceremony*, a series of works which defines the 47 connection between the Djang'kawu and Wuluyma, the Yam ancestor and founder of the Galpu clan's Morning Star ceremony at Galiwin'ku. The combination of bark paintings, feathered poles and a sculpture of Wuluyma in the installation reflects the elaborate interaction between painted images and three-dimensional forms in ritual circumstances.

The connection between the two ancestral figures of the Rirratjingu clan, Mururruma the great turtle-hunter and Djambuwal the Thunderman, is referred to in *Turtle Dreaming* 48 by Mawalan Marika, a noted artist, statesman and ritual leader of the Dhuwa at Yirrkala. Against a ground-pattern of the Rirratjingu clan design representing the sea, seaweed and sand dunes, the long pointed shapes indicate the spouts of water the Thunderman sends down in the monsoon season, while the central image is a waterhole on Dhambaliya (Bremer Island), where the rocks contain Mururruma's spirit.

Recognition of women bark painters in Arnhem Land came in the early 1970s when those who had assisted their fathers began to make their own paintings. Among the women artists are Banygul (born 1927) and Dhuwarrwarr Marika (born 1949), who were taught to paint by their father Mawalan. Their younger sister Banduk Marika, however, has pursued printmaking rather than painting. Her linocuts and screenprints adhere to the pictorial traditions of her clan, the Rirratjingu. The techniques involved in cutting linoleum are similar to those used in the layered application of *miny'tji* in bark painting and the incision of designs on wood sculptures in North East Arnhem Land.

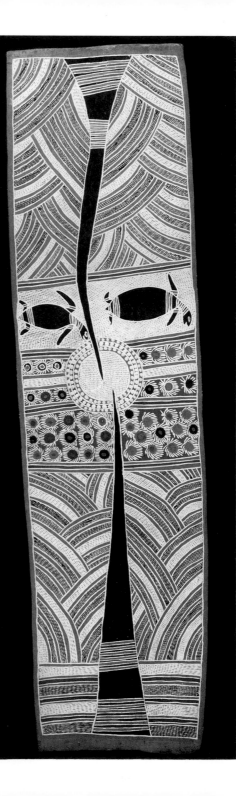

48. Mawalan Marika, *Turtle Dreaming*, c. 1963

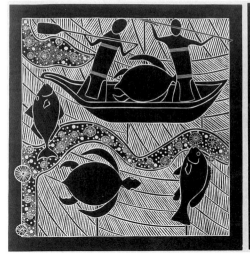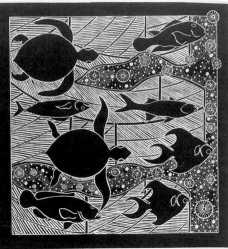

49. Banduk Marika, *Minyapa ga Dhanggatjiya*, 1990

Banduk's linocut *Minyapa ga Dhanggatjiya* shows Mururruma's 49 sons Minyapa and Dhanggatjiya, who were also famous turtle-hunters. A modified version of the Rirratjingu clan design shows the sea with dotted bands to represent sea urchins and the light glancing off the surface of the water.

Banduk's free-flowing composition contrasts sharply with the highly formal treatment of a ceremonial subject by her father's brother Mathaman Marika. *Wawilak ceremony* depicts a 50 rite performed at the lagoon at Mirarrmina. The composition of the painting is a conceptualized map of the Arafura lagoon and also a depiction of the formal arrangements of the ceremony. The descendants of the Wawilak (Wagilag) are shown below the waters of the lagoon at the centre of the painting. The image synthesizes the creation story of the Wawilak, the rituals they initiated, and the enactment of the ceremonies through time to the present. Mathaman's composition varies considerably from the spiralling structure found in Central Arnhem Land paintings of 36 this theme.

The Honey Ancestor of the Marrakulu clan, Wuyal, is associated with the Wawilak Sisters. Dundiwuy Wanambi's *Wuyal* 51 *creation story with Gundimulk ceremonial ground* shows Wuyal and a companion who like the Wawilak Sisters travelled from the south. The two ancestors carry spears and axes to extract honey from the bees' nests they find in trees. The hollow tree-trunk has a number of interpretations. Where it falls, it forms both a

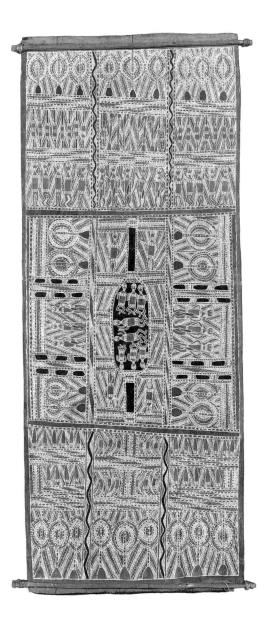

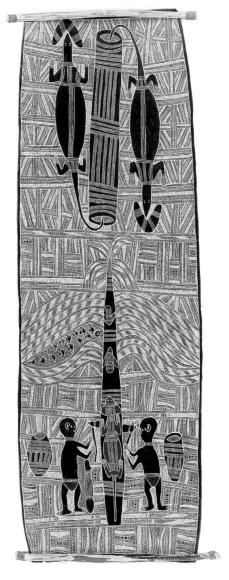

50. Mathaman Marika, *Wawilak ceremony*, 1963

51. Dundiwuy Wanambi, *Wuyal creation story with Gundimulk ceremonial ground*, 1990

ceremonial ground and the Gurka'wuy River at Trial Bay, the artist's homeland. The tree is also the ceremonial hollow log shown in the upper register of the painting, where two goannas carry shellfish in their mouths to indicate their association with the sea. As Wuyal chopped the tree, honey flowed into the ground, a metaphor for Wuyal imbuing the earth with his spirit. Dundiwuy's painting reflects some of the processes by which ancestral beings shape the landscape and leave their power in the earth to be tapped by human beings on ceremonial occasions.

Among the ancestral figures of the Yirritja moiety in North East Arnhem Land, Barama and Lany'tjung stand out. There are several versions of the exploits of these ancestors. One describes how Barama emerged from a waterhole in Dhalwangu clan country decorated with clan designs and feathered strings. He floated down the Koolatong River on a log which became embedded in the riverbed at Gangan. From here, he sent Lany'tjung on a mission to distribute the laws, songs, dances, paintings and sacred emblems among the clans. In this way, each clan would have its specific attributes yet all the clans would be affiliated. In the sculpture by Badangga and Waninyambi, 52 Lany'tjung (referred to as Djirrban) is represented with his body covered in the designs he distributed to the Yirritja clans. The figure is characteristic of North East Arnhem Land sculpture in its post-like features, a form thought to have been introduced by the Macassans (p. 21). The white face of Djirrban represents sea foam, while the long vertical descending from his chin is a Macassan beard, a legacy of the trepang fishermen's influence.

Lany'tjung went north towards Yirrkala and then west towards Milingimbi, however he broke the law by openly displaying the secret objects, an act which brought about his death. The event is commemorated in *Lany'tjung story – the death of* 53 *Lany'tjung* by Birrikitji Gumana who was the ceremonial leader of the Yirritja moiety and an influential artist. The focal image of the painting is the figure of Lany'tjung in an elliptical hollow-log coffin during a ritual intended to restore him to life. Birrikitji's variations on the Dhalwangu clan pattern impart a sense of the ebb and flow of spiritual forces. The regular diamond pattern refers to flowing fresh water. In the section above the horizontal fish-trap to the left, the pattern of diamonds running vertically is interrupted by an elliptical shape, indicating freshwater streams running down from the hills into lagoons and out again. The pattern near the tortoise is its wake as it swims by the fish-trap, and the dots represent air bubbles escaping from its nostrils.

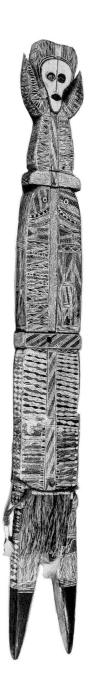

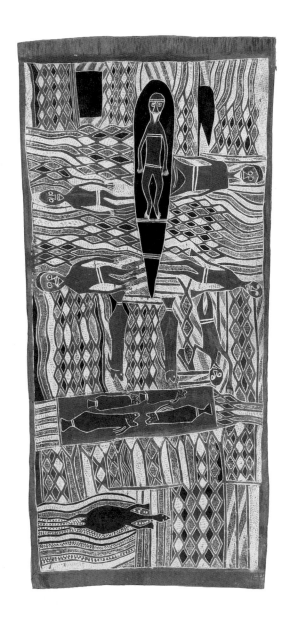

52. Badangga and Waninyambi,
Djirrban (Lany'tjung), 1960

53. Birrikitji Gumana, *Lany'tjung
story – the death of Lany'tjung*, 1960s

69

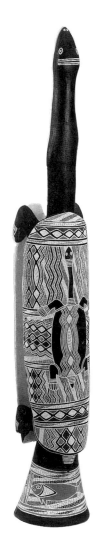

54. Yanggarriny Wunungmurra, *Minhala the Long-Necked Tortoise on the sacred log*, 1990

The freshwater tortoise Minhala was one of the creatures created by Barama. Yanggarriny Wunungmurra's sculpture is a rare rendition in three dimensions of Minhala on the sacred log at Gangan. The patterns of flowing water on the outer surfaces of the sculpture wrap around the painted white clay inner surfaces of the log and Minhala's belly. The white clay is synonymous with Minhala's home.

Fire was created by the Crocodile Man, Baru, during a ceremony in Madarrpa clan country. The ancestral fire spread to the land of other clans in the region, thereby providing ritual links between them. Munggurrawuy Yunupingu's *Lany'tjung story number two* is a compendium of aspects of the Fire Dreaming as it relates to the Gumatj clan. Here, the clan pattern represents sand, while the hatched lines separating the panels indicate submerged sandbanks. In the top-right panel Baru rests at the mouth of the river, while in the panel below he has had the fire design burnt into his skin and his left foreleg incinerated. The lower-left panel depicts the bandicoot who escaped the fire by hiding in a hollow log. Within the cone-shaped dancing ground seen in the bottom-right panel a ceremony is depicted, where the actions of the ancestral beings are performed in the dances of Bandicoot, Wild Honey, Water and Fire. A new Dreaming is called out and danced; this is Dugong, the Sea Cow, represented by the panels of larger diamonds to the upper left.

The Dugong Dreaming indicates that the ancestral fire spread out to sea, and that the rights of coastal clans to land extend to defined areas offshore. Mutitjpuy Mununggurr's *Dugong hunt* depicts the fire story as it relates to a part of the Madarrpa clan estate off Yathikpa on Blue Mud Bay. Yathikpa is the Dreaming place of the Dugong. The lower-right section depicts two ancestral figures making a harpoon and paddle in preparation for the Dugong hunt. To the left of this scene, the two men are shown in a canoe chasing the Dugong. The Dugong, however, swam away and dived underwater to create the Fire Dreaming site. The harpoon became a ritual object, while the ancestors' canoe became a rock on the shore. The marine environment is further suggested by the fish and flowers of sea grass upon which Dugong feed. Wakuthi Marawili's *Fire Dreaming with Dugong hunting story* is a geometrically rendered version of the same events.

The Macassans' marked influence on the peoples of coastal Arnhem Land went beyond the introduction of aspects of technology such as metal tools, to influences on art forms,

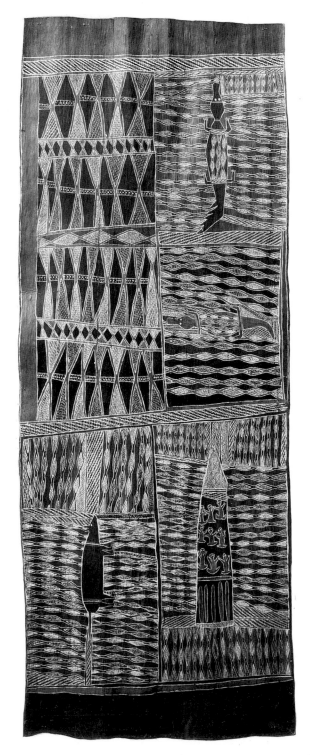

55. Munggurrawuy Yunupingu,
Lany'tjung story number two,
1959

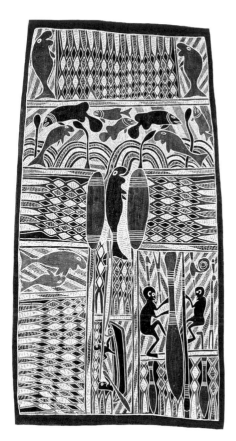

56. Mutitjpuy Mununggurr,
Dugong hunt, 1967

57. Wakuthi Marawili, *Fire
Dreaming with Dugong hunting
story*, 1982

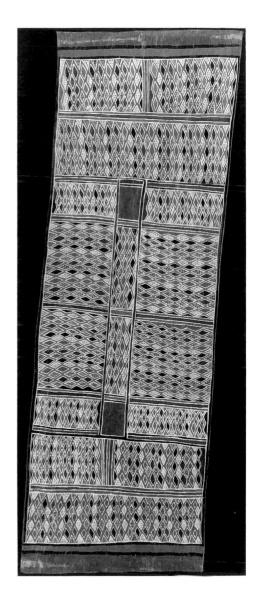

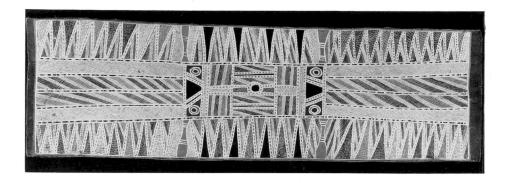

58. Liwukang Bukurlatjpi,
Mamu spirit boat, 1982

language and symbolism. The subject of *Mamu spirit boat* by the 58
Warramiri artist Liwukang Bukurlatjpi is based on a dream
recounted to him by a relative, who saw the spirit of his newborn
son in a boat coming from Galiwin'ku to the mainland. The boat
is defined by the central rectangle bounded at all four corners by
circles, and its oars appear as the adjacent waisted shapes. The
central circle represents the spirit of the boy. In the dream, the
boat had eyes like car headlamps which lit up the way. The circles
represent the lamps and the horizontal lines indicate the beams
of light. The boat, however, is simultaneously the ancestral
Squid, shown twice, head to head; the circles are its eyes and the
horizontals reaching to the sides of the bark its tentacles.

This work illustrates how ideas in different realms of experi-
ence can be synthesized in painting. The painting has further ref-
erences. The boat with eyes is one of a number of metaphors for the
constellation of the Pleiades, indicating seasonal change in rela-
tion to the comings and goings of the Macassans. The Macassan
prahu (vessel) sailing off towards the horizon symbolizes the
journey of the soul of the deceased to the land of the dead.

The journey of the soul is the subject of Luma Luma
Yunupingu's *The spirit's journey*, which interprets the transfor- 59
mations the body and soul undergo through the mortuary ritu-
als practised in Arnhem Land. Two stages of burial take place.
The first occurs upon death when the body of the deceased is rit-
ually painted with clan designs and either placed on a platform in
a tree or buried. The body is depicted on a platform in the upper
section of the painting. The white cockatoo or *ngerk*, above, will
guide the soul to the land of the dead. The lower section of the
painting depicts the reburial rite or hollow-log ceremony. For

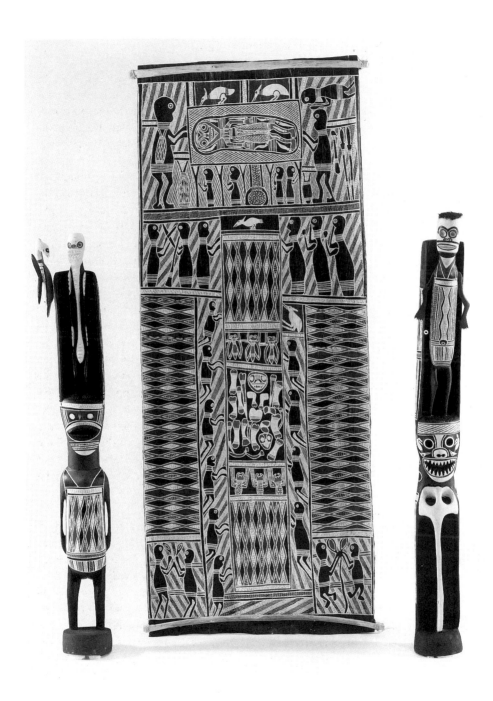

59. Luma Luma Yunupingu,
The spirit's journey, 1984

this, the bones are gathered, painted with red ochre, crushed and placed in a prepared hollow-log coffin, previously painted with the relevant clan designs and totemic images. Participants in the ritual erect the hollow-log coffin on the deceased's clan estate, and it is left to the elements. The ceremony marks the safe transition of the soul of the deceased to the land of the dead. Prohibitions, including speech and food taboos, brought into force for kin at the time of death, are now lifted.

The sculptures represent, as it were, a cross-section of the coffin, showing the body painted with *miny'tji*, the states of decay of the flesh, the skeleton, and the spirit of the deceased. The sculptures are notable for the use of negative space and the placement within it of carved forms. The introduction of specialized woodcarving tools in the early 1980s has permitted the production of more detailed and complex sculptures than were possible at the time *Djirrban* was made, in 1960.

The funerary ceremonies of the Manggalili clan to the south were instituted by the Nyapililngu beings to grieve for their dead brother, the koel-cuckoo Guwak. *Nyapililngu at Djarrakpi* 60 by Narritjin Maymuru symbolically connects the creation of the sand dunes at Djarrakpi to the Manggalili mortuary rituals. The two Nyapililngu are constructed from the symbols of women's life. Their bodies are made from digging sticks, dilly bags form their heads, and their faces feature crosses indicating women's breast-girdles. The casuarina trees that form the tops of the women's heads are the final resting place of Guwak. Ellipses of the lower sections of the women's bodies correspond to both the earth-sculpture the women made for the funeral of their brother and the lake at Djarrakpi.

Along the right edge of the bark, Guwak appears as a length of the possum-fur string that he collected and the women spun to make a sand ridge that is now the men's side of Djarrakpi. The middle of the painting depicts the lake at Djarrakpi. The Nyapililngu and the line of triangular shapes to the left indicate the sand dunes, the seaward and women's side of the lake. The anvil shape at the top of the painting represents the casuarina tree which stands at the head of the lake. Like the anvil shape in the lower section of the painting, it also symbolizes the high cumulus clouds created by the smoke from the fire the Nyapililngu lit as they mourned their brother. The composition of the painting corresponds to the spatial organization of the burial ceremony and is a map of the country but oriented from south, at the top, to north.

Characteristically for Yolngu painting, *Nyapililngu at Djarrakpi* is a matrix of visual puns. Meaning is elaborated and enriched through the multiple references of symbols and their juxtaposition within the work.

Narratives on bark: Groote Eylandt

Groote Eylandt lies less than fifty kilometres off the coast of North East Arnhem Land in the Gulf of Carpentaria, and is the largest island in an archipelago that includes Bickerton and Chasm Islands. The people of western Groote Eylandt share many of the religious beliefs of those on the mainland, but the pictorial styles of Groote Eylandt art as a whole are markedly distinctive, and are closely related to the rock paintings which abound on the islands. Figures are either simply drawn in silhouette, or else have decorative interior designs of hatching and cross-hatching, grids, and broken or dotted lines which may refer to body-painting designs or describe terrain or topographical features.

The subjects of bark paintings include ancestral beings and spirits, in both human and animal forms, flora and fauna, the constellations, the three main winds, the Macassans, ceremonies and historic events. Bark paintings are made largely for didactic purposes and as commentaries on events. The earliest barks to be collected from Groote Eylandt date back to 1922, the year after a mission was established there. In the intervening period the styles of painting remained fairly constant, reflecting the relative isolation of the islands. In the 1920s and 1930s, images were loosely composed on unpainted or red backgrounds. In the following two decades black grounds became more common, with figures outlined in red ochre. The black is derived from locally occurring manganese.

Typical of these paintings are the sets of narrative barks produced in the mid-1950s by Thomas Nandjiwarra (1923–89) and Bill Namiayangwa, both concerned with Dreaming episodes and historic events such as battles between rival groups, themes also found in the rock art. Each series is composed to read from right to left. In most cases each bark depicts one moment within an episode, but the detail from the set of seven paintings *An attack by war canoes* by Namiayangwa depicts a temporal sequence. The subject is an attack by Bickerton Island men on Groote Eylandt, where they surprise a man and his five wives. The man is a brave and illustrious fighter who manages to escape to fetch his spears and spear-thrower, with which he puts the attackers to flight and

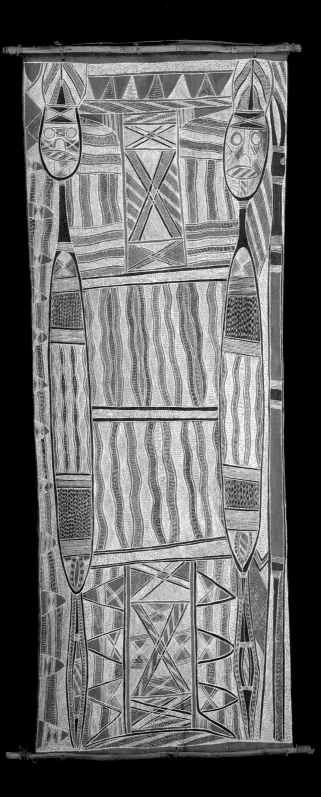

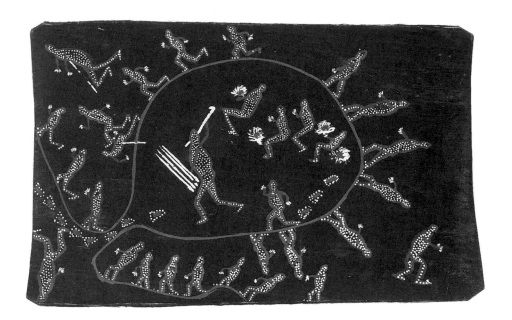

61. Bill Namiayangwa, *They surround a man and his five wives, but he escapes*, detail from *An attack by war canoes*, c. 1955

saves his wives. Namiayangwa combines a planar view of the terrain with the figures in profile to show the various events of the episode in one image. The women and the fighter are depicted enclosed by a loop, a device used to indicate both an avenue of escape for the fighter and the route of his return. The figures of the Bickerton men are distributed around the loop, approaching from the lower right and fleeing in the upper left.

Among the more common themes of Groote Eylandt painting are the constellations. The Milky Way is regarded as a river in the sky, full of fish and edible species from which the celestial beings gather their food. Minimini Mamarika depicts the stars known to Europeans as Orion and the Pleiades. Orion is a man or several men called Burumburumrunya, depicted as three circles across the bar of the T-shape, Orion's belt. The vertical is Orion's sword and it includes, from the bottom up, three fish the men caught and the fire in which they cooked them. The wives of Burumburumrunya are shown as small circles within the larger round form which represents a grass hut, now to be found in the constellation of the Pleiades. 62

The totemic winds are a recurring subject of Groote painting. Mamarika, the south-east wind, blows in the first half of the dry season and heralds the departure of the Macassan trepangers

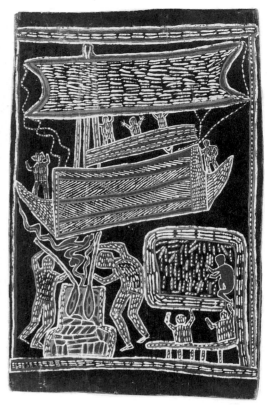

62. Minimini Mamarika, *Orion and the Pleiades*, 1948

63. Attributed to Nandabitta, *Macassan prahu and trepang curing*, c. 1974

from the shores. Designs representing the main winds are said to have been derived from the shape of the sails on Macassan *prahu*, although they are equally likely to be based on rock and water-hole formations. The sail shape seen in *Macassan prahu and trepang curing*, attributed to Nandabitta, is said by some to represent Mamarika. The painting shows the *prahu* with its crew on board, while people are shown boiling, drying and sorting the sea cucumber.

The opening of manganese mines on Groote Eylandt in 1963 resulted in significant numbers of non-Aboriginal people taking up residence on the island for the first time. This ready market stimulated the production of art and artefacts, and saw a shift in the style of bark painting. The backgrounds of paintings began to be covered with designs, the compositions became more complex, and in some cases, monochrome figures were painted to stand out clearly against these highly decorated backgrounds.

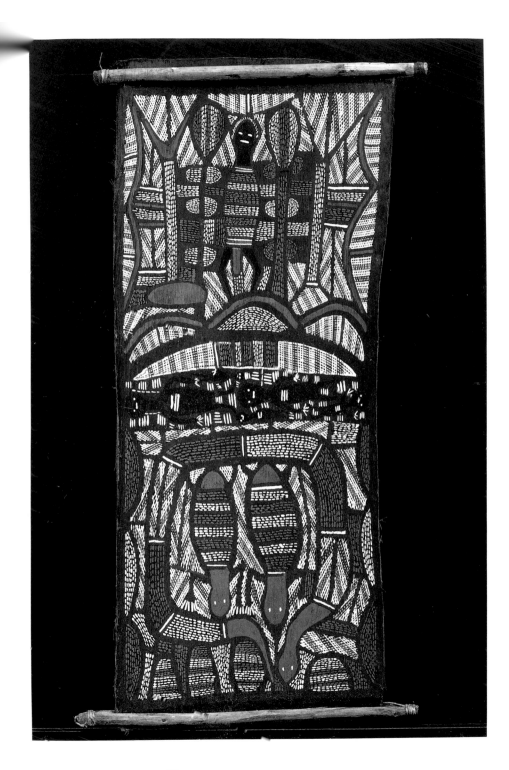

The new market's desire for seemingly more sophisticated, or at least more intricate paintings may have provided the impetus for these elaborations.

Yinikarrka (the Wind Spirit) by George Jawaranga Wurramara 64 displays the features of the more recent painting from Groote. Yinikarrka is the ancestral Kestrel who, in human form, camped with his wife and children on the west coast of Bickerton Island. He encountered the Rainbow Serpent Alja who had created the watercourse on Bickerton. Yinikarrka and his family went from camp to camp, leaving waterholes and other permanent signs of their presence. Eventually they turned into birds and made their way to the east coast of Groote where their nests are still to be seen as three caves in a cliff-face.

In the upper section of the painting Yinikarrka is shown as a man standing on rocks searching for members of the artist's clan, the Wurramara, who are swimming in a lagoon on Bickerton Island. The waterhole is depicted as the horizontal band at the centre of the painting. Beside Yinikarrka are the rain clouds which produced the lagoon, their billowing shape resembling a wind-symbol. The formal composition and the profusion of decorative patterns and cross-hatching in the painting show Jawaranga's concern to produce a vibrant picture-surface, similar in effect to paintings in North East Arnhem Land.

Narratives on canvas: Ngukurr
Despite their location around the south-eastern part of Arnhem Land in proximity to major bark painting areas to the north and on Groote Eylandt, since 1984 the artists who now live along the Roper River and in the town of Ngukurr have favoured the use of synthetic paints and canvas. A number of the pictorial devices prevalent in northern Arnhem Land paintings are evident at Ngukurr: the imagery is largely figurative, and techniques of hatching and x-ray are used. In *Fish and birds in the shallows*, for 65 example, Wilfred Ngalandarra uses a restricted palette but builds visual texture in the bodies of the animals by overlaying lines and dashes of colour. He also indicates the backbone of the creatures in the manner of West Arnhem Land painting.

Willie Gudabi, one of the instigators of the movement towards art for the outside world, focused on initiation and mortuary ceremonies in his work. As in *Untitled* he uses a composi- 67 tion of sections within which the action takes place, much as the Yolngu bark painters do. The divisions in Gudabi's paintings isolate parts of the narrative, and also indicate the boundaries of

64. George Jawaranga Wurramara, *Yinikarrka (the Wind Spirit)*, 1984

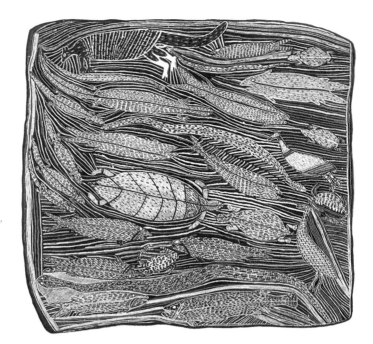

65. (*right*) Wilfred Ngalandarra,
Fish and birds in the shallows,
1989

66. (*below*) Ginger Riley
Munduwalawala, *My country*,
1988

67. (*opposite*) Willie Gudabi,
Untitled, 1990

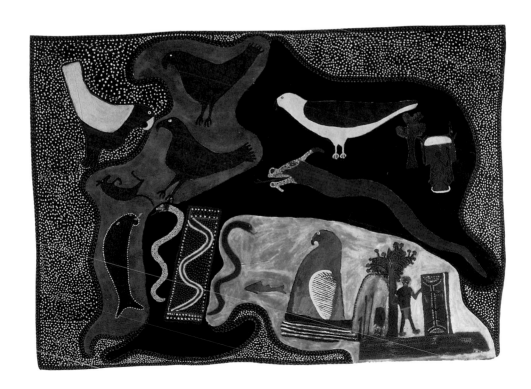

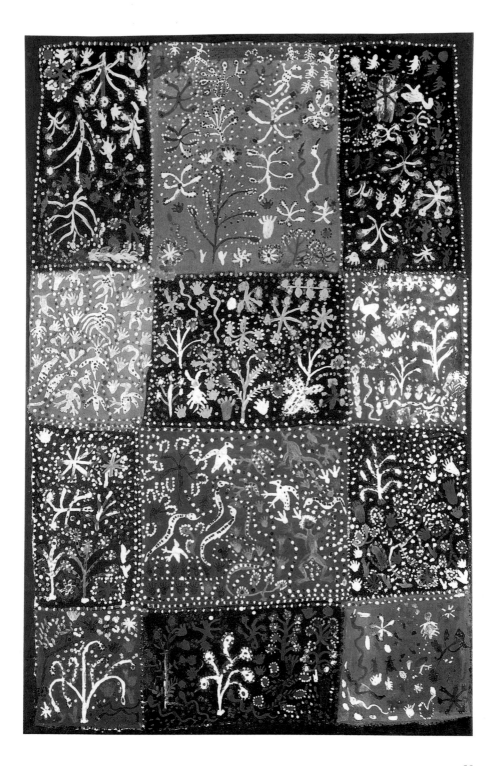

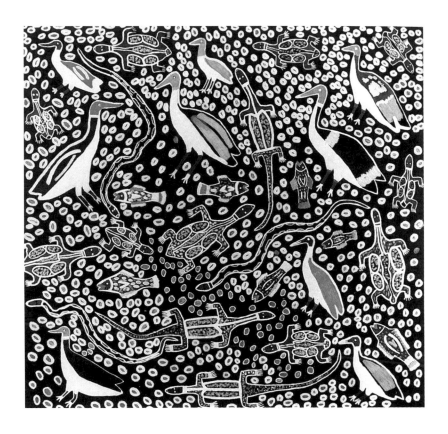

clan estates. The images include ancestors in human and animal form, weapons, tools and a plethora of flora which are used to create rich and lively surfaces.

The compositions of Ngukurr paintings are not always so formally structured, however. Amy Johnson Jirwulurr's *Some animals have secret songs* depicts brolgas (cranes) catching fish. The 'animals' represent the forms adopted by her clan's human ancestors who are seeking places to perform initiation and mortuary ceremonies. 68

My country by Ginger Riley Munduwalawala also features a compendium of the ancestral beings who created his mother's clan's country which lies around Limmen Bight, beyond Arnhem Land on the Gulf of Carpentaria. The serpent in the painting is Bandian, who possesses great powers of transformation. Bandian often appears as two snakes, called Garimala or Kurra Murra, who in turn adopt the identity of another Rainbow Serpent, Wawalu. Yet another manifestation is as the fire-breathing sea 66

monster Bulukbun who kills people, a reference to the massacres by the first Europeans who came to the region by sea in the late nineteenth century.

The bust-like image of a bird depicted in the lower-right section of *My country* is Ngak Ngak, the sea-eagle who created Yumunkuni Island in the mouth of the Limmen Bight River. In the body of Riley's work, Ngak Ngak is omnipresent, observing the creative dramas that unfold in the Dreaming, an allegory, perhaps, for the artist bearing witness through the eyes of his avian totem to the events that are depicted in the canvases. Riley's paintings also feature rectangular message-sticks or boards which announce initiation and circumcision rites, or invite people to his country. The message-sticks are flanked by two snakes, as at the left in this painting, or by a human figure, as on the right. The meandering forms of the snakes and the use of dots to define contours are pictorial devices also common in the 96 art of the desert, further south.

Art in isolation: the Tiwi

The Tiwi people live on Bathurst and Melville Islands to the 3 north of Darwin. The treacherous channel that separates the islands from the mainland has until this century precluded any meaningful contact with outsiders. Sustained outside influence on Tiwi life commenced when buffalo shooters set up a camp on Melville Island in 1900. Buffalo on the islands were a legacy of the short-lived attempt by the English to establish a settlement in 1824. A more permanent influence has been the Catholic mission which was established at Nguiu on Bathurst Island in 1911. The result of isolation is evident in several cultural differences between the Tiwi and the mainlanders, and in the development of a number of unique art forms, particularly in sculpture. Ceremonies revolve around two major cycles: the Kulama initiation ritual which celebrates life, and the mortuary rites of the Pukumani. Matrilineal inheritance is an important aspect of Tiwi social structure, and women play a prominent role in most forms of cultural expression, from ceremony to the arts.

In their Dreamings the Tiwi describe a period of genesis in which the ancestors appeared and created social structures, religious laws and the features of the land. The period begins with the emergence of an old blind woman, Mudungkala, who rose out of the ground at Murupianga in south-eastern Melville Island. She crawled across the shapeless earth creating sites and waterways. As she went she carried her three children: two

daughters, Wurinpranala and Murupiangkala, and a son, Purukuparli. Their descendants settled throughout the islands. At the end of the first part of this creation period, Mudungkala departed while her children remained.

At Yipanari, on the eastern tip of Melville Island, Purukuparli married Bima, the great-granddaughter of his sister Murupiangkala. They had a son, Jinani, of whom Purukuparli was exceptionally fond. Purukuparli's younger brother Tapara came to their camp and seduced Bima. As a result Jinani was neglected and died. Purukuparli was enraged by the death of his son. Tapara asked his permission to try to bring Jinani back to life, but a fight with Purukuparli ensued. Purukuparli wrapped his son's body in paperbark and carried it out into the sea off Yipanari, decreeing that death would become the fate of all Tiwi. Where Purukuparli drowned, a strong whirlpool formed. Tapara became the moon, and in this form, did not escape Purukuparli's decree, but died only to be reborn.

In *The death of Purukuparli* by Marruwani, the final drama of 69 Purukuparli's life is depicted in an iconic manner, with the composition echoing the mounting tension of the narrative. The crescent shape at the bottom of the painting is Tapara holding the throwing sticks which he used in the fight with Purukuparli. The white crescent above indicates Tapara asking for Jinani's body, which is represented by the horizontal bar at the centre of the painting. The two short white verticals in the dominant shape are Purukuparli's arms holding his dead son; above are his footprints as he walks out into the water. Purukuparli himself is indicated by the yellow half-circle within the round red whirlpool at the top of the painting.

Bima's father, Tokwampini the Honey Bird Man, organized the first Pukumani ceremony for Purukuparli, and directed the making of grave-poles, bark baskets, ceremonial spears and other paraphernalia of traditional Tiwi art. When the ceremony was performed, Tokwampini instructed all the ancestors in the laws of marriage and social behaviour, whereupon they dispersed to metamorphose into the various forms of flora, fauna, heavenly bodies and ritual objects by which they are now known. This ended the creation period.

More than a burial ceremony, Pukumani describes an extraordinary state of being which affects all those connected with the deceased. It includes prohibitions concerning the interaction of certain categories of kin and the touching of particular objects and food, and demands a particular style of behaviour to be

69. Maloney Porkalari Marruwani, *The death of Purukuparli*, 1954

86

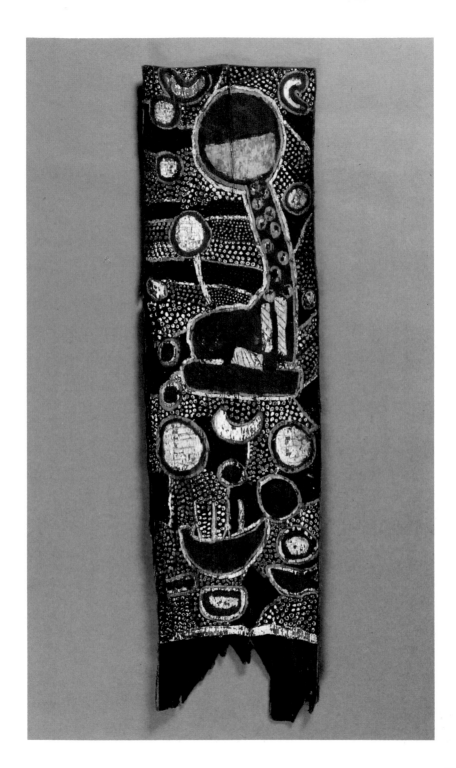

followed by the mourners in daily life. Pukumani is lifted when the long sequence of ritual is ended.

The ceremony of Pukumani yields much of the art of the Tiwi. Spectacularly painted poles called *tutini* are carved from dense ironwood and used as grave-markers. The Tiwi see the poles as analogous to the human form, for they are intended to represent aspects or associations of the deceased whose grave they surround. Any number of poles may surround a grave, although usually more than twenty signify that the deceased held high ritual status. The set of seventeen Pukumani poles now at the Art Gallery of New South Wales was made at Milikapati in 1958. 70

Large painted bark baskets called *jimwalini* are often thrust through the tops of the poles at the graveside. Bama Yu's basket 71 demonstrates an effective use of the *pwata*, a comb made from a flat piece of wood or bark with several teeth, used for making

70. Laurie Nelson Mungatopi, Bob One Gala-ding-wama Apuatimi, Big Jack Yarunga, Don Burakmadjua, Charlie Quiet Kwangdini and one unknown artist, *Pukumani poles*, 1958

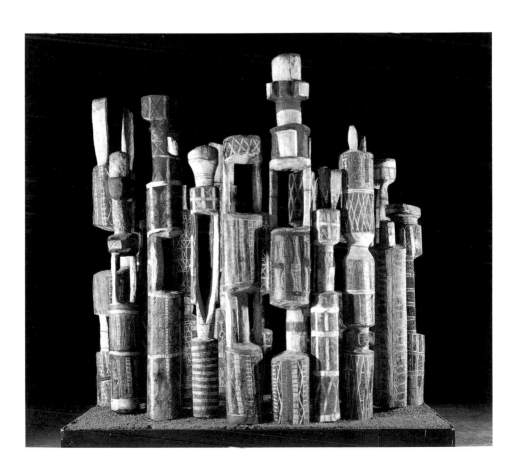

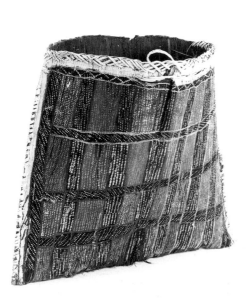

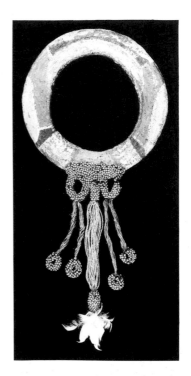

71. Bama Yu (Polly Miller), *Jimwalini, Pukumani basket*, 1984

72. Unknown artist, *Pamijini mourning band*, pre-1912

lines of dots. The Tiwi do not weave fibres, and carrying-baskets are made of folded and sewn sheets of bark which are then painted. Other ceremonial trappings of the Pukumani are elaborately carved and painted spears and a range of arm- and headbands including the *pamijini*, a wide circular band with feathered tassels. The exceptionally fine and old example shown here is 72 made from fibres, feathers and red abrus seeds. Similar arm- and headbands are still made today.

Since the 1930s the Tiwi have been renowned for painted figurative sculpture, a development from the Pukumani pole, and more recently for sculptures of animals and birds. The double-sided figures of *Purukuparli and Bima* by Enraeld Munkara (also 73 known as Djulabiyanna) owe much to the Pukumani pole tradition. The arms hang down from the figures' bulbous heads, while the negative space surrounded by the frame of the pelvis, the legs and the round base is similar to 'windows' carved into the poles.

The sculptural installation at the Museums and Art Galleries of the Northern Territory in Darwin interprets the creation period in eight episodes, ending with the death of Purukuparli.

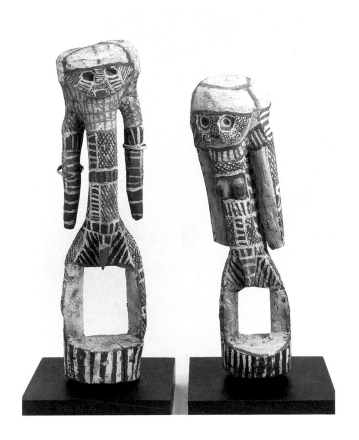

73. Enraeld Munkara,
Purukuparli and Bima, c. 1955

All the major characters are present, most in their animal or bird
forms. The detail showing Bima carrying the child Jinani is the 75
work of one of the foremost sculptors of the period, Mani Luki
(Harry Carpenter). The other main artist to work on this group
of sculptures was Paddy Henry Ripijingimpi, also known as
Teeampi, whose later figure shows Tokwampini on the head of 74
Purukuparli. The tiered configuration is commonly found in
Pukumani poles.

 While sculpture is the main art form, paintings on flat sheets
of bark became more common during the 1960s with increased
outside interest in Aboriginal art. The pictorial art of the Tiwi is
largely esoteric and non-figurative. A wide variety of geometric
designs are used, and while many patterns recur, there is a large
degree of invention so that their interpretations rest very much
with the individual artists. Figurative images appear but rarely

74. (*below*) Paddy Henry
Ripijingimpi (Teeampi), *Bird*,
1979

75. (*right*) Mani Luki (Harry
Carpenter), *Bima carrying Jinani*,
detail from the installation *The
Purukuparli and Bima story*,
c. 1970

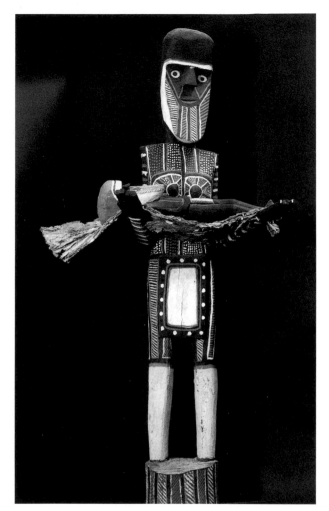

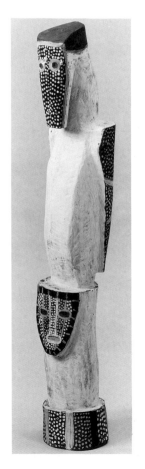

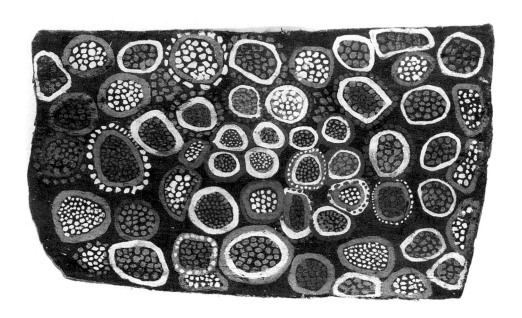

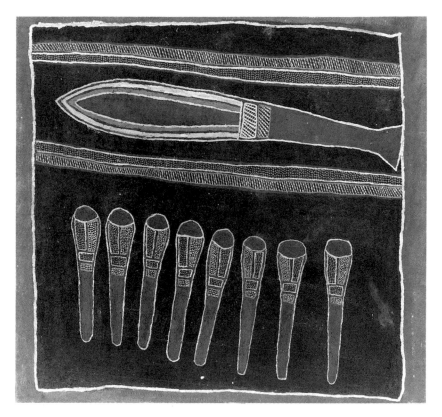

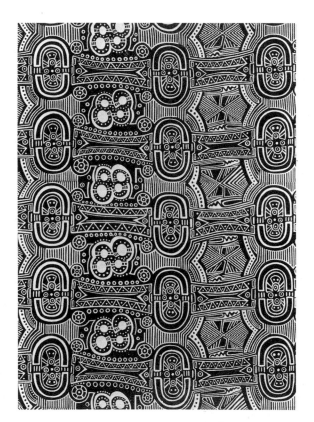

76. (*opposite, above*) Nellie Wanterapila, *Coral*, 1974

77. (*opposite, below*) Declan Apuatimi, *Clubs*, c. 1984

78. (*right*) Bede Tungutalum, Tiwi Designs, *Yam design*, detail, 1982

dominate a composition. Tiwi graphic art is bold and colourful. The ochres used are more friable than those found in Arnhem Land, and are therefore crushed rather than ground in the preparation of paint. Traditionally, brushes are made of frayed bark or feathers, and now European brushes are also used. The distinctive *pwata* comb as well as a short cylindrical stick supply the dots.

Nellie Wanterapila's *Coral* of 1974 reflects one of the activities that are the domain of women – food collecting, in this case the gathering of shellfish found on the coral reefs at low tide. The spirits of unborn babies are said to reside in the shallow waters and coral reefs about the islands, and this concept provides the spiritual dimension of the work. 76

One of the most respected, innovative and versatile artists of the modern period was Declan Apuatimi. A great ritual leader, Apuatimi possessed a broad visual vocabulary which he applied to sheets of bark, ceremonial spears, animal sculptures, bark baskets, Pukumani poles and carved figures. In the last two years of his 77

79. Kitty Kantilla, *Jurralı*,
c. 1996

80. Thecla Puruntatameri,
Irramaru, 1991

productive life he also painted several canvases. Since his death in 1985 a number of Tiwi artists have taken up canvas, including Apuatimi's daughter Maria Josette Orsto (born 1962) and Kitty Kantilla (also known as Kutuwalumi Purawarrumpatu). 79

While the traditional forms of art persist in contemporary times, since 1968 Tiwi artists have been at the fore in innovation, using new techniques and materials as vehicles for their rich pictorial heritage. The repertoire of Tiwi art has been expanded to include screenprinted cloth, batik, ceramics, printmaking and painting on paper as well as canvas.

In the late 1960s Bede Tungutalum and Giovanni Tipungwuti (1953–93) produced woodblock prints of totemic images. This led to other forms of printing, and in 1969 the company Tiwi Designs was established at Nguiu to produce screen-printed fabrics. Their bold and colourful designs continue to be based on traditional imagery. *Yam design* by Tungutalum, for example, is 78 an image drawn from the Kulama ceremony. The commercial success of the textiles led to the introduction of batik in 1988. In

1972 Tiwi Pottery was established by Eddie Puruntatameri (1948–95) and John Boscoe Tipiloura (born 1952) to enable artists to work in ceramics.

There is a general desire to experiment with new media among younger Tiwi artists. In the late 1980s several artists, principally women, adopted synthetic paints and gouache to revive old designs as well as create new ones. *Irramaru* by Thecla 80 Puruntatameri portrays the wedge-tailed eagle who introduced fire to the Tiwi world. The work is animated by the unusually dominant and dramatic rendition of the bird. Such innovations in treatment and materials are not introduced at the expense of other forms of art. Rather, they are an extension of the strong creative energies of Tiwi artists.

Convergence: the art of Wadeye and environs

In contrast to the isolation and unique qualities of the Tiwi and their art, the Aboriginal communities at Wadeye (Port Keats) and its surrounds illustrate a convergence of cultural influences. The commencement of European mining and farming in the surrounding area in the 1870s had a deleterious impact on traditional life and led to migrations of people into the region. The Murrinh-Patha and other groups have established cultural links with Arnhem Land, the Victoria River district to the south and the eastern Kimberley.

Among the major Dreamings of the Murrinh-Patha is that associated with a manifestation of the Kunapipi religious cult known as Punj. Mutjingga the Ogress, the First Mother, is the focus of the Dreaming. The theme of swallowing and re-emergence is also present here. Mutjingga was left to look after the children of the other beings while they went in search of wild honey. During their absence Mutjingga swallowed several of the children and ran off. The parents tracked her down to a river bed and eviscerated her, to find their children still alive in her belly.

Prior to the emergence of bark painting in the region the most common forms of portable pictorial art included engraved and painted sacred wooden boards and stones similar to those used in the desert. In the 1950s, bark painting was introduced through the agency of the mission at Wadeye as a means of producing collectable art at a time when bark paintings, particularly those made in Arnhem Land, were in demand. The early barks usually depict images similar to those found on the wooden boards and stones. The iconography is highly conventionalized and features many of the elements found in desert art, in

81. Charles Mardigan,
Billabongs, 1961

particular the use of sets of concentric circles, usually denoting place, and meandering lines for the journeys of the ancestors. The typically formal composition is seen in Charles Mardigan's *Billabongs*, depicting circular waterholes in the artist's country 81 at Yenmenni. The two rectangular pointed shapes at the centre top and bottom of the painting indicate the boundaries of Mardigan's clan estate.

A distinguishing feature of bark painting in the region is the extended palette favoured by most artists. This goes beyond the four basic colours found elsewhere – white, black, red and yellow – to include greens, purples and pinks made by mixing various combinations of pigments. *Dirmu* is the Murrinh-Patha name for the visually stimulating patterns and designs that are found in nature and also appear in paintings and engravings made for ceremonial purposes. The term *dirmu* indicates these patterns are

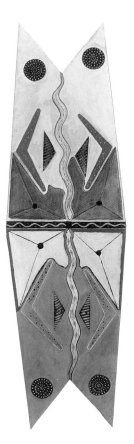

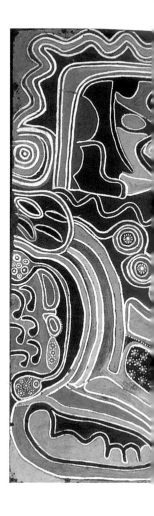

82. Simon Ngumbe, *Rainbow Snake and children*, c. 1972

83. Robin Nilco, *Water python and boomerangs*, 1991

not haphazard or accidental, but the ordered creations of the supernatural beings of the Dreaming. The composition of these designs reflects social and ceremonial arrangements.

At Wadeye, sheets of bark are often cut to imitate the oval shape of the ceremonial boards that artists are accustomed to decorating. Simon Ngumbe's *Rainbow Snake and children* is an example. The painting depicts Kunmangurr the creator-being as the ubiquitous Rainbow Serpent. The coiled shape reflects the Serpent's presence in waterholes containing the spirits of unborn children, seen in the form of snakes that frame its head. The subject of the work recalls the theme of swallowing and regurgitation.

82

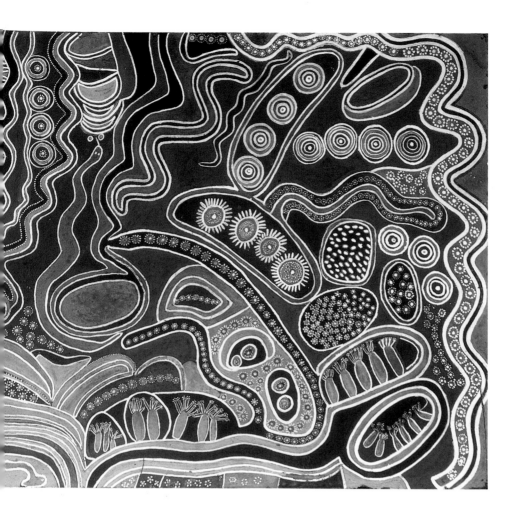

84. Nym Bandak, *Map of the Murrinh-Patha countryside 1*, 1959

Robin Nilco's shaped canvas *Water python and boomerangs* is styled on the oval barks used in the region. Again, the images are symmetrically arranged, and include naturalistic representations as well as conventional symbols. The land is shown in planar view with creeks as the straight lines joining circular waterholes. Sets of concentric dotted circles also indicate waterholes. Symbols of flowing water appear as meandering lines decorating the fighting boomerangs and the central line of the painting. The meander is reiterated in the shapes of the water-pythons which are the artist's primary totem.

The most prominent Murrinh-Patha artist was Nym Bandak, whose *Map of the Murrinh-Patha countryside 1* reflects the

abundant knowledge of a painter who was also a major ceremonial leader. The work is a comprehensive conceptual survey of Murrinh-Patha country. Using conventional symbols, Bandak plots the land occupied and owned by the various Murrinh-Patha clans in relation to that of Bandak's clan estate which is depicted in the upper left quadrant of the painting. The work was produced at the request of the anthropologist W. E. H. Stanner who sought to investigate the artist's conception of his physical and cosmological environment. To convey a subject of such all-embracing magnitude, Bandak used a much larger board than was usual. The painting's fluid lines are a departure from the highly formal compositions on bark, and it displays 81 many elements which were to appear some twenty and thirty years later in paintings by eastern Kimberley artists.

The iconography and painting styles found in the paintings of Bandak and other artists from the Wadeye region connect the art of the top end of the Northern Territory with that of the Kimberley and, in the south, to the traditions of the central desert areas.

Chapter 3: The art of place and journey: the desert

Vast regions of the central and western parts of the Australian continent, including much of the Northern Territory, South Australia and Western Australia, are covered by geographical deserts, a word which implies harsh and barren landscapes. The Australian deserts appear empty and inhospitable to those who do not know them, but to the Aboriginal groups who inhabit these areas, the lands created by their ancestors and infused with their powers are places rich in spiritual meaning and physical sustenance.

The deserts are also the home of one of the most important movements in contemporary Australian art, for, while artists continue the traditional practice of painting on the ground, on 85 their material possessions such as shields, wooden dishes and 97, 110 boomerangs, and on their bodies, they now use acrylic paint and canvases to carry the classical idioms of desert art to a wider audience than was previously possible.

Geographically, the desert includes mountain ranges and spectacular rock formations, grassy plains, stands of eucalypt and mulga trees, lakes, salt pans, sandhills, and stretches of stony country occasionally broken by seasonal watercourses and rivers and punctuated by rare permanent rockholes, springs, waterholes and soakages. The region is home to a number of Aboriginal groups who in the main share common cosmology and social systems, as well as common art traditions, and who form a major cultural bloc in Aboriginal Australia. Across this landscape spreads a web of ancestral paths travelled by the supernatural beings on their epic journeys of creation in the Jukurrpa or Dreaming, linking the topography firmly to the social order of the people.

The impact of European incursions and settlement on the peoples of the Australian desert was different from that on Arnhem Land. The first European explorers entered central Australia in 1860, and by 1885 much of the best grazing land around present-day Hermannsburg was occupied by pastoralists. Cattle and sheep polluted waterholes, and the new landholders forced many groups of Aboriginal people away from their traditional lands. Other adverse consequences of European

settlement, such as the spread of new diseases and the influx of refugees from the newly settled areas, had an impact on Aboriginal groups right across the desert, in some cases nearly a century before they sighted Europeans for the first time. Nevertheless, Aboriginal people were able to continue their relationships to their lands despite the wholesale takeovers by working on the pastoral stations, and by ensuring the continuity of rich oral traditions and ceremonies through which the land was celebrated and vivified.

The physical dislocation accelerated in the twentieth century as settlement spread. In 1941 Haasts Bluff, west of Alice Springs, was declared a reserve, and by 1955 Government settlements were established at Yuendumu and Lajamanu, with the last settlement of the assimilation era created at Papunya in 1960. Until 1966, under Government policies Aboriginal people were taken to live in these settlements, bringing them together in the most inappropriate social circumstances with detrimental effects on their cultural practices.

Federal political changes of the 1970s permitted and even encouraged people to return to live on their ancestral lands. Today, the desert towns of Papunya, Yuendumu, Lajamanu and 3 others service many often distant outstations that have sprung up since 1970. The Aboriginal councils in these towns have established cooperatives to cater for artists' needs, and to channel art from the outlying areas to the galleries of the cities. The cooperatives operate as buffers between the traditional social and cultural concerns of the artists and the demands and expectations of the outside world.

Classical desert art takes many forms, from decorated weapons and implements to personal adornments, from sacred and secret incised boards and stones, often called *tjuringa*, to rock engravings and paintings, and the more ephemeral arts of body 7 painting, sand drawings, ceremonial constructions and ground 85 paintings. While the classical traditions continue, the introduced media such as acrylic paint and canvas are usually employed for the purposes of public art.

Recently introduced techniques of dating rock engravings, and the persistence of similar painted images recorded in the nineteenth century, reveal that designs that are commonly in use today for both ceremonial and public paintings have been continuously produced in the desert for many millennia.

The basic elements of the pictorial art are limited in number but broad in meaning. The iconography of desert art is a

language separate and distinct from that of Arnhem Land. Characteristic of the range of conventional designs and icons are those denoting place or site, and those indicating paths or movement. Concentric circles may denote a site, a camp, a waterhole 93, 117 or a fire. In ceremony, the concentric circle provides the means for the ancestral power which lies within the earth to surface and go back into the ground. Meandering and straight lines may indicate lightning or water courses, or they may describe the paths of ancestors and supernatural beings. Tracks of animals 108 and humans are also part of the lexicon of desert imagery. U-shapes usually represent settled people or breasts, while arcs may be boomerangs or wind-breaks, and short straight lines or bars are often spears and digging sticks. Fields of dots can indicate sparks, fire, burnt ground, smoke, clouds, rain, and other phenomena.

The interpretations of these designs are multiple and simultaneous, and depend upon the viewer's ritual knowledge of a site and the associated Dreaming. The meanings are elaborated and enhanced by the various combinations or juxtapositions of designs in the paintings, and also by the social and cultural contexts within which they operate – whether for ceremony or the public domain, for instance. The combinations of designs allow an endless depth of meaning, and artists in describing their work distinguish between those meanings which are intended for public revelation and those which are not, and provide the appropriate level of interpretation. Certain conventional compositional structures and pictorial devices are favoured by particular groups but, unlike the case in areas of Arnhem Land, may refer not just to one but to a number of different Dreamings.

Men's religious designs are called *kuruwarri* in Warlpiri, and women's *yawulyu*. The terms refer to designs which represent the ancestral beings, or any marks which indicate their presence. The terms also embrace wider concepts to include the procreative essences or powers of the ancestors. The term *yawulyu* is also used for certain women's ceremonies, and although *yawulyu* images may refer to the same ancestors as the men's designs, they are usually concerned with notions of sexuality, fertility, well-being and growth among people, natural species and the land. *Kuruwarri* and *yawulyu* designs include many of the same graphic elements; their differentiation depends on the particular male or female contexts in which the designs operate.

Both kinds of designs possess tactile qualities; in many circumstances they are incised into wood or stone, drawn by

hand into the sand or painted on to people's bodies. Texture and colour are integral components of desert art. Birds' down and fibrous substances obtained from plants are mixed with ochre and applied to people's bodies and objects, and used in ground paintings. Colours are significant in themselves, in the ritual associations of the site where they were obtained, and in their particular lustre or dullness. Artists seek similar qualities in the synthetic paints that are available today.

In the traditional social structures of the desert, the kinship system places each member of the society in one of up to eight categories which are paired for joint custodianship of the subjects of art – the land, ceremonies and Dreamings. For males, the paired kinship groups are termed Jampijinpa and Jangala, Jakamarra and Jupurrurla, Jungarrayi and Japaljarri, Japanangka and Japangardi. The prefix 'Na' (as in *N*ampijinpa) or 'Nu' supplies the term for the female equivalents. The pairings arise from patrilineal relationships, and people customarily include their kinship categories as part of their names.

To varying degrees across the desert, paired ceremonial roles are followed in the making of art for the public domain. Here as elsewhere in Aboriginal Australia, the collaboration between members of the opposite moieties is fundamental in the production of art for ceremony. In the desert those with patrilineally inherited rights to land, ceremonies, Dreamings and associated designs, i.e. the owners, are termed *kirda* (again in Warlpiri), while those with matrilineally inherited rights are known as *kurdungurlu*. An individual is *kirda* of certain ceremonies and *kurdungurlu* of others. In the making of public art, however, *kirda* may often act singly, or with the assistance of *kurdungurlu*. The practicalities of everyday life also allow for collaboration between those in other family relationships, such as husband and wife, parents and children, and siblings. On occasion, and with the appropriate permission from the owner of the Dreaming, people will make paintings alone of themes to which they are in a *kurdungurlu* relationship.

Among the most spectacular art forms of the desert are the large ceremonial ground paintings or mosaics made from earth-pigments and other natural materials on a prepared soil surface. Ground paintings are usually of a highly sacred and often secret nature, but some have been made in public contexts. In 1989 a group of six artists from Yuendumu installed a Yam Dreaming painting, *Yarla*, in the exhibition *Magiciens de la terre* organized by the Centre Georges Pompidou in Paris. As a concession to the

85

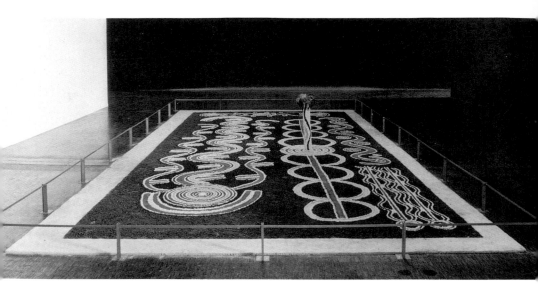

85. Paddy Jupurrurla Nelson, Paddy Japaljarri Sims, Paddy Cookie Japaljarri Stewart, Neville Japangardi Poulson, Francis Jupurrurla Kelly and Frank Bronson Jakamarra Nelson, *Yarla*, ground painting installed in Le Halle de la Villette, Paris, May to August 1989

context the artists confined the painting within a rectangular shape, as occurs on canvas. A feathered pole emerging from a set of concentric circles was the focal point of the work. Covering an area of forty square metres, the work provides an indication of the potential size of ground paintings.

Ground paintings provided one of the models for acrylic paintings on canvas and board which initially emerged around 1970. Yet, the first recorded example of innovation in desert art intended for sale appeared in 1903. *Toas,* small assembled sculptures made of carved wood, gypsum, ochres and other natural materials, were made by the local Diyari and other language-speakers at the Lutheran Mission at Killalpaninna, near Lake Eyre in South Australia. More than four hundred *toas* were made between 1903 and 1905 in response to the wish of the missionary, Pastor Johann Reuther, to build a collection of Aboriginal artefacts to raise funds for the mission. The *toa* collection was acquired by the South Australian Museum in 1907, but it appears that their production had ceased when Pastor Reuther left the mission in 1906.

86

The popular belief that Aboriginal culture was static encouraged the view that the *toas* were a traditional form of sculpture. The Diyari themselves described them as direction-markers or signposts that were left at abandoned camps to inform the next visitors of the ancestral nature of the landscape, or to indicate

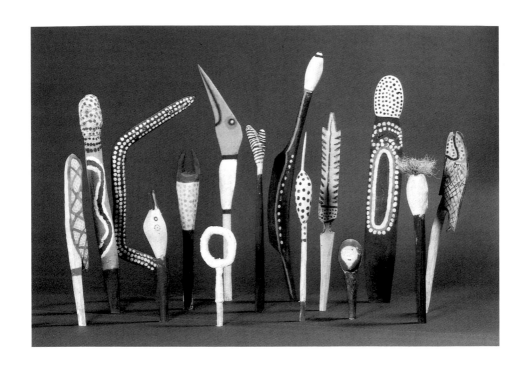

86. Various artists, *Group of toas*, 1904–5

where the previous party had gone. However, it appears the *toas* were purely innovative works with no recorded antecedent in traditional life, although they embody a prevailing system of iconography and meaning. Of the *toas* illustrated, the third from the right depicts a deep waterhole (a dark vertical ovoid) on Cooper Creek. The arc above represents the waterhole, and the dotted knob a sandhill where the ancestor Patjalina hunted. By way of contrast, the seventh *toa* from the left shows, in a summary and naturalistic manner, a standing pelican, one of a flock seen by the ancestor Mandramankana, at a lake represented by the white band under the pelican's head.

In many ways, the *toas* set a precedent for Aboriginal artists across the desert. Sculpted objects were the first forms of portable art to be made specifically for the public domain.

The influx of non-Aboriginal people into the desert gathered momentum with the opening of the trans-Australia railway in 1915. Missions were established in the Warburton Ranges in 1934 and at Ernabella in 1939, and Aboriginal people were encouraged to produce wood carvings for sale to the mission shops in the cities. Uluru (Ayers Rock) opened up for tourist

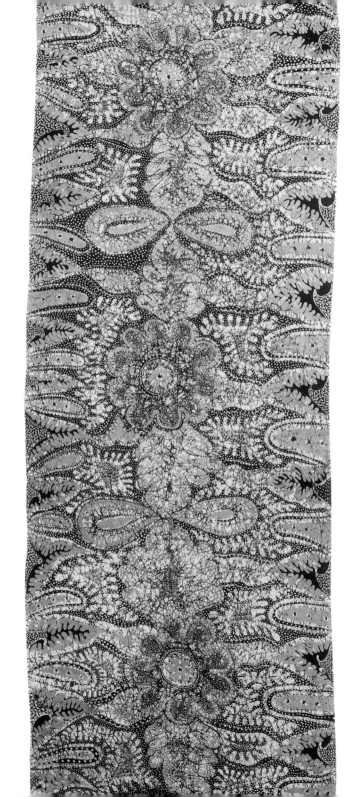

87. Angkuna Graham, Ernabella
Arts, *Untitled*, 1984

travel after World War II, and the boom in tourism since 1980 has provided a steady market for Aboriginal artefacts.

Much of the public art in the southern desert made since outside interest in Aboriginal art increased in the 1970s has been produced by women. The men have been generally more reluctant to produce public paintings, though both men and women make plain and decorated wooden carvings of animals, carrying-bowls, digging and music sticks and clubs. Artists have adapted introduced tools and materials to their needs; for instance, heated fencing wire provides the means to burn or brand linear designs onto the carvings. The images belong to traditional idioms, but the new techniques allow for more innovative interpretations of *kuruwarri* and *yawulyu* designs.

88

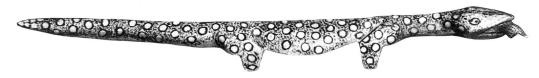

88. Unknown artist, *Animal carving*, 1977

Women traditionally spin animal fur and human hair into cord with which to make skirts, belts, and headbands and headrings for carrying-bowls. Since 1948, Pitjantjatjara women at Ernabella have spun and woven sheep's wool into products ranging from traditional carrying-bags to non-traditional belts, scarves and floor rugs. These items incorporated designs which the Pitjantjatjara women also produced in crayon drawings and watercolours based on *yawulyu*. The production of weavings was largely replaced by fabric dyeing after the introduction of batik techniques in 1972. The use of the *canting* (wax pen), paintbrushes, waxes and dyes allowed for new elaborations on *yawulyu* on silk and cotton fabrics. Angkuna Graham's fabric-length *Untitled* is characteristic of Pitjantjatjara batik designs; it shows organic forms based on leaves, flowers and plants, composed in a manner which owes something to the traditional Javanese batiks with which several Ernabella artists had become familiar. The arrangement also relates to the formal compositional structures of contemporary acrylic paintings. While many of the paintings, especially those by men, take an expansive and heroic view of country, the women's batiks build images based on a knowledge of the more intimate details of the land.

87

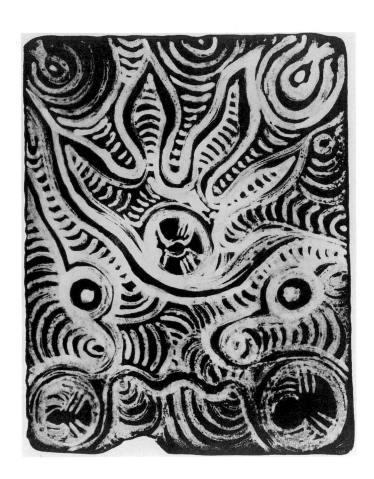

89. Sadie Singer, *Summer landscape*, 1988

The success and popularity of the work of the Ernabella women encouraged others in the neighbouring communities of Fregon, Indulkana, Amata, and even as far away as Utopia to take up batik and other introduced techniques.

The experimentation and innovation in the use of colour and designs evident in the early Ernabella paintings continues today. From Fregon in South Australia, Kay Tunkun's watercolour *Kipara (Wild Turkey) Dreaming* combines florid forms and dotted circles suggesting ceremonial *yawulyu*. Sadie Singer was among the first group of artists to take up linocut prints at Indulkana in 1981. She has since developed other printmaking techniques through workshops outside the community. In the lithograph *Summer landscape*, the *yawulyu* is similar to designs traditionally drawn in the sand to accompany narratives told by women.

90

89

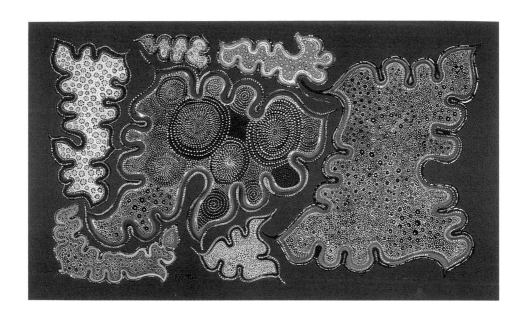

90. Kay Tunkun, *Kipara (Wild Turkey) Dreaming*, 1986–87

91. Judith Pungarta Inkamala, *Cockatiels*, 1996

The propensity for desert communities to adopt introduced techniques and materials has continued to this day. In 1995, the Ngaanyatjarra people at Warburton started an art-glass workshop that produces both architectural and domestic works; glass is the only art from Warburton to be shown outside the community. Similarly, at the Lutheran Mission at Hermannsburg, west of Alice Springs, artists had flirted with pottery in the 1960s, and were reintroduced to the techniques of ceramics in 1989. Hermannsburg pottery is flourishing today; primarily the domain of women, the hand-coiled pots with moulded lids are painted in 91 a naturalistic style which harks back to the images of Arrernte watercolour landscapes, first introduced to the area half a century earlier.

In the 1930s, watercolour landscape painting in the European vein was introduced by Rex Battarbee, a non-Aboriginal artist, to Aboriginal people at the Lutheran Mission at Hermannsburg, west of Alice Springs. It was taken up by Albert Namatjira, who 92 became Australia's first popularly known Aboriginal artist. In the era of assimilation, Namatjira's mastery of European techniques was interpreted as evidence for the potential success of this policy. The school of painting which developed among the

Arrernte at Hermannsburg continues to produce watercolours today.

For all his success, Namatjira's achievements were dismissed as derivative by art commentators until the recent reassessment of his work in the modern era of Aboriginal art. Namatjira is now seen to have reworked the models of European pictorial perspective to express his personal vision. His subjects were not chosen for their ostensible beauty in European terms, as had been thought, but were ancestral landscapes through which he expressed his personal relationship to the country to which he was spiritually bound. Namatjira's images are of the land created in the Dreaming, untamed by the requirements of the pastoral industry and by other evidence of European settlement.

Namatjira held his first solo exhibition in 1938, but despite his fame, he died disillusioned by white society. Nonetheless, Namatjira had made a major contribution towards changing negative public perceptions of Aboriginal people and laid the groundwork for the acceptance of more recent developments in Aboriginal art, particularly in the desert, where the Papunya school of painting emerged twelve years after his death.

92. Albert Namatjira, *Anthewerre, c.* 1955

The Papunya painting movement

Papunya is the birthplace of one of the most significant movements in modern Australian art, for it was here that, in 1971, Aboriginal artists transferred their ancestrally inherited designs and images into synthetic paints on portable surfaces which were destined to leave the local community. The wider appreciation of the richness of the art of the desert commenced.

Papunya is situated at a site of the Honey Ant Ancestor. It was established under the assimilation policy in 1960 for a number of groups including Arrernte, Anmatyerre, Luritja and southern Warlpiri, but principally Pintupi people, all of whom have ritual connections with the Honey Ant Dreaming. The transition from a semi-nomadic life of camps to a sedentary one had been very rapid and harsh. As a result, Aboriginal people had neither the power to determine their own futures, nor a voice with which to express their aspirations to the outside world.

A catalyst for change was an art teacher, Geoffrey Bardon, who arrived to teach children in the school in Papunya in 1971. After a while, Bardon encouraged the school yardmen and other local elders to join in painting a mural in the traditional mode on 93 the walls of the school. The issue of making a public painting using traditional images caused much debate among the older men. Such designs had previously only been painted on to rock walls, objects and participants' bodies in ceremony, and in related ground paintings. Eventually Old Tom Onion Tjapangati, the owner of the Honey Ant Dreaming, gave permission for Billy Stockman Tjapaltjarri, Long Jack Phillipus Tjakamarra, Kaapa Mbitjana Tjampitjinpa, Mick Wallankarri Tjakamarra and other artists to paint the mural. Other murals followed, although after Bardon left Papunya in 1972 they were destroyed under regulations intended to keep the school pristine.

Nonetheless, the successful completion of the murals encouraged other local artists to paint. Sympathetic to their aspirations, Bardon provided the new materials of synthetic paints and boards. Kaapa Mbitjana Tjampitjinpa, who had occasionally made similar paintings on board prior to Bardon's arrival, was the main protagonist in the painting movement that followed. The Papunya Tula Artists' Cooperative was formed during Bardon's stay to look after the artists' interests.

The movement at Papunya has developed through a number of phases, marked by changes in style, technique and type of imagery. While the range of colour in ground paintings could go beyond ochres, pipeclay and charcoal to include other colours

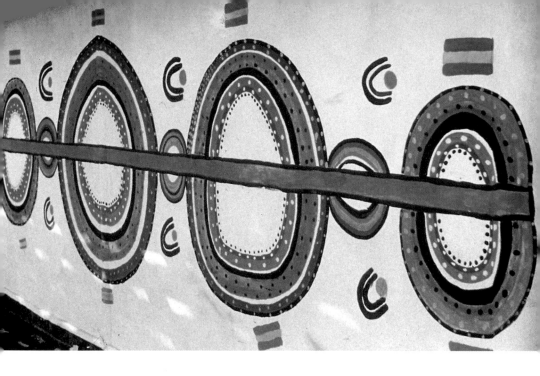

93. Billy Stockman Tjapaltjarri, Long Jack Phillipus Tjakamarra, Kaapa Mbitjana Tjampitjinpa, Mick Wallankarri Tjakamarra and other artists, *Honey Ant Dreaming*, mural at Papunya School, 1971

derived from natural materials, the synthetic paints offered a wider palette than that previously possible. The artists experimented with the newly available colours: orange, red and pink found favour for a while, but by and large the palette remained restricted until about 1980 when a wider range of colours again became common. Synthetic paints also reproduced the qualities associated with the use of natural pigments, such as the luminosity sought in ceremonial painting, and their quick-drying properties are indispensable for artists who usually work in the open air.

The first paintings were small, and painted flat on the ground or on the artist's lap. The rectangular boards would be turned around and painted from all sides if necessary, like bark paintings in Arnhem Land. The planar nature of the works and the consequent lack of a horizon line in the European style of landscape painting, makes the viewing orientation of minor significance, unless otherwise implied by the artist. The relationship between the arrangement of elements in the paintings and the cardinal points of the compass conveys greater meaning, as the latter are commonly used in the description of distant people and places, and the direction of the travels of the Dreaming beings.

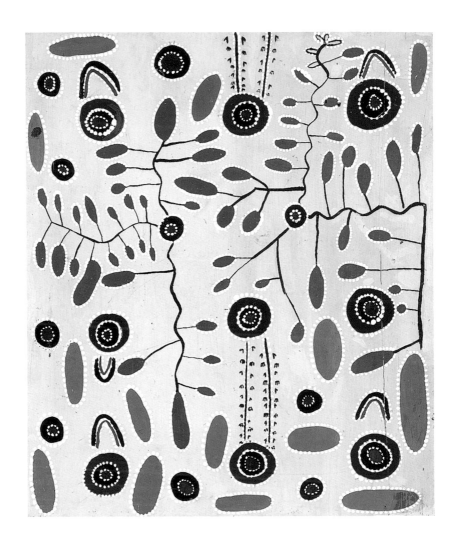

94. Billy Stockman Tjapaltjarri,
Yala (Wild Potato) Dreaming,
1971

Within the first three years of the movement, the size of the boards increased and artists moved to painting on canvases which could be rolled and transported with ease. As with the boards, the canvases are painted lying flat.

Originally painters employed a combination of naturalistic or schematic depictions of objects such as shields, spears, axes and sacred emblems used in men's secret ceremonies, with more conventional symbols, all usually painted against monochrome, often dark backgrounds. Human figures in full ceremonial regalia and body designs were also represented at one stage. However, the classical pictorial language of the desert seldom

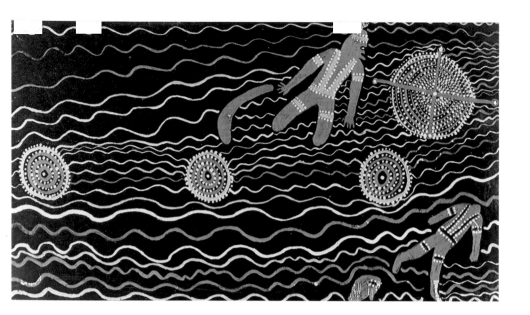

95. Long Jack Phillipus Tjakamarra, *Children's Kadaitcha Dreaming*, 1972

includes such naturalistic representations. In the traditional context, conventional iconography painted on to an object makes it unnecessary to depict the object itself. The fact that imagery of a sacred and secret nature could be broadcast to a public who did not possess rights to the deeper significance that it encompassed was beyond the experience of the painters. This realization prompted artists to develop mechanisms to render their paintings appropriate for the public.

In *Children's Kadaitcha Dreaming*, Long Jack Phillipus 95 Tjakamarra depicts the decorated figure of the Kadaitcha or law-enforcer at the top of the painting, and the decapitated body of a transgressor below right. The painting also includes conventional imagery, such as the three sets of concentric circles representing the Kadaitcha's fires and the wavy lines for smoke. The theme of the painting is didactic, and it is intended for the education of young children. Like outsiders, children are not initiated, and so the painting has been deemed suitable by the artist for public display.

By 1974 the naturalistic elements in paintings became less frequent and the narrative was expressed through conventional symbols which, given their multi-referential range of meanings, allowed the artists to describe their work without reference to secret information. Thus the public story could be separated from

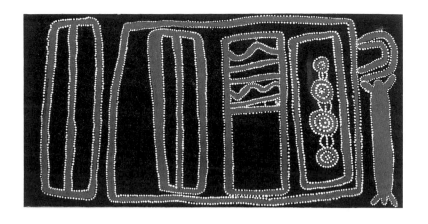

the more esoteric meanings. Charlie Tjararu Tjungurrayi's *Mitukatjirri* dispenses with overtly naturalistic images. It 96 describes the creation of a landscape by ancestors who performed ceremonies at the site which contains a sacred cave. At an unusual rock formation nearby, the male ancestors broke the law by having sexual intercourse with women of the wrong kinship group. The concentric circles joined by lines indicate the sites and the ancestral paths between them, while the other images relate to the geological formations and to the ancestors. The story is a warning about proper sexual conduct; it is also about the cataclysmic events leading to the creation of the land.

A feature of *Mitukatjirri* is the use of dots. In ritual painting dots are used to outline design elements, and so they appeared in the acrylic paintings, until gradually artists extended their use to cover the entire picture surface. The use of dots or repeated marks in this way may have a number of origins, none of which is mutually exclusive. They may be intended to evoke the use of birds' down or fibrous fluff, or to imitate the process of making ground paintings. They have been used to indicate differences in topography and vegetation. Areas of dots may mask sacred designs, and they may be used to produce visually stimulating effects intended to evoke the presence of supernatural power in the earth. The broad use of dots creates a field within which the action in a painting takes place.

In the painted shield by Dinny Nolan Tjampitjinpa, the dots 97 imitate feathery down and relate to the subject of the work: Lyurulyuru, a small bird with a red breast, at Ingiri waterhole near Mount Doreen. The entire design suggests the bird's body.

The concentric circles are the entrails, the main dark vertical is the back, while the shorter, horizontal lines indicate the sides. At another level, the concentric circles represent a camp and the dotted lines a landscape.

One of the masters of visual effects created by the overlaying of patterns of dots was Johnny Warangkula Tjupurrula. In *Water Dreaming at Kalipinypa* he carries the use of dots, and in this case dashes too, to the point where the iconographic elements dissolve into the field of the painting. Warangkula had primary responsibility for the site at Kalipinypa. While each of the features of the site are associated with aspects of storms – sandhills represent cloud formations, outcrops lightning – the artist's focus is the richness of the vegetation after the rains. The black dots in the painting allude to a nutritious bush raisin. Other features of the landscape, including caves, soaks and watercourses are embedded into the picture plane. The overlaying of dots, however, finds its extreme expression in Timmy Payungka Tjapangarti's *Secret Sandhills* which depicts ridges of sandhills covered by fields of vegetation.

Among the Pintupi, who by the early 1980s had begun to return to their ancestral lands around Kintore and Kiwirrkura in the west, artists began to develop archetypal images constructed purely of concentric circles representing sites with journey lines joining them. The circles are often surrounded by U-shapes indicating the participants in the events depicted, and the areas in between are filled with contour-like parallel lines of dots. The device allows artists to compose pictures about highly esoteric subjects such as the Tingari ancestors (pp. 162–4). Anatjari Tjampitjinpa's *Ceremonial ground at Kulkuta* depicts a Tingari initiation ceremony. The larger sets of circles represent the body-designs of the older men who are painting the bodies of the young initiates, shown as smaller circles. The background stipple represents the cleared ceremonial ground, while around the perimeter of the painting the dots indicate a body of water surrounding the camp.

Anatjari makes minimal use of iconography to imply a wealth of concepts far deeper than the interpretation given to the uninitiated, and the device is taken to extremes in the work of other Pintupi painters. Ronnie Tjampitjinpa's *Two Women Dreaming*, for example, concerns two ancestral women who travelled to Pitijinpirri where they built a shade, represented by the white lines in the painting, within which they placed their coolamon or carrying-dishes, seen as the innermost rectangles.

98

99

103

100

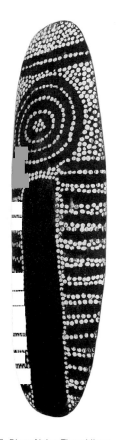

97. Dinny Nolan Tjampitjinpa, *Shield*, 1972

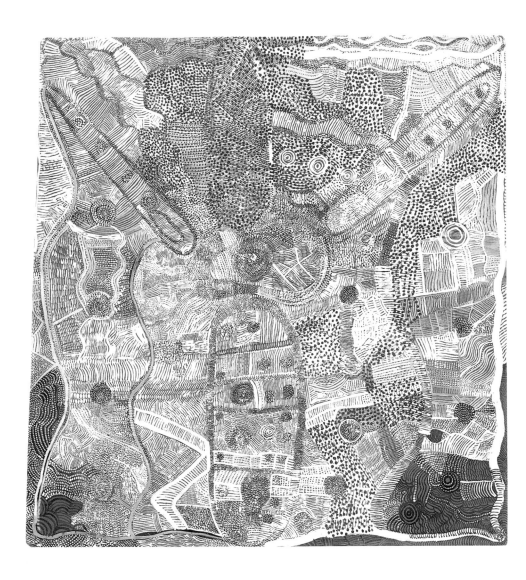

98. Johnny Warangkula
Tjupurrula, *Water Dreaming
at Kalipinypa*, 1972

99. Timmy Payungka
Tjapangarti, *Secret sandhills*,
1972

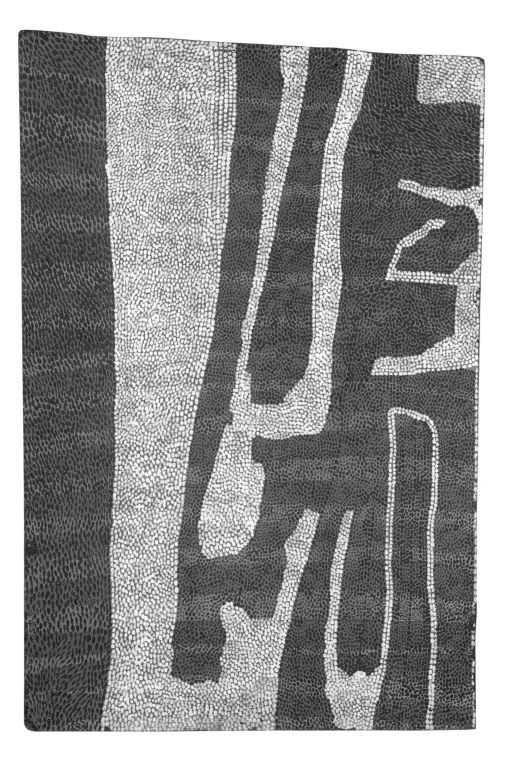

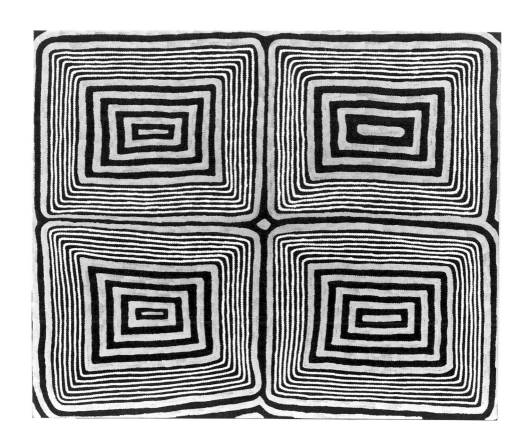

100. Ronnie Tjampitjinpa, *Two Women Dreaming*, 1990

Opposite:
101. Uta Uta Tjangala, *The Old Man's Dreaming*, 1983

102. Turkey Tolson Tjupurrula, *Straightening spears at Ilyingaungau*, 1990

The indentations in the earth made by the coolamon became life-sustaining water soakages. The propensity for austere compositions among the Pintupi is exemplified by Turkey Tolson Tjupurrula's *Straightening spears at Ilyingaungau,* based on a 102 pre-battle ceremony, while in *Bandicoot Dreaming* Mick 104 Namarari Tjapaltjarri practically dispenses with dots to show the scratch-marks made by Tjakalpa the desert bandicoot as it digs its burrow at the Dreaming site of Putja.

Uta Uta Tjangala was an influential artist who lived in the area around Kintore. His *The Old Man's Dreaming* is another 101 Tingari subject which concerns the punishment of a man who had a sexual affair with his mother-in-law. The painter has dispensed with many of the graphic symbolic elements. Joined circles represent sites visited in the saga, while the larger ovoids represent the rock formations at the site of Yumari. The powerful composition reflects the cataclysmic forces that created the

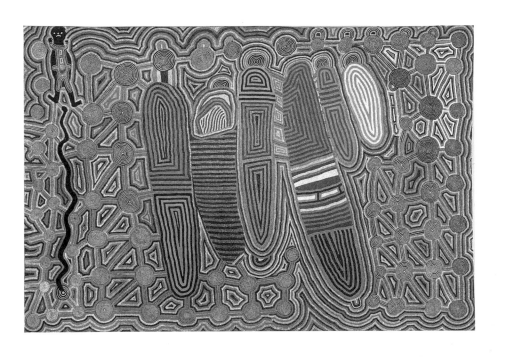

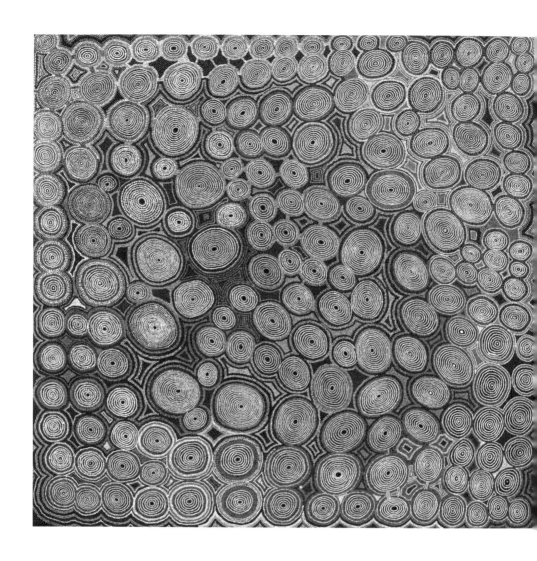

103. Anaṯjari Ṯjampiṯjinpa,
Ceremonial ground at Kulkuta,
1981

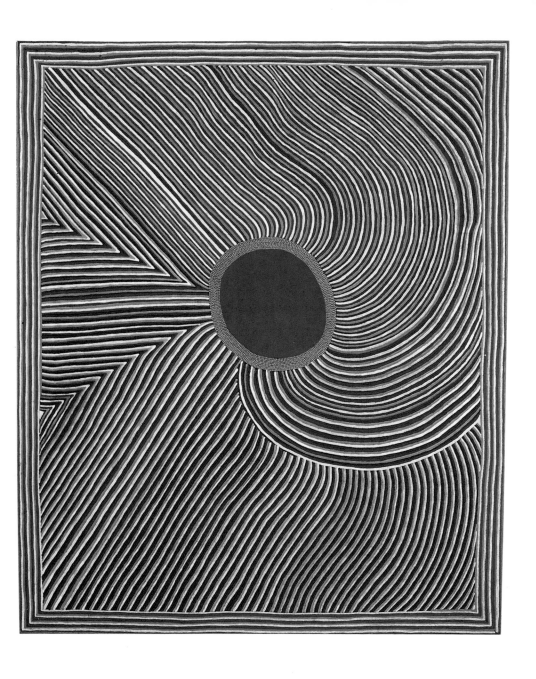

104. Mick Namarari Tjapaltjarri,
Bandicoot Dreaming, 1991

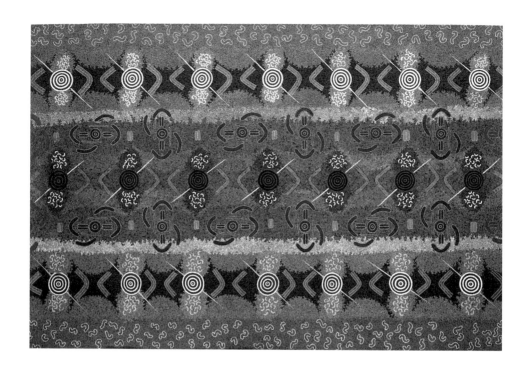

landscape. Offsetting the summary elements is a meandering path that leads from a site to the figure of the Old Man, his body painted in designs.

Pintupi and related artists living at Haasts Bluff, south-west of Papunya, have been part of the painting movement from the beginning; however, in 1992 they established a local arts centre, Ikuntji. Among the leading lights is Long Tom Tjapanangka 107 whose work is a departure from the normal plan view of desert painting; his paintings are usually composed of areas of broad and flat colour showing the landscape in stark profile thereby retaining the feel of the non-objective paintings usually associated with Pintupi artists. Long Tom's wife Mitjili Napurrula, on 109 the other hand, paints intricate mosaics of organic shapes in contrasting colours.

By way of contrast to the austere compositions favoured by Pintupi painters, artists such as the Anmatyerre/Arrernte brothers Clifford Possum Tjapaltjarri and Tim Leura Tjapaltjarri create rich, painted surfaces and employ a wide range of the available iconography. Clifford Possum's *Yinyalingi (Honey Ant* 105 *Dreaming story)* and Tim Leura's *Men's camps at Lyrrpurrung* 106

Ngturra embody formal compositions to make connections between land and ceremony. The ultimate meanings of these two works, however, are diametrically opposed, and they serve to illustrate artists' capacity to combine religious and aesthetic concerns with another level of personal expression.

Clifford Possum's *Yinyalingi (Honey Ant Dreaming story)* 105 depicts camps at ceremonies connected with the Honey Ant Ancestor at Yinyalingi, a site to the north of Papunya. Lines of men's camps alternate with those of the women. Large ceremonies are usually held at a time of plenty after the rains, when the land is capable of supporting large numbers of people in one place. The richness of the land is indicated by the presence of the grubs which are depicted along opposite edges of the painting and around the camps. The two light-coloured horizontals, which form a compositional device in much of Clifford Possum's work, represent the morning mists that spring up at the site at this time of year. The painting reflects seasonality, the cyclical nature of good seasons, and concentrations of people and ceremony.

Similarly, Tim Leura's *Men's camps at Lyrrpurrung Ngturra* is 106 concerned with formal ceremonial arrangements. An ancestral Hunter, represented at the centre of the painting by the large

106. Tim Leura Tjapaltjarri, *Men's camps at Lyrrpurrung Ngturra*, 1979

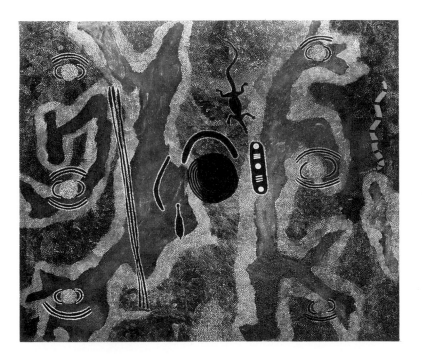

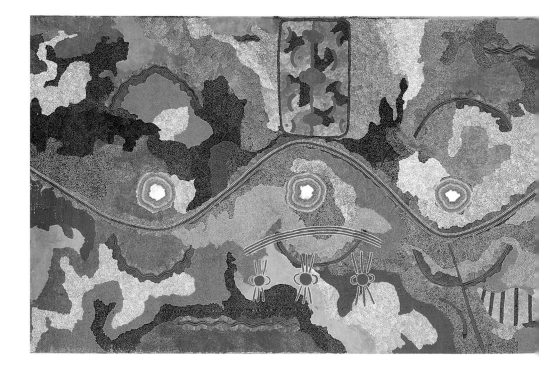

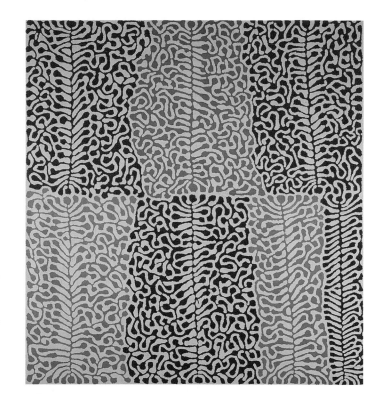

107. (*opposite*) Long Tom
Tjapanangka, *Mereenie Range,
Mikarnta Spring, Ulampawarru*,
1995

108. (*below*) Tim Leura
Tjapaltjarri with Clifford Possum
Tjapaltjarri, *Napperby Death
Spirit Dreaming*, 1980

109. (*right*) Mitjili Napurrula,
Uwalki: Watiya Tjuta, 1998

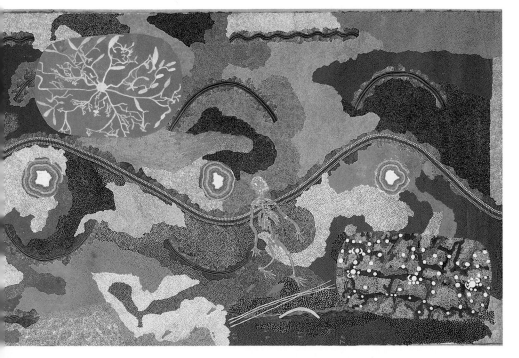

U-shape and his weapons, is seated at the major ritual camp. Other ritual participants are shown in the surrounding camps. A snake and a goanna represent the Hunter's entire catch – the land which had once been rich in resources such as kangaroo and emu was now impoverished. Leura's work carries the sense of melancholy engendered by the hostile and destructive intrusions of European culture upon his country. Characteristic of Leura's work, *Men's camps* is painted in washes of dark colours, heightening the sense of oppression.

Napperby Death Spirit Dreaming, Leura's major painting, is 108 seven metres long and made with the assistance of his brother Clifford Possum. It was commissioned by Bardon, and depicts the journey through the artist's life and country. The painting features a path-line meandering between circular resting places, and major Dreamings of the artist are shown in three vignettes. From left to right, these are the Old Man's Dreaming, the Yam Dreaming and the Sun and Moon Dreaming. The spears and a boomerang indicate the presence of the great ancestral Hunter. The spirit of death, a skeleton, is shown nearing the end of the journey.

Although it is common for artists to depict one Dreaming in a painting, exceptions such as Tim Leura's *Napperby Death Spirit Dreaming* have appeared since the early days of the Papunya movement. Michael Jagamara Nelson's country near Vaughan Springs lies at the intersection of several major Dreaming paths, and consequently his paintings integrate a number of these. In *Five Dreamings* the central horizontal represents the Dreaming 111 path of the Flying Ant, Pamapardu; the circles at the bottom left and top right are Possums at Jangankurlangu and Mawurji, while the tracks at the lower right are those of the two Kangaroo Ancestors at Yintarramurru. The circles at the lower right represent Mirrawarri, a Rain Dreaming site near Mount Doreen. The snake is Warnayarra the Rainbow Serpent at Yilkirdi near Mount Singleton. Concentration of several Dreamings in one painting reflects the seniority of the artist in the religious life of the region, and so his individual status. Jagamara Nelson also intimates the connections he has with Aboriginal groups beyond his country, with whom he shares these Dreamings.

In *Five Dreamings* Jagamara Nelson was assisted by his wife Marjorie Napaljarri. At Papunya, women were rarely acknowledged to have had a hand in the production of paintings until about 1979. Among the first to be recognized in her own right was Sonder Nampitjinpa. *Pankalangu ceremonies at Yamunturnga* 110

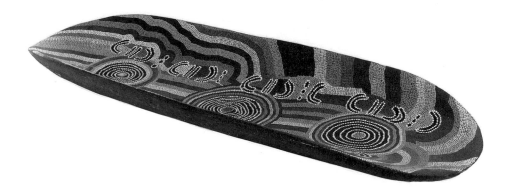

is a painted coolamon (carrying-dish) depicting ceremonial camps and women, represented by the arcs, sitting in formal arrangements. Nampitjinpa also paints on canvas; her painted dish of 1987 recalls a time in the early 1970s when boards for painting were sometimes in short supply, and artists would paint on sculptures, objects, even linoleum tiles instead. Pansy Napangati was taught to paint by her relative Johnny Warangkula in the early days of the movement. *Old Man at Ilpilli* also depicts a 112 ritual scene: the central rounder is the waterhole at Ilpilli, while the three U-shapes, rather than representing three individuals, are a single elderly Tjakamarra man with his spear, boomerangs and hair-belt, at different stages of performing his own ceremony.

Similarly, *Flying Ant Dreaming at Wantungurru* by Maxie 113 Tjampitjinpa relates to ceremonial events, as indicated by the regular arrangement of the icons. The circles indicate the holes in the earth from which the ancestral termites known as Flying Ants emerge to perform their creative acts. The rounders with bars to each side are designs painted on the bodies of the key participants in ceremonies. The termites swarm in nuptial flights after the rains, and are associated with fertility and reproduction. This richness is evoked by Tjampitjinpa's characteristic areas of stippled paint which are comparable to the washes of paint applied to people's bodies and objects in ceremony.

The Warlpiri artists discussed above, especially Michael Jagamara Nelson, Sonder Nampitjinpa, Dinny Nolan and Maxie Tjampitjinpa, have had a considerable impact on the Papunya movement. However, the traditional lands of the Warlpiri also include a vast area of the Northern Territory to the north of Papunya, incorporating the settlements of Nyirrpi, Yuelamu, Willowra, Yuendumu and Lajamanu.

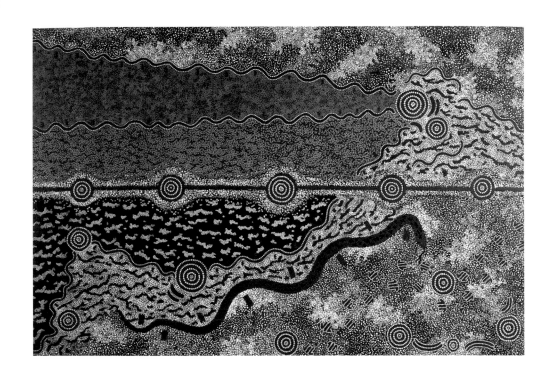

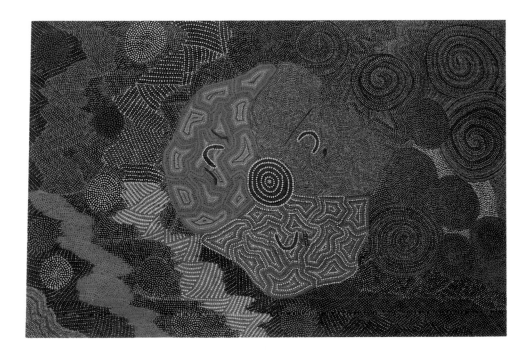

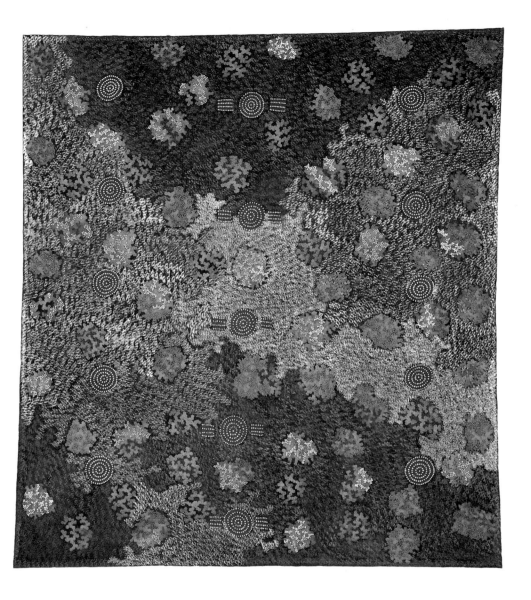

111. (*opposite above*) Michael
Jagamara Nelson, *Five Dreamings*,
1984

112. (*opposite below*) Pansy
Napangati, *Old Man at Ilpilli*, 1990

113. (*above*) Maxie Tjampitjinpa,
*Flying Ant Dreaming at
Wantungurru*, 1988

Warlpiri artists of Yuendumu and Lajamanu

The origins of the painting movement at Yuendumu, and subsequently in other Warlpiri settlements, were markedly different from those at nearby Papunya. Watercolours and acrylic paints had been made available to artists here in the early 1970s, when the Papunya movement was still in its infancy, but the Warlpiri were reluctant to reproduce ancestral designs for a wider public. When the artists at Yuendumu did eventually decide to take up the new materials in the early 1980s, they benefited from the experiences of their neighbours.

Yuendumu artists were more aware of the art market process from the outset. It was understood that their works would be kept publicly and permanently, rather than being ephemeral statements. Lengthy debate amongst the elders ensured that mechanisms were in place to permit only the transmission of the secular and public aspects of their imagery. In 1985, the cooperative Warlukurlangu Artists Association was formed to act as a vehicle for the implementation of this policy, and to channel the work into the public domain. The fact that the artists belong predominantly to one language group, the Warlpiri, has facilitated the adoption of traditional social procedures in the organization. As a consequence, the collaborative methods of producing traditional art forms (see p. 104) are more common in the production of acrylic paintings, and the co-artists are usually acknowledged.

Also in contrast to the events at Papunya, in 1983 the principal of the Yuendumu school, Terry Davis, actively encouraged a group of senior men to paint the doors of the school with major Jukurrpa or Dreamings of the area. The elders regarded this as an opportunity to remind the students of their religious heritage and identity, and to provide a context for the non-Aboriginal values they encountered at school.

The painting of the doors was seen as an affirmation of cultural strength, and gave the artists the opportunity to work on a scale and within a time-frame which corresponded with traditional ritual practices. Each door was painted within a short period of time, just as ritual requirements would dictate a certain speed of execution, and the resultant images were bold and painterly. *Ngapakurlu (Rain)* by Paddy Japaljarri Sims illustrates an encounter between two ancestral Rain Beings who were strangers to each other. The first Rain Being travelled north of Yuendumu, camping at Jurntiparnta, a waterhole belonging to Sims's mother's father, and struck the ground with bolts of lightning. From small clouds, the Rain Being created people who are 114

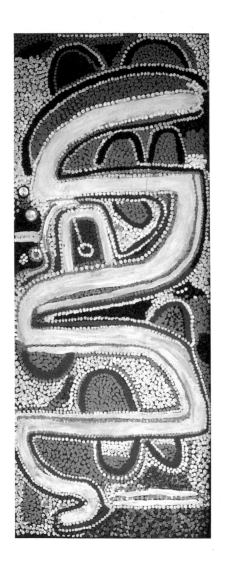

114. Paddy Japaljarri Sims,
Ngapakurlu (Rain), 1983

the ancestors of the current owners of this land. Tiring from its exertions, the Rain Being transformed itself into clouds. In the north it met a second Rain Being which it covered with its cloud-form, and sending down a deluge, it entered the ground as a stream. In the painted door, the dominant zig-zag represents lightning, the inverted U-shapes clouds and the dots rain. The Dreaming narrative is continued in the paintings on other doors.

The Yuendumu school door-paintings provided a catalyst for the men to make paintings for the outside world. In the physical scale of the doors the artists recognized the potential to paint

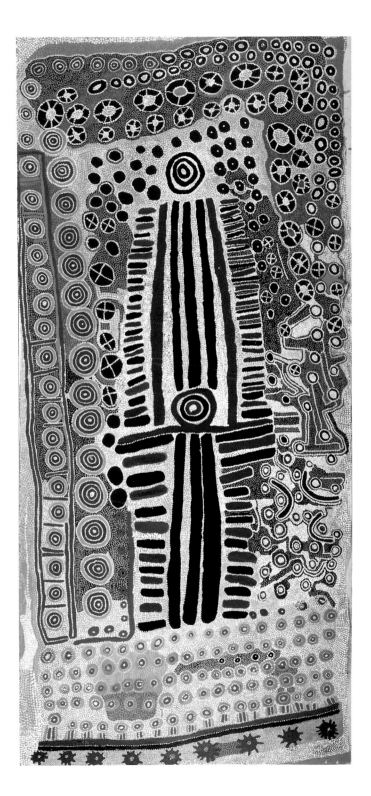

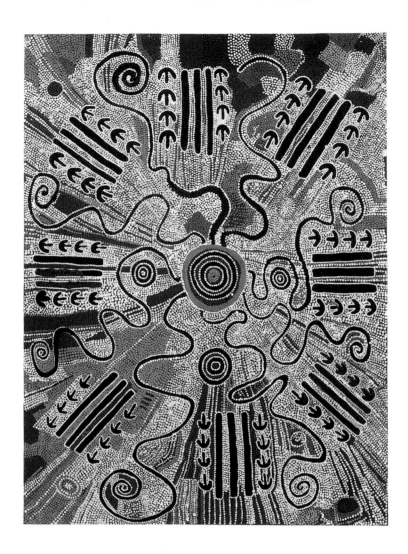

115. (*opposite*) Paddy Jupurrurla Nelson, Paddy Japaljarri Sims and Larry Jungarrayi Spencer, *Yanjilypiri Jukurrpa (Star Dreaming)*, 1985

116. (*above*) Darby Jampijinpa Ross, *Emu Dreaming*, 1987

meaningful sequences of the Dreamings, rather than the details that small canvases permitted. Three of the painters involved in the school project painted one of the first large canvases to leave Yuendumu. Jimmy Jungarrayi Spencer was the *kirda* or owner of the Dreaming depicted in *Yanjilypiri Jukurrpa (Star Dreaming)* of 1985. He supervised the painting but did not participate. Paddy Jupurrurla Nelson had matrilineally inherited rights to the Dreaming and was therefore the *kurdungurlu* and main painter, and he was assisted by Paddy Japaljarri Sims and Jimmy Jungarrayi Spencer's younger brother Larry Jungarrayi Spencer. The work concerns the Warlpiri fire ceremony associated with

the creation of the constellations. The dynamic qualities of the painting became a hallmark of the earlier paintings by men. *Emu* 116 *Dreaming* by Darby Jampijinpa Ross is another such example. Ross's work depicts several Emu ancestors, indicated by arrow-like footprints and the vigorous meandering lines which represent their intestines. The sets of bars represent spears and digging sticks, symbolic of men and women respectively, at the sites of Kunurrulypa and Ngunkurrlmanu.

Women artists have had a much more prominent role at Yuendumu than at Papunya, partly as a result of the interest shown in their work by the anthropologists Nancy Munn who first went to Yuendumu in 1956 and Françoise Dussart who worked there in the 1980s. Women had decorated mundane objects such as carrying dishes and digging sticks for sale prior to 1984, but in that year a group of elder women started to paint small canvases for sale in order to raise money for a vehicle which would allow them easy access to their often distant ceremonial grounds. The impulse to paint pictures thus arose from pressing cultural needs. In 1985, the year of *Yanjilypiri Jukurrpa (Star Dreaming)*, Liddy Napanangka Walker, Topsy Napanangka and Judy Nampijinpa Granites collaborated to paint *Wakirlpirri* 118 *Jukurrpa*. The work depicts a Dogwood Dreaming site owned by Liddy, who painted the most prominent designs, and Topsy, the *kirda* of the Dreaming. They were assisted by Judy who, although younger, is classed as their mother and is the *kurdungurlu*. The collaboration reflects the pattern of joint custodianship of the land which is expressed in art. Typical of *yawulyu* (women's designs), the painting celebrates the fertile aspects of the land. Women are depicted as U-shapes, collecting the dogwood seeds and winnowing them. The seeds are half-cooked, then washed in their *parraja* (carrying-dish) before being ground to a paste and made into damper (bread dough). The dominating images are three clusters of seed-pods. In contrast to the broad brushwork favoured by male artists at Yuendumu, women's paintings are characterized by dense, rich surfaces.

The Fire Dreaming at Warlukurlangu, depicted by Uni 120 Nampijinpa Martin and Dolly Nampijinpa Daniels, was created by Lungkarda the Blue-Tongued Lizard Man to punish his two sons for killing a sacred kangaroo and not sharing the meat in the customary manner. The work concerns punishment of transgressors and the need to care for the land – in this case by firing the country as is the practice in many parts of Aboriginal Australia. This great fire was followed by torrents of rain which

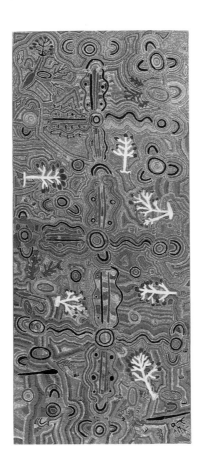

117. Peggy Napurrurla Poulson,
Maggie Napurrurla Poulson
and Bessie Nakamarra Sims,
*Janganpa Jukurrpa (Possum
Dreaming)*, 1988

fertilized the land and caused all species of flora and fauna to
thrive. The painting is composed to reflect formal ritual
arrangements; between the two large curves representing wind-
breaks at either end of the canvas, the tracks of participants
weave around circular ritual icons.

The ordered nature of creation is echoed in the structure of
ceremonies and the composition of paintings. *Janganpa Jukurrpa* 117
(Possum Dreaming) by Peggy Napurrurla Poulson, Maggie
Napurrurla Poulson and Bessie Nakamarra Sims concerns the
Possum Ancestor who created the waterholes of Warrkaparli,
Lawanjajarra and Mawurji, represented by the three sets of con-
centric circles running vertically through the middle of the
painting. All the action in the painting is focused on the circles.
The straight and sinuous lines indicate the nightly journeys of
the Possums from the main sites to others shown as circles

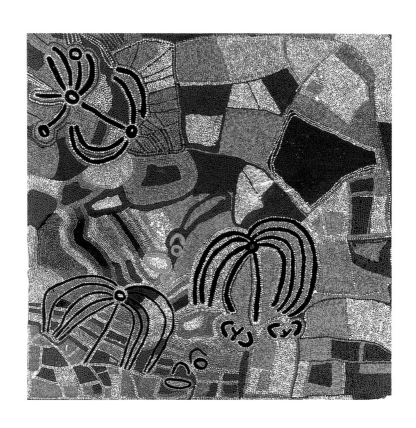

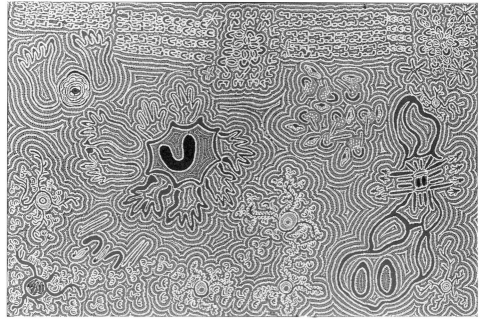

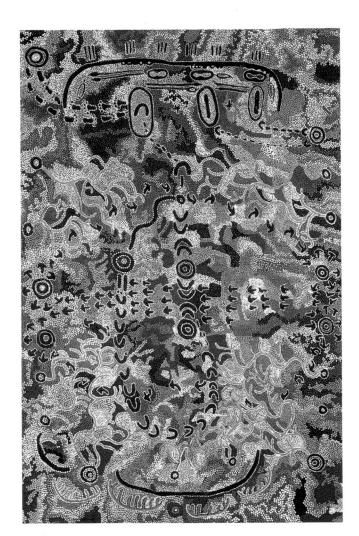

118. (*opposite above*) Liddy Napanangka Walker, Topsy Napanangka and Judy Nampijinpa Granites, *Wakirlpirri Jukurrpa*, 1985

119. (*opposite below*) Jeannie Nungarrayi Egan, *Jardiwampa Jukurrpa (Snake Dreaming)*, 1989

120. (*right*) Uni Nampijinpa Martin and Dolly Nampijinpa Daniels (formerly Granites), *Warlukurlangu (Fire Country) Dreaming*, 1988

between two U-shapes, and map the movements of performers in the ritual. The E-shaped icons represent the tracks of the Possum, and mark each of the journey-lines.

The dense tapestry of *yawulyu* in Jeannie Nungarrayi Egan's *Jardiwampa Jukurrpa (Snake Dreaming)* recalls sand drawings where designs depicting one episode of a story are wiped smooth and others are interposed. The work is a complex composition incorporating six Dreamings located in an area between Ngarna to the south of Yuendumu and Katurnu to the north. The main image is the journey of the Snake Ancestors in human form, represented by the footprints along the upper edge of the painting. 119

As they travelled, they danced and performed various rituals at camps along the way. The combination of Dreamings within the painting expresses the connections between kinship groups. For example, the Snake Dreaming belongs to the Nungarrayi-Napaljarri kinship group, while Kinki the Giant Woman Dreaming, represented by the large footprints in the upper left of the painting, belongs to the Nakamarra-Napurrurla group.

One of the major Warlpiri Dreamings, Pamapardu or Flying Ant at Wantungurru, west of Yuendumu, belongs to the Nampijinpa-Nangala group. Flying ants or termites provide food and nesting areas for goannas and are also eaten by people, so signifying the fecundity of the land. The graphic quality of *Pamapardu Jukurrpa (Flying Ant Dreaming)* by Clarise Nampijinpa 121 Poulson indicates her concern with the spatial organization of the Flying Ant ceremony, enclosed by two large arcs. The central set of concentric circles is at the same time the site at Wantungurru and the central construction on the ceremonial ground. The other sets of circles simultaneously represent smaller ceremonial camps and the termites' mounds, surrounded by the U-shapes of women who will collect the ants and their eggs.

Nampijinpa Poulson's treatment of the subject contrasts sharply with the atmospheric effect achieved by a male Warlpiri artist, Maxie Tjampitjinpa, in *Flying Ant Dreaming at* 113 *Wantungurru*. Both works evoke the material and spiritual richness of the land within the artists' respective male and female spheres of ritual knowledge.

Lajamanu, about four hundred kilometres north of Yuendumu, is a settlement established by the Government in 1947 to make way for mining and pastoral leases in the area. Although it lies well beyond traditional Warlpiri lands, in the following years Lajamanu was mainly populated by Warlpiri speakers from Yuendumu, many of whom were selected at random and taken there under Government regulations. The succeeding years saw a number of migrations between the two communities. Although many Warlpiri settled at Lajamanu and have established ritual links to the land they now occupy, contact with Yuendumu is constant. The Warlpiri at Lajamanu demonstrate the contemporary relevance of art by the fact that through painting they are largely able to fulfil their responsibilities to their ancestral lands which lie to the south and west and are difficult to access.

121. Clarise Nampijinpa Poulson, *Pamapardu Jukurrpa (Flying Ant Dreaming)*, 1990

The genesis of the art movement at Lajamanu was slow. Here, too, artists were apprehensive about making art intended for the

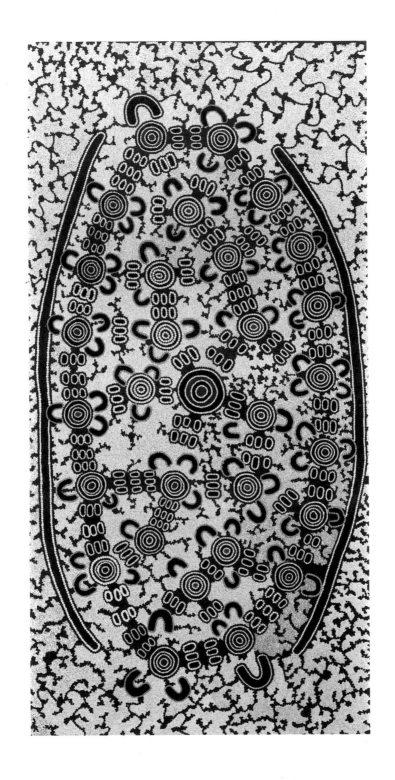

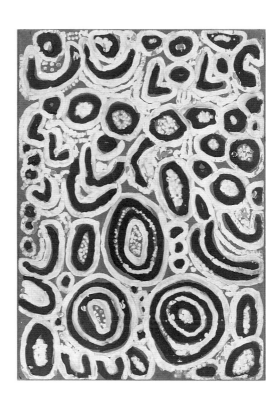

122. Molly Napurrurla Tasman,
*Marsupial Mouse Dreaming
at Marlungurru*, 1986

public domain, and they were concerned not to lose rights to their land through the exposure of religious secrets. Nonetheless, in 1983 twelve artists went to Paris to construct a ground painting and perform open ceremonies as part of the exhibition of contemporary Australian art entitled *D'un autre continent: L'Australie, le rêve et le réel* at the Musée d'Art Moderne. In late 1985 a meeting of senior men gave approval for public paintings to be made. It was the men who created the first of these works, using house paint on large sheets of composition board, plywood and cardboard. At the same time women artists also began to paint, mainly in gouache on cardboard.

In 1986 a group of women produced a set of paintings for the local school at Lajamanu with much the same intention as the men at Yuendumu three years before. One of these was *Marsupial Mouse Dreaming at Marlungurru* by Molly Napurrurla Tasman which shows women of the Napurrurla and Nakamarra kin groups sitting down at Marlungurru. The large circles are the burrows of the Marsupial Mouse, the smaller circles depict the animal sitting and the Mouse's tracks are represented by the

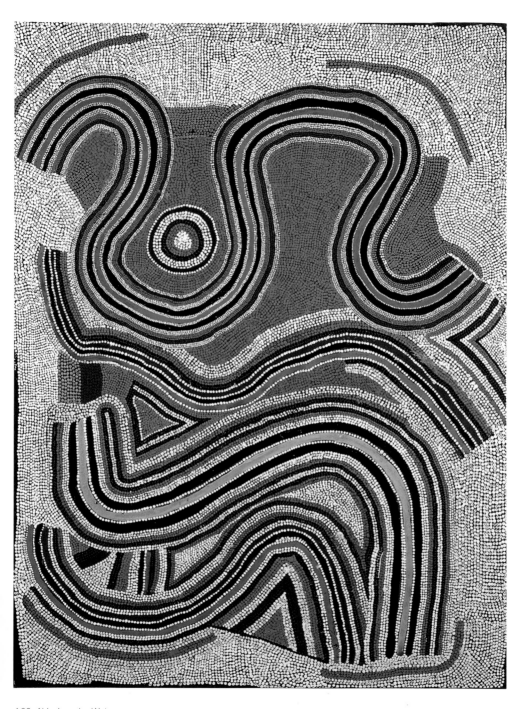

123. Abie Jangala, *Water Dreaming*, 1987

V-shapes. The work represents another variation in desert painting: the designs are concentrated so as to form the ground and contours of the picture surface. There is no space between the icons, no background.

Although they share the art traditions of Warlpiri elsewhere, the artists at Lajamanu favour freer compositions, emphasizing the strong graphic quality of the basic elements of desert iconography. Figurative elements and even animal and human footprints appear less frequently than elsewhere in the desert. Images are usually set against a background of uniformly coloured dots. The colours are austere, with little of the subtlety achieved through the overlay of dotted patterns. The compositions of the paintings are usually bold and brash, while the pictorial detail common to many of the later paintings at Papunya and Yuendumu is deliberately avoided.

Abie Jangala and Peter Blacksmith Japanangka were two of those deeply involved with the Lajamanu painting movement from the beginning. Jangala was one of the founders of the community, and Blacksmith was a senior ritual man with direct responsibility for the country around Lajamanu.

Among the major Dreamings painted by men are water, rain, clouds and thunder, and Jangala had ritual custodianship of many of these Dreamings. His paintings are characterized by white backgrounds and a restricted palette, as can be seen in *Water Dreaming*. This painting depicts an ancestral flood which originated at Mikanji near Yuendumu, travelled to Puyurru and then branched out to Kulpulunu and Kamira in the north. The waters washed through the country and continued northwards until they reached the sea, linking the innermost regions of the Tanami desert with the coast.

The theme of water, the very source of life, is also the subject of Peter Blacksmith's bold and graphic *Snake Dreaming*. This depicts a Snake Ancestor and his brother who came from the west looking for water. They reached a place called Mundululu in Kurindji country where they encountered a number of Fish Ancestors who were suspicious of the Snakes and repelled them. The Snakes made for Wadjipilli, a waterhole near Lajamanu, in the artist's country. A rainbow, and then rain, followed the Snakes wherever they went, fertilizing the land.

The abundance of the land is celebrated in Jimmy Jampijinpa Robertson's *Seed Dreaming* which depicts two women, the large U-shapes in the painting, grinding seeds on rocks to make bread dough, while their children, shown as the smaller U-shapes, play

123

124

125

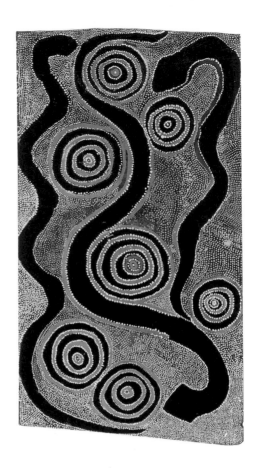

124. Peter Blacksmith
Japanangka, *Snake Dreaming*,
1986

a game of snatching the seeds. The arabesques surrounding the
scene represent drying seed-pods and lend the work a dynamic
quality in marked contrast to the contemplative treatment of a
similar subject in *Wakirlpirri Jukurrpa*.

118

From silk batik to car doors: Utopia

The Anmatyerre and Alyawarre artists in and around Utopia in
the eastern part of central Australia have artistic traditions simi-
lar to those of their western desert neighbours, despite differ-
ences in language and social structure. Their land was taken
over by pastoral leases or stations in the 1920s, but some fifty
years later the Anmatyerre and Alyawarre began to re-occupy
their traditional lands north and north-east of Alice Springs. In
1979 they won back that part which had been temporarily the
Utopia cattle station. Instead of establishing a central town or

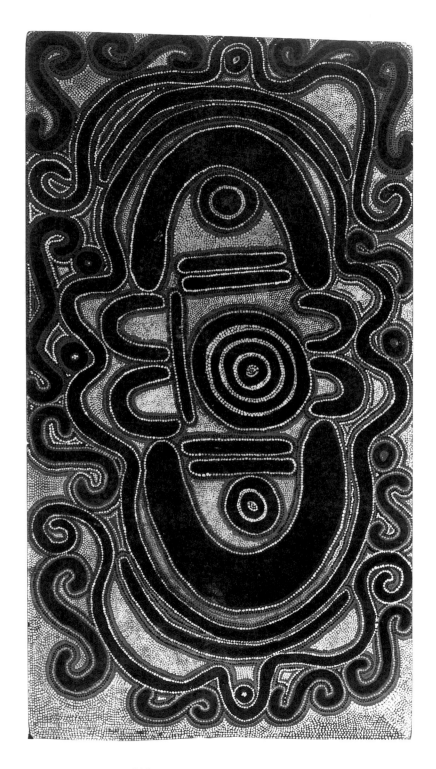

settlement, the Anmatyerre and Alyawarre prefer to live in small outstations or camps, close to their ancestral country and the spiritual sustenance it affords.

The rise to prominence of Utopia artists began with the making of batik in the 1970s and continued with painting and other art forms as these were introduced in the late 1980s. Through a series of specialized education programmes commencing at the time of the move back to their country in 1977, the women of the community were introduced first to woodblock printing and tie-dyeing of fabric, and later in the same year to batik.

The opportunity to gain a degree of economic independence through the sale of batik, as well as the social nature of its production which accords with local customs, led to the formation of the Utopia Women's Batik Group in 1978. The Utopia women artists quickly developed a preference for free drawing, using a brush for broad areas, and the *canting* (wax pen) for fine work. As in Ernabella and Fregon, the artists prefer to use silk fabric which enhances the fluidity of the drawing. The designs of the batiks are mostly based on ceremonial *awelye* (Anmatyerre for *yawulyu*, or women's designs) which are applied to the breasts, arms and legs, and they often incorporate naturalistic images based on the organic contours of plants. Such designs are used as the vehicle to depict women preparing for ceremony in Edie Kemarre's batik of 1987. 126

The history of the recent art of Utopia is punctuated by a series of survey exhibitions. The first of these in 1988 was a collection of 88 batiks, including Sandra Holmes Kemarre's *Morning Star Dreaming.* The work deals with an ancestral crea- 127 tion story concerning two Sky Brothers, the younger of whom had a stick with which they made a fire to cook a kangaroo. The brothers argued and the younger one fell into the fire and exploded, thereby creating the stars. The elder brother became the Morning Star. The batik image depicts the creation of the firmament which is mirrored in the landscape. Circles represent stones on the ground while the central circle is a waterhole.

The medium of painting was taken up in 1989 by artists in the second major survey exhibition, *A Summer Project.* As with later projects of woodblock prints and watercolours, the survey introduced a wide range of artists at Utopia to new media. Along with batik, painting has become the most popular form of art. The freedom of expression that the artists find in batik carries through into paintings that range from highly formal compositions and narratives to works which dispense with conventional

125. Jimmy Jampijinpa Robertson, *Seed Dreaming*, 1986

147

126. (*right*) Edie Kemarre, Utopia Women's Batik Group, *Women sitting in groups painting each other for corroboree*, 1987

127. (*below*) Sandra Holmes Kemarre, Utopia Women's Batik Group, *Morning Star Dreaming*, 1988

iconography of the desert altogether to incorporate naturalistic imagery and landscapes in the European manner.

Lyndsay Bird Mpetyane, one of the few male artists to partici- pate in the batik projects, was among the instigators of the move to painting in acrylic on canvas. His *Utnea* identifies the Snake Ancestor of that name with a site at Arremela, near the artist's home at Mulga Bore. The Snake is depicted both stretched out asleep and in motion. The short dashes represent the Snake's bones, which remain at this site and are tangible evidence of the ancestral events that occurred there.

An important leader of women's ceremonies, Emily Kame Kngwarreye emerged as one of the senior artists from Utopia. Kngwarreye participated in the original Utopia Women's Batik Group and took up painting on canvas in her seventies. Her work

128

128. Lyndsay Bird Mpetyane,
Utnea, 1991

is testimony to a lifetime of creating images. The designs in her batiks are usually composed of linear organic forms which cover the entire surface of the silk. In her paintings Kngwarreye uses these linear designs as a ground on which to lay fields of pure colour and dots. The paintings are based on *awelye* of plants, seeds and body painting. In *Untitled* Kngwarreye creates a visual 130 texture which evokes the physical and spiritual fertility of the land and the radiance of being that is sought in ceremony.

By way of contrast to Kngwarreye's minimal imagery, renditions of the landscape in the western perspectival manner are common in Utopia, in particular among artists working at the Antarrengenye outstation. *Sandover River* by Lilly Sandover 131 Kngwarreye depicts the river of the artist's Dreaming. The formal composition of the river, the trees on the banks, the hills and the rising sun is offset by the repeated motif of parakeelya flowers across the canvas, indicating the artist's concern with the seasonal nature of the land rather than its topographical features alone.

Women's ceremonies are the subject of *Sacred grasses* by Ada 132 Bird Petyarre. The plant forms around the perimeter of the canvas point inwards to the centre of the work where a circle represents a ground painting. On either side of this circle are rectangular shapes described in dots which resemble a ceremonial

ground. The painting indicates a planar perspective landscape, as though one were looking down on it from above, while at the same time the composition suggests the viewer is looking up through the ground as, indeed, the supernatural beings are said to view the world from their subterranean home.

Sculpture has become another popular form among Utopia artists. Sculpted objects such as men's shields and boomerangs and women's carrying dishes, digging and dancing sticks are part of the traditional creative output of the people of Utopia.

Artists have also in the past carved wooden animal figures and decorated them with pokerwork designs. Figurative sculpture blossomed in 1989, and artists use the figures as a ground on which to apply painted designs. This concept is the basis for the Antarrengenye artist Mavis Holmes Petyarre's landscape 129 painted on to a found object, an old car door. This work is yet another example of the degree to which Aboriginal artists are prepared to extend the parameters of their artistic traditions through experimentation and innovation.

129. Mavis Holmes Petyarre, *Untitled*, 1990

Overleaf:
130. (*left*) Emily Kame Kngwarreye, *Untitled*, 1991

131. (*above right*) Lilly Sandover Kngwarreye, *Sandover River*, 1989

132. (*below right*) Ada Bird Petyarre, *Sacred grasses*, 1989

Caring for distant lands: Balgo

Balgo, on the edge of the Tanami and Great Sandy Deserts of Western Australia, was established in 1939 as a Catholic mission to cushion the effects of the developing pastoral and mining industries on the Aboriginal peoples of the region. The mission did not have such traumatic consequences for the local people as similar settlements elsewhere in the desert. The respect accorded Aboriginal customs and beliefs by the missionaries ensured their continuity.

The majority of those who moved to Balgo are Kukatja, Walmajarri, Warlpiri and Jaru language speakers. In cultural terms, the people of Balgo and the more recently established nearby settlements of Billiluna and Mulan are connected to the Pintupi and Warlpiri on the south and east, and to the Wangka-junga and Walmajarri whose land lies to the west in the Great Sandy Desert. They also have strong affiliations with the various groups in the Kimberley to the north. Not surprisingly, Balgo is a centre for major religious events.

The classical traditions of the art of Balgo are similar to those found elsewhere in central Australia. In the late 1950s soapstone and sandstone carvings of animals and objects were made, but this practice, briefly revived in 1981 and 1982, has since been discontinued, and painting is now the main art form.

Although from 1979 on a number of artists produced small portable paintings in acrylic and watercolour, the movement towards painting for an outside audience did not begin in earnest until 1986, with the exhibition *Art from the Great Sandy Desert* at the major art museum of Western Australia in distant Perth. Drawing on experiences of artists in other desert communities, those at Balgo keenly appreciated this opportunity to establish the nature of their relationship to the land in the eyes of the world at large. Significantly, one of the major contributors to the exhibition, Peter Sunfly (Sandfly) Tjampitjin, was a senior Kukatja ritual leader. Tjampitjin emphasizes his authority over this country with works such as *Sleeping at Naligudjana*, which 133 concerns two ancestral hunters (the double U-shapes) camping in the sandhills of Balgo. The more recent paintings from Balgo continue to be modest in scale, and now most artists favour a palette of deep hues, often offset by raw colours to create densely animated surfaces.

Wimmitji Tjapangarti was another for whom the significance of painting lies in its assertion of inherited authority over the country in the face of European intrusion. *The artist's country* 134

133. Peter Sunfly (Sandfly)
Tjampitjin, *Sleeping at
Naligudjana*, 1986

shows the main features of the land at Yapparry to the west of
Balgo. The rectangles in the painting represent hills and clay-
pans, with meandering creeks weaving their way around water-
holes and soakages. One of the Tingari group of ancestors was
an Old Woman who turned into a small bird, and her tracks are
depicted in the painting to establish the artist's connection with
these ancestral beings.

The linear arrangement of the elements in Wimmitji's paint-
ing is also evident in Donkeyman Lee Tjupurrula's *Untitled*. 135
This work is a comprehensive map of his particular country,
Walla Walla in the Pintupi lands close to Kiwirrkura. The paint-
ing focuses on the life-sustaining properties of water and impor-
tant ceremonial sites. The major topographical features and the
watercourses connecting them were created by the Tingari.
Three large sets of circles represent major soakages which are

134. (*opposite above*) Wimmitji Tjapangarti, *The artist's country*, 1989

135. (*opposite below*) Donkeyman Lee Tjupurrula, *Untitled*, 1989

136. (*right*) Susie Bootja Bootja Napangarti, *Kutal soakage*, 1989

also important ritual centres. They are surrounded by a string of lesser waterholes, joined by lines indicating rainfall and the grasses that provide the food-seeds which sprout after the rain. The significance of the sites depicted along the top of the painting is suggested by combinations of symbols: the sets of circles bracketed by black lines represent ceremonial places, while to the right an aggregation of symbols depicts caves in which the ancestral beings performed ceremonies, and where sacred objects are housed.

Experimentation and innovation in painting are more evident in the work of the Balgo women artists. Susie Bootja Bootja Napangarti creates a distinctive dynamism by emphasizing the diagonal journey lines which connect site-symbols in her paintings. In *Kutal soakage* the waterhole which is the home of a 136 Rainbow Snake responsible for storms and lightning is depicted at the centre. The area is known for a particular marbled stone whose patterns make up the ground of the painting. The animated surface evokes the violent and turbulent nature of the being who resides there.

The death of the Tjampitjin fighting man at Tjunta, by the 138 Warlpiri artist Patricia Lee Napangarti, relates the heroic events which led to ancestral energies entering the land at a site in her grandparents' country. A man of the Tjampitjin kinship group is shown as the inverted U-shape at the centre of the painting. A fearsome fighter, he stopped at a rockhole, the large circle at the top of the painting. The footprints in the smaller circle indicate the man standing in the water, drinking. He is challenged to a fight by a group of men shown by several U-shapes at the bottom. After a heroic battle the Tjampitjin succumbs to the wounds he receives. He is buried; the grave is shown as the oval shape on the right of the painting. Beneath the grave is a dish containing his hair which has been removed to be taken to his mother and sisters who will spin it into a hair-belt, as is customary. The significance of the event, the land permeated by ancestral essence, is suggested in the juxtaposition of the icons against a highly innovative and energetic ground of dripped and splattered paint. Such inventiveness sits comfortably within the classical traditions of desert painting. In *Tiddal in the Great Sandy Desert*, 139 Richard Tax Tjupurrula composes angular forms within a frame of traditional roundels joined by tracks. The central section represents a waterhole surrounded by cliffs.

Away from Balgo, another departure from traditional desert painting can be seen in the work of Linda Syddick Napaltjarri

137. Robert Ambrose Cole,
Untitled, 1994

(Pintupi, born 1941), Pantjiti Mary McLean (born *c.* 1930) and Robert Ambrose Cole who use traditional pictorial devices such as dotting for subjects which are not directly related to ancestral narratives. Linda Syddick's work focuses on Christian themes. The paintings of McLean, a Ngaatjatjarra woman, feature clusters of figures in flowing compositions which relate to her experiences as a musterer (cowgirl) on Western Australian cattle stations. Robert Ambrose Cole, on the other hand, produced 137 prints and paintings of highly esoteric nature. His works rely on the exact composition of layers of white dots to produce optical

138. (*opposite*) Patricia Lee Napangarti, *The death of the Tjampitjin fighting man at Tjunta*, 1989

139. (*above*) Richard Tax Tjupurrula, *Tiddal in the Great Sandy Desert*, 1994

effects in which patterns and figures may be discerned. Cole's work is formally related to that of traditional desert painters, especially the Pintupi, to express the spiritual through art.

The richness, subtlety and vigour of the art of the desert has become widely appreciated since artists at Papunya found the means to render its distinctive visual language in portable, permanent materials, and artists in the other desert communities adopted similar methods over the following decade. While artists across the desert share a common artistic heritage, their work displays a variety of approaches in carrying the classical idioms beyond the region to the world at large.

Chapter 4: Land of the Wandjina: the Kimberley

The Kimberley region in the north-western corner of the conti- ₃ nent is famous for the distinctive images of the Wandjina ances-tors, but is also home to a variety of styles of art whose spread was determined by the patterns of traditional exchange systems within the region. The diffusion process was accelerated from the end of the nineteenth century by the impact of European set-tlement and the changes this brought in the social conditions and mobility of the Aboriginal people.

The Halls Creek gold rush of 1886 and the establishment of the pastoral industry which followed led to the dislocation of Aboriginal family life and a series of massacres of Aboriginal people in the region. Despite this, traditional practices persisted as many Aboriginal people continued to live on their own lands, though now at the behest of the new pastoralist overlords. Forced migrations of people again became a reality in 1969 when laws granting equal wages to Aboriginal workers on the cattle stations resulted in wholesale evictions. People moved off the land to take up residence in towns and refuges.

The Great Sandy Desert is the ancestral home of the Walmajarri and related peoples. Their art is part of the contin-uum of the traditions of the desert, but also shows influences from the Kimberley and the central desert region. Many Walmajarri now find themselves living on land in the southern and eastern Kimberley to which they may have no ancestrally ordained connection, so that, as in Lajamanu and elsewhere in the desert, affiliations are formed to the local area and the con-nections with traditional lands are maintained largely through ceremony and its associated art forms.

The Tingari come to the southern Kimberley
One result of the migrations was that religious cults associated with the great ancestral Tingari beings have spread from the western deserts to the region. Often regarded as a group of ances-tral people with one or more dominant men or women, the Tingari travel across the land, and through events which occur at a par-ticular location, provide the place with spiritual connotations.

140. Ronta Lightning, *The Dingo and the Emu*, 1983

In *The Dingo and the Emu*, Ronta Lightning, a Jaru/ Walmajarri artist from Halls Creek, has chosen an episode from the great journeys of the Tingari as a means of asserting his connection to his country near Balgo, more than two hundred kilometres to the south. As opposed to the generally non-figurative renditions of Tingari subjects among Pintupi painters, the naturalistic depiction of this subject together with the annotations indicates the explanatory nature of the work. It is intended to be read by outsiders. The transformative powers of the Tingari are expressed through the multiple images of the two Dingo Ancestors in both animal and human form. They chase the Emu Ancestor along Sturt Creek until they reach Lake Gregory near Mulan. In the painting the landscape is shown both in plan view and in profile, as though seen from the riverbed which runs laterally across the painting and branches out to Lake Gregory in the lower section.

140

141. Jimmy Pike, *Jamirtilangu Parrija Purrku II*, 1987

The subject of *Moses and Aaron leading the Jewish people across the Red Sea* by Jarinyanu David Downs also relates to the Tingari. In much of Aboriginal Australia, people have integrated aspects of Christian mythology and the history of Europeans with models existing within their own cosmologies. Religious beliefs concerning the Tingari and associated beings provide ready models for Bible stories because of the Tingari's

143

142. Juwaliny, Mangala,
Manjiljarra, Walmajarri
and Wangkajunga people,
*Maparngujanka Ngurrara
(Painting this country)*, 1997

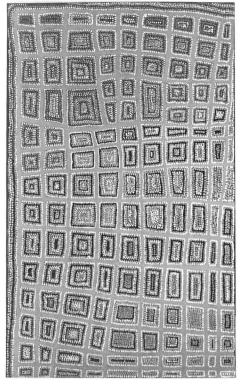

143. Jarinyanu David Downs, *Moses and Aaron leading the Jewish people across the Red Sea*, 1989

144. Peter Skipper, *Kurrkuminti Kurrkuminti*, 1987

importance and the concepts of metamorphosis they incorporate. In Downs's painting, Moses and Aaron are distinguished by the size of their footprints, corresponding to the great powers they possess compared to ordinary people. Against this, the Egyptians and their horses are shown schematically, drowning in the arc of the sea. The chalice-like forms which frame the upper half of the painting represent burning bushes. Downs's work follows the pictorial conventions of desert painting in depicting travel across the land in relation to events at specific sites, and in the planar view of the land.

In the pastoral town of Fitzroy Crossing where Christianity has been a force in people's lives, Downs was both a religious leader of the Wangkajunga and Walmajarri groups and a Christian. Downs's artistic repertoire includes Dreaming themes of major ancestral beings, but a body of his work reflects a personal response to Christianity. For Downs, both religions served similar purposes in revealing divine order in the cosmos.

The approach which draws on elements of the regional pictorial tradition and extends the parameters in a highly personal vision is characteristic of several artists of the region. It is especially evident in the work of Jimmy Pike, a Walmajarri man who came from Japingka and spent much of his time in the Great Sandy Desert. Pike started to make art for the market in 1980, and his artistic activity included a successful venture into the commercial world as a designer of fabrics for clothing and furnishings. His early work consisted of black-and-white linocuts and highly keyed non-figurative paintings whose designs are comparable to those found on engraved pearlshells that originate around Broome in the western Kimberley (p. 171). Pike's later paintings and prints recount traditional religious themes of the creation of the country.

Jamirtilangu Parrija Purrku II illustrates part of an ancestral 141 narrative in which social mores are linked to the creation of features of the landscape. The schematic images in the painting are set against a ground with no horizon, and depict a sequence of events. The painting concerns a boy who felt that he was constantly mistreated by his grandfather, recognizable as the face in profile with a beard and traditional hairstyle. The pair made a camp to shelter from an impending storm. The old man kept the best food for himself and took the driest spot, as befitted an elder. The boy refused to accept this arrangement, and an argument ensued. The boy ran away while the old man slept, taking his dogs and a firestick. In the morning the old man followed the boy and found him making camp, but the dogs attacked the old man and killed him. A rock in the sandhills marks the site of the attack, and is the transformed body of the old man.

In 1997 Jimmy Pike and Peter Skipper, along with Ngarralja 144 Tommy May (born 1935), Jarinyanu David Downs's widow Purlta Maryanne Downs (born 1945), and some 55 other artists working through Mangkaja Arts in Fitzroy Crossing, created a 10 by 8 metre painting mapping out their lands in the Great 142 Sandy Desert. Inspired by the Yirrkala bark petitions of the early 1960s (p. 17), the artists made the painting as evidence in Native Title Claim hearings in their ongoing attempt to have their ancestral connections to the country recognized in Australian law. The painting is an extraordinary achievement composed along the line of the Canning Stock Route. The main features of the work are the many waterholes belonging to each group through which individual artists can describe their relationship to their own country and to that belonging to adjacent peoples.

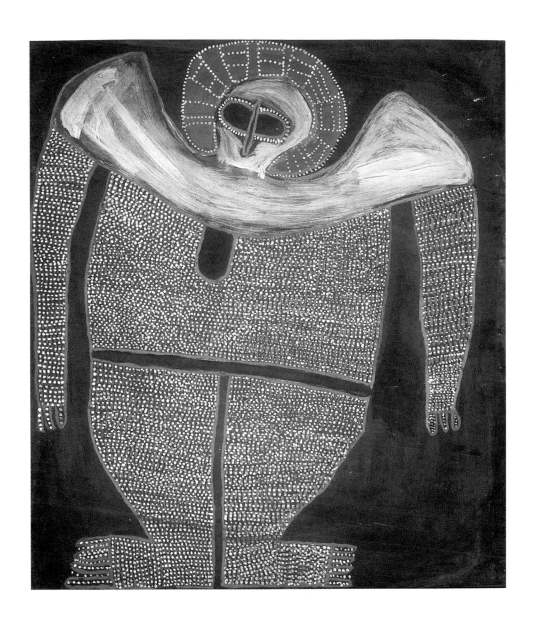

145. Alec Mingelmanganu,
Wandjina, 1980

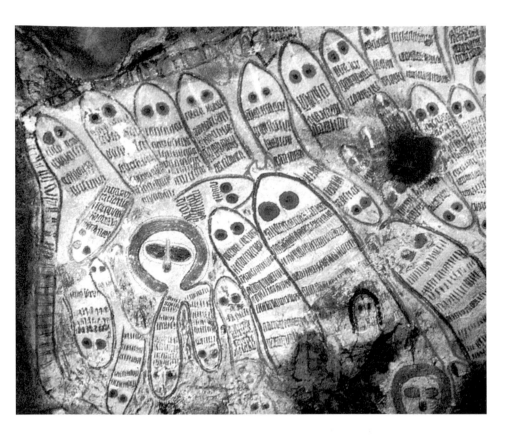

146. Wandjina figures painted on rock at Mandanggari on the Gibb River, Kimberley, Western Australia

The Wandjina

The central and northern areas of the Kimberley region are renowned for rock art which features Gwion Gwion figures, pre- 146 viously known as Bradshaw figures after the first European to record them, and the more recent Wandjina images. Gwion Gwion bear some resemblance to the 'dynamic' or 'mimi' figures found on the rock walls in West Arnhem Land; they are usually small, monochrome, animated human images. It is difficult to judge the antiquity of these paintings, but they are believed to be at least three thousand years old, and they predate the larger polychrome images of the great Wandjina and associated beings. The Wandjina, however, are a constant source of inspiration in contemporary times. The recent migrations of Wororra and Ngarinyin people from the central and northern parts of the Kimberley, southwards and westwards to Derby and Mowanjum, have spread the influence of the Wandjina beyond their original boundaries.

'Wandjina' is a generic term for a group of ancestral beings who come out of the sky and the sea. They bring with them the rains, control the elements, and maintain the fertility of the land and natural species. They have shaped the features of the landscape, and left their images in ochres and white clay on the cave and rock walls of the region. These impressive images can be up to six metres long. Artists belonging to the groups descended from the Wandjina regularly care for the images by repainting them to restore their brightness and preserve the spiritual essence of the ancestors, which is invoked in ceremony and in art.

A number of individually named Wandjina are distinguished, each with its own character and attributes. They exist along with a variety of associated beings such as benevolent and malevolent spirits, Lightning Men, women, pythons and other animal forms. Kaluru Wandjina are responsible for depositing the spirits of those about to be born in waterholes.

Wandjina-kaluru beings at Mamadai by the Ngarinyin artist 147 Charlie Numbulmoore shows the characteristic features of the Wandjina: the faces and bodies are white, the round black eyes have radiating lashes and, although the nose is indicated, the images are mouthless. The head is usually surrounded by a halo, thought to represent both the hair of the Wandjina and clouds, often with radiating lines which have been interpreted as feathers or the lightning controlled by the Wandjina. An oval shape in the middle of the chest may indicate the breastbone, although its form has affinities with pearlshell ornaments which originate in the western Kimberley. Not all Wandjina, however, have such a human form.

Images of Wandjina appear in a number of materials. They are painted on to slabs of sandstone and pieces of bark, engraved into pieces of slate coated with resin and cut into the hard shells of the nuts of the boab tree. Bark paintings seem to have first emerged in the Kimberley in the early 1930s in response to the demands of anthropologists working in the region. Paintings on bark were not produced on a regular basis until 1975, when stimulated by the work of Alec Mingelmanganu from Kalumburu, other artists in the region began to create characters or scenes drawn from their cosmological repertoire.

The imminent power of the Wandjina is expressed in the canvas by Mingelmanganu. The scale of the work is similar to that 145 of rock paintings of Wandjina. Mingelmanganu's stated ambition was to continue cultural practices and religious beliefs through his work; he saw his paintings as perpetuating the

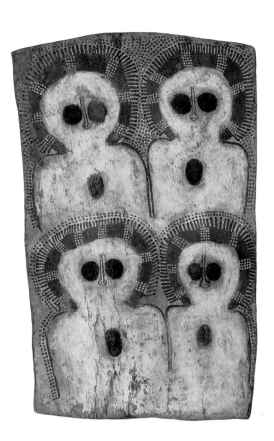

147. Charlie Numbulmoore,
*Wandjina-kaluru beings at
Mamadai*, 1970

power of the Wandjina in the same fashion as do regular restorations of rock paintings. Typical of the full-length figures of Wandjina, the body of Mingelmanganu's image is decorated in lines of dots similar to body-painting designs. They are intended to give the image a visual brightness which expresses the spiritual essence of the ancestral being.

The associations of the Wandjina with water, rain and the flashing of lightning, and consequently with the Rainbow Serpent, are also those of the highly prized pearlshell pendants 148, 149 from the western Kimberley. The coastal area around Broome is the source of decorated pearlshells which form a distinctive pictorial tradition in the art of Aboriginal Australia. The antiquity of both undecorated and engraved pearlshells has not been determined, but their production predates the arrival of Europeans. The introduction of metal tools and the arrival of the pearling industry in the latter part of the nineteenth century led to the proliferation of decorated pearlshells from about 1900.

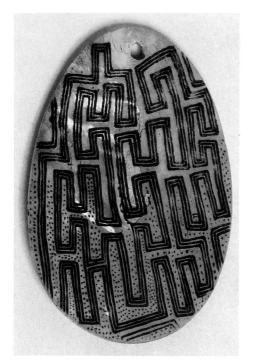 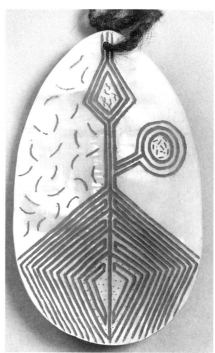

148. Pearlshell pendant collected in the 1930s

149. Pearlshell pendant depicting Min-nimb the whale, 1988

Pearlshells are used in a number of ways: for rain-making and magical purposes, for trade, in ceremonies, and as personal adornment, when they are worn attached by belts or necklaces of hairstring. Their lustrous quality evokes supernatural power and well-being, and equates with the aesthetic of shimmer and brilliance found in painting in Arnhem Land and in the desert. Both decorated and undecorated pearlshells are objects of great value, and are exchanged along trade routes over vast areas of the continent, appearing as far afield as Balgo and Yuendumu in the desert, Roper River in south-east Arnhem Land, Queensland and South Australia.

Historically, pearlshells have often been engraved at the point where they originated, introducing a number of local styles of decoration into the art form. In the Kimberley the designs of pearlshell fall into two general categories, the figurative and the geometric. The latter type encompasses a number of recognizable varieties, including parallel zig-zags, meanders and interlocking key designs. The meanings of the geometric designs are rarely known, although when interpreted they usually indicate

manifestations of water in its varied forms, including rain clouds, tidal movements and associated Lightning Snakes.

The early pearlshell pendant illustrated was collected in the 1930s and shows a variation on the interlocking key pattern. Typically the engraved lines will be filled with fat and red ochre or, as in this example, powdered charcoal, to highlight the design by giving it the appearance of an inlay. By and large, the production of decorated pearlshells for traditional use had ceased by 1970, although a collection was made for sale by young Bardi and Nyul Nyul men in 1988. The example shown carries a highly stylized image of a whale. Plain shells continue to be circulated inland, and old decorated shells are still highly valued. Plain shells will sometimes be incised at centres far removed from their points of origin.

Another feature of Bardi ceremonial regalia are dance wands called *ilma*. They are constructed from wooden frames around which strings of human and animal fur are wound in specific patterns and colours. The term *ilma* refers to the wands and to the dances in which they are used. For the public domain, Roy Wiggan makes vividly painted *ilma* from commercially available timbers and brightly coloured threads and cotton wool. A series of nine *ilma*, *The voyage of my father* is a set of constructed

148

149

150

150. Roy Wiggan, *The voyage of my father: Cape Leveque lighthouse*, 1991

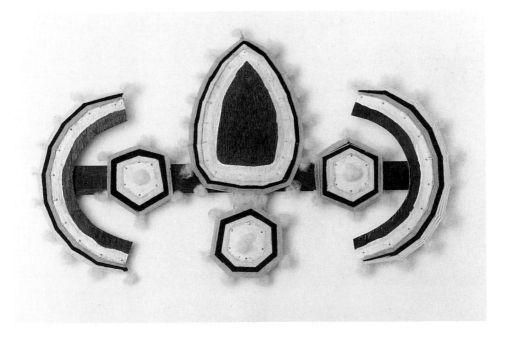

seascapes which describe an episode when the artist's father was chased out to sea by a powerful sorcerer, and his eventual safe return to land.

Bardi *ilma* are exceptional in that they represent features of the land, sea and natural phenomena such as the ebb and flow of tides, whirlpools and winds. The *ilma* illustrated shows the sea around the lighthouse at Cape Leveque, north of Broome on the western Kimberley coast. The circle at the top represents dangerous tidal currents, while the largest pointed shape is the meeting of the tidal currents which form a whirlpool shown at the centre of the *ilma.* The lower arc represents the outgoing tide.

Figurative sculpture has seldom appeared in the Kimberley, although wooden sculptures are known from Wyndham and Kalumburu, towards the east, and clay figures from Halls Creek. In the 1960s a Karajarri artist, John Dodo from La Grange, south of Broome, was commissioned by an elder to carve two wooden figures of the *rayi* (spirit) Walkarurra for a ceremony. Dodo continued to carve figures, and eventually began to sculpt heads in wood, clay and stone. He influenced a number of other artists to take up stone sculpture. Prior to this Dodo had engraved fine wooden ceremonial objects and pearlshells. 151

Dodo's sandstone sculptures relate directly to the Dreaming in two essential ways: the subjects are ancestral figures, and the stone that he carves was created through an epic ancestral event that occurred near Eighty Mile Beach, south of Broome. The Dreaming relates how a boy broke the law by eating the eggs of a goanna he had killed. This act enraged Pulanj, the Rainbow Serpent, who attempted to swallow the boy. Pulanj sent down rain and thunder, and the boy and his family took shelter in a mountain cave. After they had succeeded in blocking the mouth of the cave, the Serpent in his anger began to destroy the mountain, but eventually he gave up and departed. When the storm eased, the family emerged cautiously to find the ground strewn with pieces of rock from the mountain.

Revival in the eastern Kimberley: the Warmun community
There is no dividing line to separate the eastern Kimberley from the west. Given the historical movement of people throughout the region, the art of the east is part of the continuum of Kimberley art, associated with the Wandjina, but also with strong ties to Balgo in the desert, and through the Victoria River Downs area, into Wadeye in the Northern Territory.

151. John Dodo, *Kungolo*, 1987

The last two decades have seen a flourishing of artistic activity in the eastern Kimberley, the focus of which has been the community of Warmun at Turkey Creek. As at Papunya and elsewhere, events in the region show a contemporary development in Aboriginal art which is founded within traditional idioms.

The early 1970s were unsettling years. Amidst the social upheavals caused by the forced migration of peoples, Aboriginal elders were concerned that the younger generation was forfeiting its culture and law. On Christmas Day 1974, tropical cyclone Tracy destroyed Darwin, the capital city of the Northern Territory. An interpretation of this catastrophic event was revealed in a dream visitation to an elder at Kalumburu; the cyclone was a manifestation of a Rainbow Serpent who had destroyed Darwin, the main centre of European influence in the north of Australia, as a warning to all Aboriginal people to uphold their culture.

In the dream, the elder had revealed to him the songs and dances of a *palga*, or narrative dance cycle, concerning the

cyclone. The *palga* provides a vehicle by which the interpretation of such events can be revealed to the general public. The ceremonies that ensued were the beginning of a renascence of ritual activity and cultural affirmation across the Kimberley. For these ceremonies, constructions incorporating emblems or painted boards and structures of coloured threaded string or wool, commonly known as thread-crosses, are made and carried behind the performers' heads. Most prominent are the boards painted with a conventionalized image of the cyclone near Darwin, and a long thread-cross of the associated Wandjina in serpent form.

During the same period a Kukatja/Wangkajunga man at Warmun, Rover Thomas, had a visitation from the spirit of a female relative who had died, after a car crash, in an aeroplane taking her to hospital in Perth. At the moment of her death the aeroplane was over a whirlpool out at sea, in the Indian Ocean off Derby. The whirlpool is the home of another Rainbow Serpent, Juntarkal, who named sacred sites and gave people language right across the eastern Kimberley. The stories of the travels of the spirit of the deceased woman from the whirlpool to her conception-site near Turkey Creek were revealed to Thomas in the form of songs and dances, a new *palga*, called the Kurirr Kurirr (or Krill Krill). The spirit of the woman was accompanied by another being called Tjimpi, the spirit of a long-deceased woman. The Kurirr Kurirr painted boards carried images of Darwin and the cyclone, as well as of ancestral beings and places the two female spirits encountered on their journey.

As the owner of the ceremony, Rover Thomas did not paint any of the early boards, but instructed others, principally his mother's brother, Paddy Jaminji. *Manginta the Devil Devil* was 152 one of the boards used in the first Kurirr Kurirr. At a place that bears its name, Manginta replaced Tjimpi as the companion of the woman's spirit on the journey. The connection between spirit and place is expressed in the painting, which represents the horned head of Manginta while simultaneously suggesting the landscape, seen in plan view as a combination of conventional symbols. This visual duality is a characteristic of the art of the eastern Kimberley.

In the early 1980s, outside interest in the emblems used in the public ceremony encouraged artists to paint boards of subjects related to the Kurirr Kurirr and other themes, not for ceremonial use but for sale. As they were not to be carried in the *palga* the size of these paintings increased, and in 1986 the Warmun artists were introduced to canvas as a substitute for the original

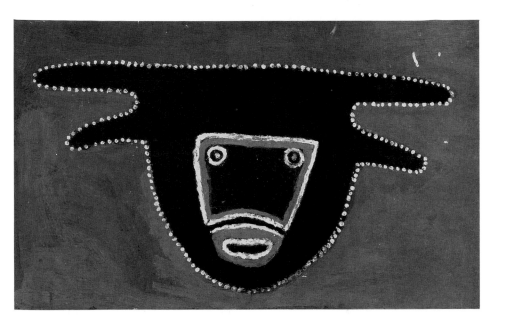

152. Paddy Jaminji, *Manginta the Devil Devil*, c. 1977, from the *Kurirr Kurirr* ceremonial series

wooden boards. In the early paintings, the Kurirr Kurirr *palga* provided the context in which the images operated; consequently the boards usually contained single images against monochrome red or black grounds. As paintings were made for sale, the images have become more complex, and the context in which the icons operate is provided by the painting and its associated text or story.

The subject of *Cyclone Tracy* by Rover Thomas recalls the origins of the Kurirr Kurirr ceremony. The black form represents the cyclone gathering intensity as it heads towards Darwin. The shape relates to conventional images of the subject developed in early dance emblems. Minor winds are shown as forms emanating from the main image. 153

Rover Thomas had begun painting Kurirr Kurirr emblems in 1981, and over the next decade pursued a vigorous and prolific artistic life which led to his selection in 1990 as one of the first two Aboriginal artists to represent Australia at the Venice Biennale (the other being Trevor Nickolls). Thomas elaborated on the pictorial conventions of the region to articulate a highly personal vision. He introduced an interplay between broad areas of natural colour, unfaltering line, bold forms, and uncompromising composition. In his paintings, the land becomes an allegory for ancestral dramas, personal experiences and historical events. 176

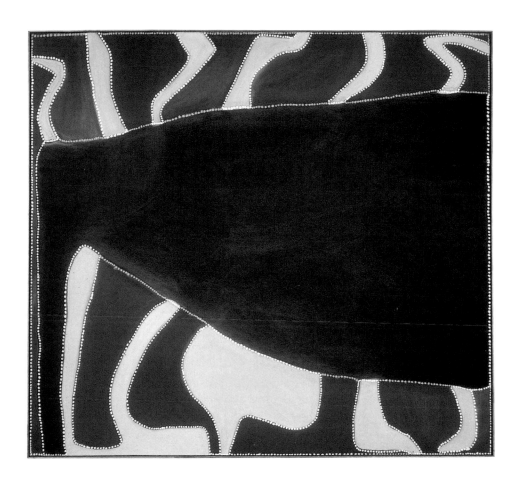

153. Rover Thomas, *Cyclone Tracy*, 1991

The paintings by artists from Warmun display some of the elements of the art of the desert, in particular the use of concentric designs such as circles to denote specific sites, lines of dots to describe shapes, and a planar view of the landscape. Among Warmun artists, however, the emphasis is on the depiction of the features of the environment created by the ancestors, rather than on the narration of ancestral events, as in desert painting.

Jock Mosquito Jubarljari's *Kawarrin* on the Kurirr Kurirr trail, for example, depicts the hills in profile as rows of arches, and sites as linked sets of concentric circles. Queenie McKenzie literally maps out the land belonging to her Kija people as series of rows of hills seen in profile. The setting for Jack Britten's *Purnululu (Bull Creek country)* is the spectacular sandstone canyons of the Purnululu or Bungle Bungle ranges near Turkey

155

154

156

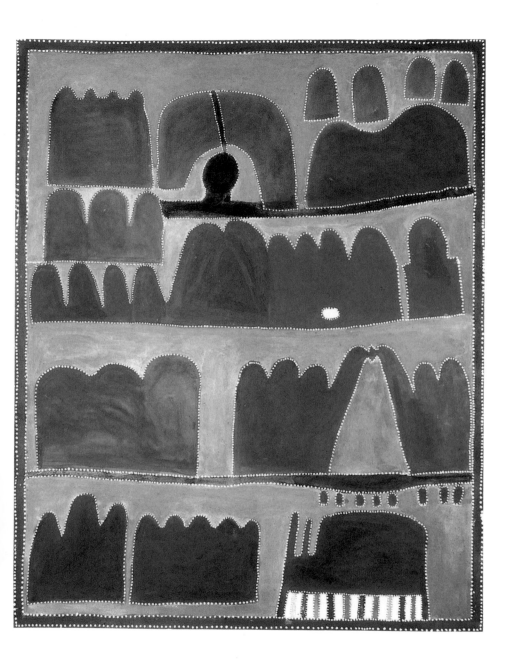

154. Queenie McKenzie, *Kija country*, 1995

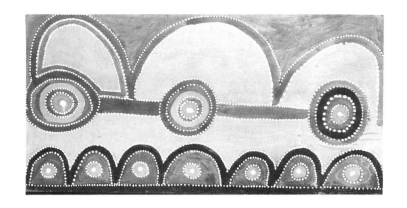

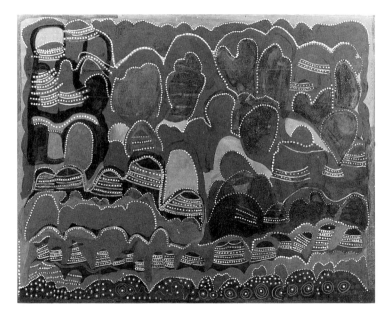

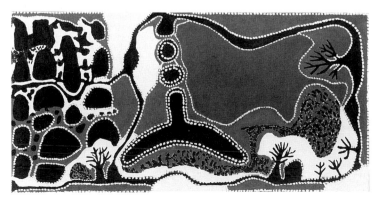

158. (*above*) Freddie
Ngarrmaliny Timms, *Blackfella,*
whitefella, 1999

Opposite:
155. (*above*) Jock Mosquito
Jubarljari, *Kawarrin*, 1984

156. (*centre*) Jack Britten,
Purnululu (Bull Creek country),
1988

157. (*below*) George Mung
Mung, *Binoowoon country*, 1990

Creek, the site of an encounter between two spirit beings. The
hills and valleys of Purnululu are depicted in profile. The alter-
nating rows of dots and lines echo the striated surfaces of the
cliff-faces while also referring to ceremonial body designs.
These lines are incised into the surface of the painting in a
zig-zagging motion, a technique similar to one used to engrave
boab nuts and pearlshell pendants.

The simultaneous use of different perspectives of the land is
evident in *Binoowoon country* by George Mung Mung. The 157
meandering black line at the right of the painting defines the high
hill surrounding the valley of Gandawarranginy in Binoowoon
country, south of Turkey Creek. This is where the ancestral
Crocodile walked in the Dreaming. Trees are shown in profile,
oriented towards an area of flat, undecorated ground and the
dominant curved shape of a site called Garnawoony, associated

with a toxic yam. In contrast, the black shapes indicating an area of rocky hills to the left offer a profile view of the landscape.

Freddie Ngarrmaliny Timms represents the current generation of eastern Kimberley painters who, as with their predecessors, expanded their repertoire of themes to comment on historical events and their understanding of the contemporary world. *Blackfella whitefella*, for example, is a derisory statement 158 on racism in modern Australia. The painting symbolically represents humanity as a hierarchy of political and financial power based on skin colour; the white man sits above the Asian and the African men, while the Aboriginal is at the bottom of the heap.

The art of the Kimberley, as seen through the artists mentioned here, is marked by a range of idioms and influences. The traditions of the Wandjina continue to pervade much of the area, while the Walmajarri and other desert people have introduced their own artistic styles. In a few years, the artists of Warmun fostered a school of painting begun in response to the need of Aboriginal people in the Kimberley to strengthen their culture in the face of adversity. Cultural renewal is marked by artistic activity throughout the Kimberley. Within the diverse artistic practices that make up the art of the region, a number of artists have developed distinctively individual approaches, Jarinyanu David Downs, Jimmy Pike, John Dodo and Rover Thomas among them.

Chapter 5: Diversity: North Queensland and the Torres Strait Islands

The art of the northern part of Queensland, including that of the peoples of Cape York Peninsula, Mornington Island and the Torres Strait Islands, represents a number of distinct traditions, each of which today incorporates many innovations. Culturally and historically, the region is not homogeneous. In parts of the Cape, Aboriginal people have maintained traditional links with their ancestral lands, while the people of the Torres Strait Islands have cultural affiliations with Papua New Guinea and their art traditions are distinctive. As a consequence, the region is characterized by a diversity of art styles, influences and practices.

A unifying art: Cape York Peninsula
The most enduring form of art in northern Queensland is found at Cape York Peninsula in the spectacular galleries of paintings and engravings on the rock walls and caves of the Laura district,

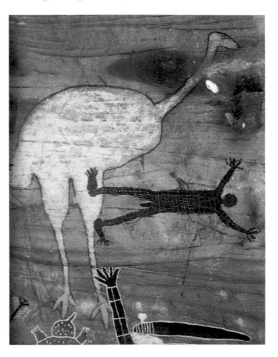

159. Paintings on rock wall in the Emu Gallery, Laura, Queensland

183

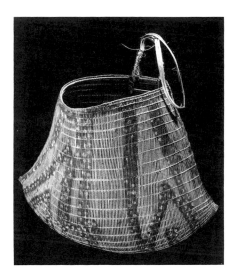

160. Unknown artist, shield,
collected 1897

161. Unknown artist, basket,
nineteenth century

north of Cairns. Engravings here have been dated to fifteen thousand years ago. The rainforest regions along the eastern coast are renowned for a range of painted clubs, throwing sticks, paddles, shields and weavings. In contrast to the figurative and often schematic images of Laura rock art, these objects are characterized by bold geometric or conventionalized designs, although some naturalistic images do appear.

Among the best-known rainforest art forms, perhaps because their broad, flat decorated surfaces are readily equated with European notions of painting, are men's fighting shields, used in initiation ceremonies and in battle, when the painted designs were intended to embody protective qualities. The range and variety of these conventionalized, often symmetrical designs suggest a highly developed visual language. The significance of these designs is not well known; however, a number have been described as denoting totemic species as well as objects such as boomerangs and carrying-bags. The same is true of the distinctive horned baskets woven from strips of lawyer-cane and painted with earth-pigments. The works shown were collected at the end of the nineteenth century from the Cardwell district near Cairns. In recent years, artists in the region have revived techniques and forms as part of a movement towards cultural renewal.

In the early 1950s boldly painted figurative sculpture emerged from Aurukun on the west coast of the Cape. Although simple sculptural forms from earlier times are known, the recent works

are often composite in nature. They are usually painted in broad areas of colour, similar to ceremonial body decorations, and represent ancestral beings in human and animal form. The sculptures are the foci around which ceremonial narrative dances are performed. The sculptural tradition continues today but it is generally restricted to ceremonial objects. Only a few sculptures have been made for sale outside the community.

While most Aurukun sculpture is overtly naturalistic, conventional forms do exist. *Kalben (Flying Fox Story Place)* by Arthur 162
Koo'ekka Pambegan senior and his son of the same name is a sculpture that was used in a public ceremony. The sculpture concerns two ancestral Flying Fox Men who broke the law by killing their own totem, the flying fox. The event is part of a saga about the continuous bickering and fighting among Flying Fox ancestors. The Men tied the flying foxes to a pole and attempted to cook them. In the sculpture, the long sticks represent black flying foxes and the short sticks are red flying foxes. The arrangement of this sculpture, two forked sticks supporting a horizontal bar, is similar in form to the bark huts and ceremonial structures used in the region and in Arnhem Land.

162. Arthur Koo'ekka Pambegan senior and Arthur Koo'ekka Pambegan junior, *Kalben (Flying Fox Story Place)*, 1962

Two Young Women of Cape Keerweer points to the contempo- 163
rary relevance of religion, ceremony and art in Aboriginal society. The sculpture was made for a ritual to release the spirit of a

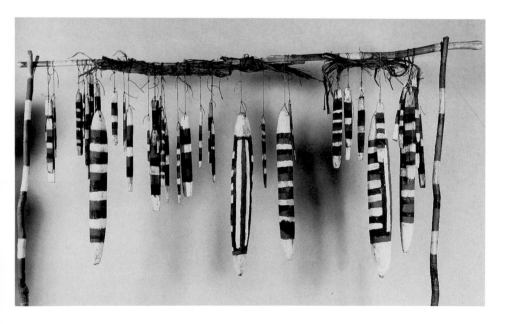

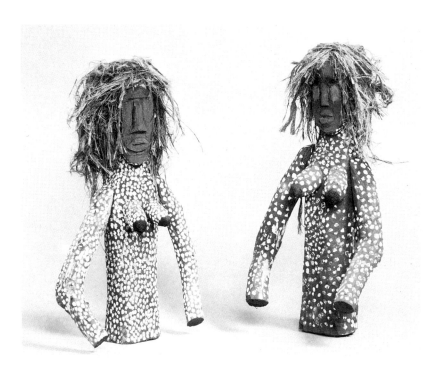

young man who died in the Aurukun jail. The subject of the
sculpture is two young Quail Women from different clans who
were caring for a sick child. The women sat on their adjacent clan
lands and each sang mourning songs which the other admired.
The child died but its relatives, all Bird Ancestors in human form,
refused to grieve for it. The women crossed an estuary and met
at the boundary between their clan estates, where they sank into
a cave and became sharks, causing the murky waters of the estuary
to clear. The child's relatives were transformed into bird beings.

The dotted body-painting design on the sculpture reflects the
sparkle of the clear waters of the estuary after the monsoon sea-
son and, as in desert art and the *rarrk* of Arnhem Land, the dots
impart a notion of brilliance indicating the presence of supernat-
ural power. In combination with the physical attributes of the
women the dots signify health, beauty and fertility.

The particular significance of the sculpture lies in the fact
that the Quail Women belonged to the Wik-Ngatharr and Wik-
Ngathan clans, as did the parents of the man for whose spirit the
ceremony was performed. The three artists who made the work
in collaboration also belong to these clans, Angus Namponan to

the Wik-Ngatharr clan and his assistants Nelson Wolmby and Peter Peemuggina to the Wik-Ngathan. By the collaborative nature of their work they reinforce the theme of social cohesion at a time of communal unrest expressed by the story of the Quail Women.

To the north of Aurukun, the town of Weipa is the birthplace of Thancoupie, one of Australia's leading ceramicists, and one of the first contemporary Aboriginal artists to be recognized in the international art world. While Thancoupie draws inspiration from the traditions of her people, the Thanaquith, she has developed a vehicle for personal artistic expression in her ceramics. There is no history of pottery in traditional Aboriginal society, although clay has a significant role in ceremonial activity and in art. The Thanaquith traditionally baked clay balls which were stored to make paint for use in rituals. Their affinity with clay has been translated into Thancoupie's spherical pots which are sym- 164 bolic of unity, fire and mother earth, and are decorated with images from traditional stories.

A notable recent development on the eastern coast of the Cape is the establishment in 1996 of an art and culture centre in the community at Lockhart River to train the younger members of the community. Artists work in a variety of media, particularly in prints and on canvas.

164. Thancoupie, *Garth Eran and Evarth Eran*, 1988

165
165. Goobalathaldin (Dick Roughsey), *Rainbow Serpent, Thwaithu dance, Mornington Island*, 1972

Narrative art: Mornington Island

The Lardil people on Mornington Island, in the south-eastern basin of the Gulf of Carpentaria, have associations with Aurukun to the east and with Groote Eylandt in the west. Since the 1950s bark painting has become a feature of Mornington Island art, showing some connections in style with the bark painting of Groote Eylandt. The most prominent painter from Mornington Island was Goobalathaldin (Dick Roughsey), who worked in a 165 number of media and also illustrated several children's books of ancestral stories.

The narrative nature of Mornington Island bark painting appears in *Two stories* by Kirk A. Watt, one of the current generation of artists. Watt depicts, in the upper panel, the Whirlwind 166 Man chasing a Brolga (Crane) Woman he intends to marry. She adopts the form of the bird, and flees. In the lower section, a Turtle Boy who has broken the law and run away from his people is depicted diving into the water. By singing, he transforms

166. Kirk A. Watt, *Two stories*, 1991

himself into a turtle and makes good his escape. In the centre of the painting, three Lardil people are fishing with spears and traps. The painting concerns metamorphosis, the great spiritual theme common throughout Aboriginal Australia. In the case of the Turtle Boy, the metaphor of entering and emerging to effect the transformation is expressed through the image of the hollow log.

The figures here are rendered naturalistically and set against a decorated ground of dots, although patterns of dashes, similar to those in recent Groote Eylandt paintings, are also found in Mornington Island bark paintings. The use of dots in *Two stories* links the work with the art of Aurukun, while the division of the painting into panels and the centrally placed waterhole reflect the influence of Arnhem Land. The work also displays a degree of innovation in the treatment of the figures; they are highly animated with details of physical features, and several figures are shown in profile with an indication of perspective in the European sense.

Moving images: Torres Strait Island art

The more-than-one-hundred islands of the Torres Strait, of 3 which only a few are permanently inhabited, once formed a land bridge between Aboriginal Cape York and Papua New Guinea. While Island culture bears affinities with both Papuan and Aboriginal cultures, it is distinct from either. Today many Islanders live on the mainland, particularly in northern Queensland, but social contacts with Papua are maintained. Contact with Europeans was intermittent until the London Missionary Society established itself on Erub (Darnley Island) in 1871, heralding the spread of European influence throughout the islands. Over the decades the cumulative effect of missionary prohibitions and colonial rule disrupted but did not eradicate traditional practices. In recent years Islanders have had some of their ownership rights to land recognized; in 1992 Islander people gained native title to their land and coastal waters in a landmark decision known as the Mabo case, brought by four Murray Islander elders including Eddie Mabo. For the first time since the British declaration of *terra nullius* at the beginning of colonization, indigenous Australians' ownership of the country prior to the advent of European settlement was officially recognized. The process of cultural renewal which has underpinned such events in recent years has been marked by a flourishing of art practice by Torres Strait Islanders.

167. *Krar* (mask), nineteenth century

168. Ken Thaiday senior, *Beizam (shark) dance mask*, 1991

In common with Aboriginal Australians, the Islanders' cultural history is primarily transmitted orally and through ceremonies which provide the stimulus for the production of many of the plastic arts. Among the ritual accoutrements are masks, 167 articulated headdresses and dance accessories, drums and woven items. In the eastern islands elaborately carved and incised turtleshell once formed the basis for spectacular dance masks. Turtleshell masks were observed by the explorer Torres in 1660. Nearly four centuries later the drums and masks of the Torres Straits were the first types of Australian plastic arts to make an impact on the artists of the Surrealist movement in Paris.

The tradition of mask-making for ceremony continues today with artists adopting modern materials in their construction. Ken Thaiday senior from Erub constructs headdresses and hand-held 'dance-machines' for use in public ceremonies. As with their forerunners, Thaiday's constructions are articulated to enable the dancer to move parts of the mask during the performance. *Beizam (shark) dance mask* is constructed of plastic and 168

169. Jenuarrie, *Our time has begun*, 1986

plywood, showing the jaws and teeth of a shark which hide the wearer's face. The menacing presence of the shark, a symbol of law and order, is mitigated by the rows of feathers attached to the jaws. In the upper half of the mask is the figure of a hammerhead shark, which can also be manipulated by the wearer.

In 1984 the opportunities for Islander and Aboriginal people of the region to develop their art were enhanced by the establishment of an art school in Cairns, dedicated to their needs. The school was set up by European art teachers, although the prominent Aboriginal potter Thancoupie was one of the original instructors. Students are encouraged to work in a variety of media and to draw on their local traditions; for example, Jenuarrie's batik *Our time has begun* is influenced by the Quinkan 169 figures found in the rock art of the Laura district. The print- 159 makers Denis Nona and Alick Tipoti (born 1975) and the painter 170 Brian Robinson (born 1973) are among the many graduates from Cairns who draw their inspiration from traditional visual languages and ancestral narratives.

170. Denis Nona, *Naath*, c. 1995

Today, for many Islander artists the Cairns art school has proved a springboard to study and work elsewhere around the country. Nonetheless, many Islander artists have remained in the Torres Strait where they continue to develop traditional techniques and forms. In 2000, the touring exhibition *Ilan Pasin* proved a watershed in the appreciation of historic and contemporary Islander art, whether it is made using traditional visual lexicons or more universal forms and techniques such as those preferred by many indigenous artists living in urban and rural areas throughout Australia.

Chapter 6: Artists in the town and city

Aboriginal people living outside traditional environments have played a significant role in the renascence of Aboriginal culture in the second half of the twentieth century. The period has witnessed the rise to prominence of artists from urban and rural backgrounds whose links to their cultural heritages have been, to varying degrees, severed by the impact of colonization and decades of official policies of family separation and assimilation. While their art proclaims their Aboriginal identity – indeed, it often acts as a medium for cultural renewal – it often operates beyond the classical idioms. It does not conform to one style, but draws inspiration from Aboriginal practices and European and other visual languages and techniques alike. This art reflects a unique perspective born of a distinctive experience.

Such urban and rural Aboriginal artists have been seen as on the periphery of artistic practice in Australia. When seeking to accept Aboriginal art, Australian society at large perceived traditional forms alone as the authentic expression of Aboriginality. At the beginning of the century, for example, the value of the *toas* (pp. 105–6) was considered to lie in their antiquity as forms of Diyari art. The first acrylic paintings from Papunya were regarded in many quarters with suspicion. Authenticity was equated with tradition, and the value of the object lay in its expression of a time and culture gone by rather than in its relevance as a reflection of contemporary circumstances. As a consequence, urban and rural artists who did not fit into any preconceived categories were denied the opportunities open to other Australian artists, and their work was largely ignored.

The phrases 'urban' and 'rural' Aboriginal are generally used to refer to artists who prefer to describe themselves by local generic words for Aboriginal, the most common of which are 'Nyoongah' in south-western Australia, 'Nunga' in coastal South Australia, 'Murri' in the north-east and 'Koori' in the south-east. In addition, artists often identify their particular language group to establish their cultural identity. The descriptions 'urban' and 'rural' are, at best, useful terms to denote not a style of art but the social milieu of the artists.

The political and social breakthroughs of the 1960s and 1970s saw the end of the policy of assimilation of Aboriginal people into the dominant European culture, and laid the groundwork for the official recognition of Aboriginal culture. The emergence of urban and rural art has been part of this process of change. The origins of such art, however, can be found in the nineteenth century.

Some of the precursors of today's urban and rural artists emerged from the south-eastern corner of the continent where the first impact of European colonization was keenly felt. South-eastern Australia, as other areas, has a rich heritage of traditional art forms, many of which are common to most of Aboriginal Australia, though some types are peculiar to the area. The carving of trees as grave or ceremonial ground markers in New South Wales and the making of mantles from decorated possum skins are distinctive practices. Besides rock engraving and painting, 4,9 body painting and ground painting in ceremony, painting or drawing on bark is also known, although only two barks from mid-nineteenth-century Victoria survive. Of these, one from near Lake Tyrrell, made in the 1860s, is executed in a naturalistic fashion to show scenes of hunting and fishing, a ceremony or fight, and a squatter's house as evidence of European presence.

In the mid-nineteenth century, new forms of Aboriginal art began to develop at the interface of Aboriginal and European cultures. The tradition of drawing as seen on bark and rock continued in the work of a number of artists using the introduced materials of ink, pencil, paper and board. William Barak and Tommy McRae, the best known of several artists working at the time, produced drawings which were commissioned from them by European settlers.

William Barak was an elder of the Wurundjeri people who lived on the site of the present city of Melbourne. When, in 1863, the Wurundjeri were resettled at nearby Coranderrk, Barak began to draw images primarily of ceremonial life. *Corroboree* 171 depicts a ritual where figures draped in possum-skin mantles are formally arranged in rows. Barak's concern with naturalistic representation appears secondary to the expression of the organized relationships between the participants in the ceremony, reflecting relationships on the social and ancestral planes.

Tommy McRae lived on the upper Murray River in northern Victoria, and from the 1860s on, he found a number of patrons who supplied him with the materials to draw scenes of hunting, fishing and ceremonies, as well as other images of contemporary

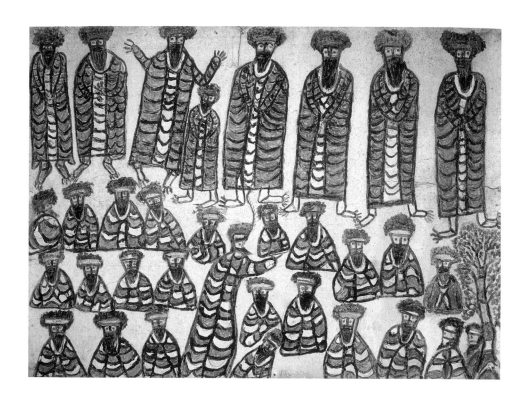

171. William Barak, *Corroboree*, c. 1885

life. McRae's work was well regarded, and examples were used to illustrate two volumes of Aboriginal stories published in 1896 and 1898. McRae imbued his thin silhouetted figures with individual character and expression. The arrangement of the figures in a page from his sketchbook (*c.* 1890) shows dancers accompa- nied by an orchestra which includes a Chinese fiddle-player and a drummer. The composition diverges from the formality of Barak's ceremonial image, and indeed from McRae's own drawings of rituals. In this drawing, apart from their clothing and the musical instruments, the jaunty postures of the figures and their loose alignment in rows suggests a scene of revelry rather than ritual.

The fact that Aboriginal artists such as Barak and McRae were commissioned by and sold their work to Europeans is significant in the history of relations between the two groups. Despite the prevailing attitudes towards Aboriginal people, these artists could command a place in the new environment. In addition, their work provides rare Aboriginal commentaries on nineteenth-century life in the rapidly changing Australia. Their

art embodies cultural ideals and perspectives which are an important part of the heritage of urban-based artists today.

The Australian art establishment in the first half of the twentieth century was still concerned with European models from the previous century, and virtually ignored the revolutionary developments in Western art. While the Cubists, Surrealists, Dadaists and others found avenues for release from the tired artistic structures of Europe in the forms of African, indigenous American and Oceanic art, Australians were more interested in the official art of the Salon. With a few exceptions, the work of Aboriginal artists living in the urban and rural areas who continued to elaborate on traditional techniques such as weavings and decorated boomerangs was regarded by the Australian art world as a manifestation of a degenerate tradition, or as kitsch. Despite this, the persistence of art practices among urban and rural people has proved significant in the flowering of art in the late twentieth century.

The popularity of the work of Albert Namatjira in the 1950s 92 was a source of inspiration to urban and rural artists, who

172. Tommy McRae, page from a sketchbook, c. 1890

sought role models where these were sadly lacking. Ronald Bull (1942–79) from Melbourne and Revel Cooper (1933–83) from the Aboriginal settlement at Carrolup, outside Perth, both regarded as painters in the European landscape tradition, gained a degree of recognition in their lifetimes, and showed the potential for urban artists to break through the barriers of prejudice.

The first wave

In the second half of the twentieth century, as the movements for the recognition of Aboriginal rights gained momentum, urban and rural artists found compelling reasons to produce art. Aboriginal people required imagery and symbols with which to express their ideals and aspirations. The issues of dispossession, broken families, racism – the secret history of Australia – and an intensification of the sense of cultural identity provided strong motivation, and these themes are all part of the repertoire of artists.

The 1970s was also a period of change in Australian culture generally and in Australian art in particular. New government initiatives promoted the arts and offered financial and practical support for a greater number of artists. A broadening of the concept of what constituted art saw an explosion of activity in areas previously deemed the lesser arts. Ephemeral arts such as performance art and the multiple forms of photography and printmaking became popular vehicles for expression because of their potential to reach wide audiences.

The print, as a relatively simple and inexpensive way of creating multiple images, became an attractive medium for urban artists. The era saw the establishment of community print workshops across the country to which Aboriginal artists had access. Avril Quaill produced the screenprinted poster *Trespassers keep* 174 *out* at the Earthworks Poster Collective in Sydney. Quaill's image is based on the unifying symbol of Aboriginal Australia, the Aboriginal flag, designed in 1971 by the artist Harold Thomas (born 1947). In the circle of the yellow sun of the flag, an old Aboriginal man crouches defiantly against a typical white Australian suburban picket fence bearing the ironic admonition of the title.

Alice Hinton-Bateup, working through the Garage Graphix print workshop in Sydney, combines words and imagery to express a sense of loss of heritage and a call for social justice. *Dispossessed* is another poster boldly revealing the plight of 175 Aboriginal people and proclaiming Aboriginal ties to the land.

173. Kevin Gilbert, *My father's studio*, 1965, reprinted 1990

The text speaks of the institutionalized movement of Aboriginal people for reasons of 'poverty, harassment or white housing policy'.

The first Koori printmaker, Kevin Gilbert, began working in the period before the establishment of widely accessible facilities, and before Aboriginal art generally had made an impact on the consciousness of the Australian public. Gilbert, a Wiradjuri poet, playwright, social activist and artist, produced a set of linocuts between 1965 and 1969 which were reprinted in 1990. As in his writings, the subjects concern the maintenance of traditional values in the quest for social justice and equality in modern Australia. 173

In the 1970s Thancoupie and the painter Trevor Nickolls were pioneers in establishing a place on the Australian scene for artists working outside the classical Aboriginal traditions. Their achievements opened the way for others to follow. 164, 176

Nickolls had been an art student in Adelaide, and while he cared little for the institutionalization of art, he accumulated a wealth of influences as diverse as Giotto, Cubism and Surrealism at a time when hard-edge abstraction held sway in Australian art. However, Nickolls chose his Aboriginality as his main subject, and he set about expressing in paint the dilemmas facing the

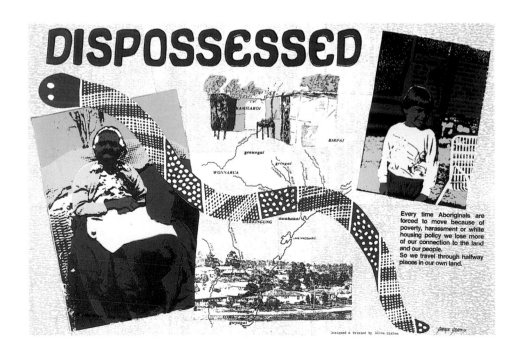

individual caught between two cultures and isolated from both. Alienation is the theme of the *Dreamtime/Machinetime* series of paintings, begun in the period 1978 to 1981, in which Nickolls developed a personal lexicon of imagery. The turning point in Nickolls's career came in 1979 when he became acquainted with the Warlpiri artist Dinny Nolan Tjampitjinpa. Through Nolan, 97 Nickolls learnt about desert painting. In 1981 Nickolls went to live in Darwin where he could experience at first hand the art of Arnhem Land. As he became familiar with traditional art practices, Nickolls found inspiration in the formal elements of classical Aboriginal painting.

By the time he painted *Waterhole and trees* in 1986, Nickolls 176 had moved back south to Sydney. Although more strident images were to follow, the work embodies a reconciliation of stylistic influences; it pays homage to the classical Aboriginal idioms while reinforcing the artist's personal vision. The painting depicts a formally arranged landscape with the waterhole at the centre and four trees arranged symmetrically around it. The ground is made of clusters of coloured dots which flatten the landscape against the picture plane in a manner reminiscent of the planar view of the landscape in desert painting. However, the perfectly circular waterhole is seen in perspective as an ellipse, and the trees cast shadows indicating the three-dimensional nature of the space. The pictorial depth of the image is emphasized by the boomerang shape and the shadow it casts which continues beyond the picture frame.

Nickolls was one of nearly thirty artists represented in *Koori Art '84* at the Contemporary Art Space in Sydney, a watershed exhibition for urban Aboriginal art and artists. The show articulated the concerns of Aboriginal artists working outside the traditional Aboriginal framework, but also included non-urban artists using European media and techniques: Banduk Marika's 49 prints, Turkey Tolson Tjupurrula's and Johnny Warangkula 102, 98 Tjupurrula's experiments with landscapes in the European manner, Ernabella batik and contemporary watercolours from 89 Hermannsburg, among others.

Koori Art '84 also brought together several artists who had been working in isolation yet had much in common. All lacked opportunities to have their work seen and shared similar aspirations. From the exhibition developed the Boomalli Aboriginal Artists Cooperative, formed in 1987 by Sydney-based artists to provide studio and exhibition spaces as well as to promote the work of its members.

174. Avril Quaill, *Trespassers keep out*, 1982

175. Alice Hinton-Bateup, *Dispossessed*, 1986

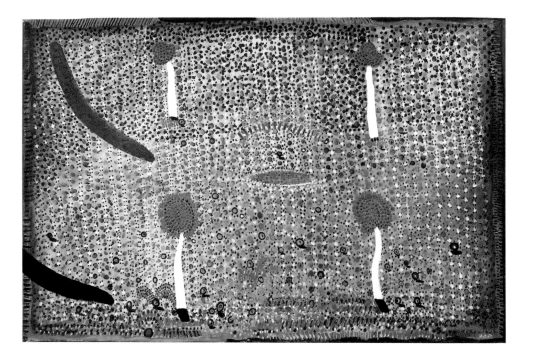

176. Trevor Nickolls, *Waterhole and trees*, 1986

177. Jeffrey Samuels, *This changing continent of Australia*, 1984

Institutional acceptance of the work of Koori artists began. One work in *Koori Art '84*, Jeffrey Samuels's *This changing continent of Australia*, was acquired by the Art Gallery of New South Wales. The painting, composed of repeated silhouettes of the continent of Australia, reflects the traditional Aboriginal theme of identification with and definition of one's own land. It also heralded a new age for urban artists across Australia. 177

As with the print, the photograph became a popular and powerful means of visual communication for indigenous artists. The photographs of Mervyn Bishop, Tracey Moffatt, Brenda L. Croft and Michael Riley present a powerful alternative to the negative stereotypes of Aboriginal people seen in popular imagery and in the daily press. Starting out as a press photographer in Sydney in 1963, Bishop's career represents an inversion of the prevailing relationship between indigenous Australians and the hand that holds the camera. Previously Aboriginal people had been simply the perennial subjects, often depicted for scientific purposes, as curiosities, and especially in the press, as objects of pity. From behind the camera, Bishop was able to take control of the photograph. Images of Aboriginal successes in the media 178, 1

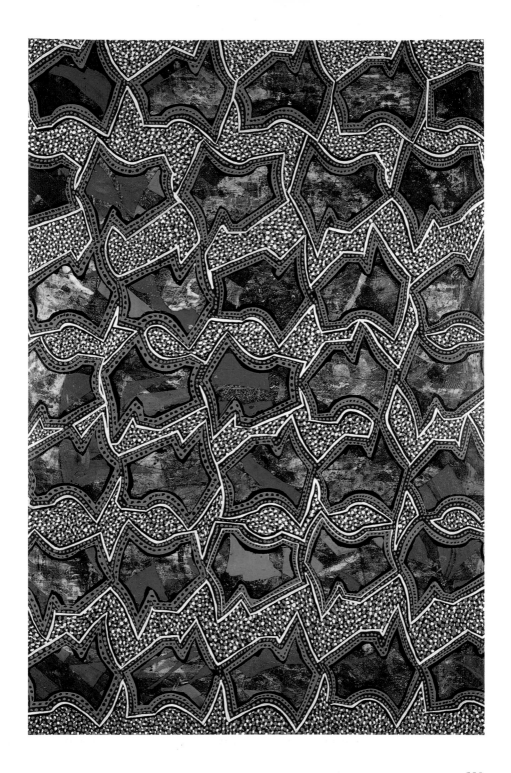

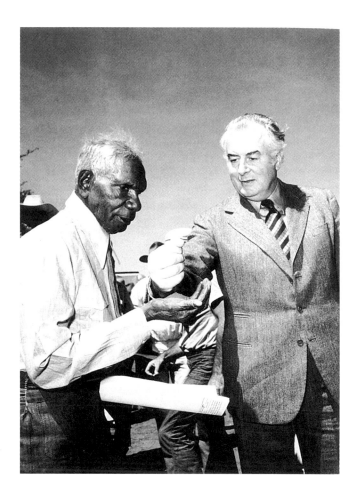

178. Mervyn Bishop, *Prime Minister Gough Whitlam pours soil into hand of traditional owner Vincent Lingiari, NT*, 1975

were rare, but his famous photograph of 1975 epitomizes a dif- 178
ferent perspective; in this case the success of the Guringji people
in gaining back their traditional lands in what had become a
cause célèbre of the land rights movement. Bishop went on to
inspire an emerging generation of Aboriginal photographers.

Riley's studied portraits of Aboriginal people such as *Christina* 179
emphasize the beauty and dignity of individuals, as opposed to
the voyeuristic and anonymous images which proliferate in the
public domain. Croft records the Aboriginal struggle from the
perspective of the Aboriginal as hero, rather than villain as usu-
ally portrayed in the popular media. The defiant figure of *Michael* 180
Watson sports a shirt which ridicules the claiming of Australia
for the British by the sea captain James Cook in 1770. The occa-
sion of Croft's photograph was another significant moment in

179. Michael Riley, *Christina*, 1986

180. Brenda L. Croft, *Michael Watson in Redfern on the Long March of Freedom, Justice and Hope, Invasion Day, 26 January 1988, Sydney, NSW*, 1988

the Aboriginal political struggle when Aboriginal people from all over Australia gathered in Sydney in a demonstration of cultural strength on the day Australia was celebrating two hundred years of European colonization.

One of the original Boomalli artists, Tracey Moffatt, has emerged as a world-renowned photographer and film-maker. She works in series and the staged tableaux of her photographs imply a narrative or multiple, simultaneous narratives. In an inversion of stereotypical perceptions of Aboriginal art – where every picture must tell a story – Moffatt's work relies on the viewer to put together the narrative.

Fiona Foley seeks inspiration within the traditional cultural setting, in particular from the culture of her own people, the Badtjala from Fraser Island in Queensland. *Annihilation of the blacks* is a potent allegory of the treatment of Aboriginal people at the hands of the colonizers; a white figure stands watch over a

181. Fiona Foley, *Annihilation of the blacks*, 1986

182. Bronwyn Bancroft,
The marine cape, 1987

group of hanging black figures. The structure of the work
reflects classical ceremonial sculptural forms such as the *Kalben* 162
(Flying Fox Story Place) from Aurukun.

The paintings and sculptures of Lin Onus are executed in a
hyperreal manner to juxtapose images drawn from Aboriginal
Australia with those of western culture. Onus, like Foley, sought
direct exchange with artists living in traditional communities,
and was one of several artists who made pilgrimages to Arnhem
Land and other art provinces. Onus's installation *Dingoes* con- 183
sists of sets of fibreglass dogs painted in stripes of red, yellow,
black and white, the four basic Aboriginal colours. The sculpture
is a sympathetic but ironic comment on popular perceptions of a
much-maligned indigenous dog: the word 'dingo' has entered

183. Lin Onus, *Dingoes; dingo proof fence*, detail from the series *Dingoes*, 1989

Opposite:

184. (*above left*) Bluey Roberts, *River spirit*, 1992

185. (*below left*) Arone Raymond Meeks, *Healing place*, 1988

186. (*right*) Euphemia Bostock, *Possum skin print*, 1990

non-Aboriginal Australian parlance to mean a despicable person or a coward. In one detail, the spirit-dog breaches the dingo fence which runs across thousands of kilometres of the country to protect introduced grazing animals, cattle and sheep, and serves as a metaphor for the treatment of Aboriginal people.

The first wave of urban artists work in a variety of media. Bluey Roberts continues the tradition of decorating boomerangs 184 in highly innovative ways. His work includes engraving the multi-layered shells of emu eggs. Euphemia Bostock's fabric length *Possum skin print* translates images based on decorations 186 found on possum-skin mantles, once common in the south-east of the country, on to fabric that is also intended to be worn. The painter and fabric designer Bronwyn Bancroft's hand-painted *The marine cape* features a large octopus whose tentacles stretch 182 out to protect the oceans from pollution. The concern to continue traditional narratives through images is evident in the work of a number of urban artists, including Arone Raymond Meeks's lithograph *Healing place*. Ellen José continues to explore 185 the history of her Torres Strait Islander ancestors through a variety of means including painting, installations and video. 187

Byron Pickett and Sally Morgan were among a group of Nyoongah artists from Western Australia that made an impact

187. Ellen José, *In the balance*,
1993, video still

188. Sally Morgan, *Moon and
stars*, 1987

With pride, my children will use the names of our ancestors.

'Nyoongar' 'Njamanji'

FELLOW AUSTRALIAN

189. Byron Pickett, *Fellow Australian*, 1985

in the art world at the same time as their counterparts on the east coast. Sally Morgan's colour screenprint *Moon and stars* relates to traditional beliefs and includes the image of the Rainbow Snake. In other works, Morgan explores her family's history of survival in an often antagonistic and threatening society. Byron Pickett's *Fellow Australian* expresses the sense of pride in Aboriginal culture and its continuity. It also appeals for the equal treatment of Aboriginal people. The quest for equality and justice within Australian society as a whole has been a resonant and recurring theme in the work of the first wave of urban Aboriginal artists. 189

The second wave
The pioneering efforts of the first group of urban artists during the 1970s and 1980s created opportunities for urban and rurally based artists and a wider interest in their work. The second wave emerged in the late 1980s, and included Robert Campbell junior, whose stated ambition as a painter had been to record Aboriginal history for his family. By 1987 his work was receiving wider

190. Robert Campbell junior,
Aboriginal embassy, 1986

scrutiny. Campbell worked in the manner of a social commentator, depicting episodes of Australian history as seen from the Aboriginal perspective. His art deals with a wide range of subjects, from pre-European Aboriginal life to commentaries on racism through images of segregated picture-theatres and whites-only swimming pools.

Campbell also documented significant moments in Aboriginal history. *Aboriginal embassy* was painted fourteen years after the dramatic events which forged a change in official attitudes to Aboriginal land rights. A tent embassy had been set up outside the federal parliament building in Canberra in 1972 to highlight the dispossession of Aboriginal people and the denial of sovereign rights to their land. The painting displays the characteristics of Campbell's work – the sequential narrative and the depiction of the figures, usually naked, to show the oesophagus. The top panel depicts the protagonists and their supporters, who are shown being arrested in the lower section. The intensely rich decoration on each of the elements animates the

190

painting surface and has parallels in the fine engravings on shields, clubs and boomerangs of south-eastern Australia.

The Aboriginal perspective on Australian history and society is also a theme in the work of Gordon Bennett. Bennett's analysis of contemporary Australian culture reveals the extent to which negative stereotyped images of Aboriginal people are used as a vehicle for propaganda and social conditioning. Bennett constantly juxtaposes familiar images of Aboriginal Australia and western art to lend both new meanings. *Outsider* is a metaphorical 191 attack on the citadel of European art. The headless Aboriginal figure, in full ceremonial body paint, infiltrates one of the western world's icons, van Gogh's *Vincent's Bedroom at Arles*, 1889. The figure has crashed through the window to stand menacingly over two classical heads lying on van Gogh's bed. Blood spurts into the swirls of van Gogh's *Starry Night* of 1889. Despite the assault, Bennett's admiration for van Gogh's achievement is undisguised.

191. Gordon Bennett, *Outsider*, 1988

192. Karen Casey, *Got the bastard*, 1991

The writing of history by the dominant culture is a subject of the work of Tasmanian-born Karen Casey. *Got the bastard* depicts 192 a burly hunter with a gloating expression holding a rifle across his lap, while to his right in the dim light hangs the carcass of a Tasmanian tiger, a now-extinct marsupial. The image refers to the systematic hunting down of Tasmanian Aboriginal people in the early part of the nineteenth century, an exercise so effective that the Tasmanian Aboriginal population was believed to have been exterminated by 1876. The placing of the symbol for the oppressed, the tiger, in the half-light of the background suggests that the story of the oppression of Aboriginal people has been deliberately hidden in Australia's official history. *Got the bastard*

193. Judy Watson, *Heartland*,
1991

When I was a teenage boy at Gerard Mission and just started worcking we were tought how to put a crop in we were getting that good that we used to put in a crop after darck while the weather was cooler.

Ian.W. Abdulla

194. Ian W. Abdulla, *Sowing seeds at nite*, 1990

also has more universal implications, in commenting on the aggressive and wanton destruction of the environment through misunderstanding and ignorance.

In the paintings of Judy Watson, history is embedded in the land which is marked with the evidence of past events. Watson focuses on the processes of art-making in Aboriginal Australia. The concepts linking land, family and history are expressed in her work. Washes of paint and marks in dry pigment combine to produce textures of stone, water and earth, and refer to the presence of her ancestors in the land. Paintings such as *Heartland* 193 are tactile maps of her ancestors' country of north-western Queensland.

The personal life experiences of rural people provide a rich source of inspiration for artists. Ian W. Abdulla's work records childhood memories of growing up on the fringe of Australian society, in this case in the Coorong on the lower Murray River, near Adelaide. In *Sowing seeds at nite* the tractor lights illuminate 194 the ground, allowing the planting to take place in the cool night air. Abdulla's preoccupation with recording family history is expressed through the combination of image with descriptive

text. Ricky Maynard records his people's environment and working life through the camera lens: *Jason Thomas, Terry Maynard and David Maluga* portrays a mutton bird hunt on Flinders Island in Bass Strait. Images such as these express people's pride in their lives and a positive self-image that contradicts common negative stereotypes. 195

Concern with identity is a recurring theme in urban art. Pooaraar (Bevan Hayward) investigates the dilemma of the individual of both Aboriginal and non-Aboriginal heritage through a series of metaphorical images of the animals and spirit figures that inhabit the Australian bush, as in the linocut *Spirits of the Australian bushlands*. The subject is reinterpreted in imagery symbolic of fertility in *Rebirth II* by Treahna Hamm. 196 197

195. Ricky Maynard, *Jason Thomas, Terry Maynard and David Maluga*, 1985

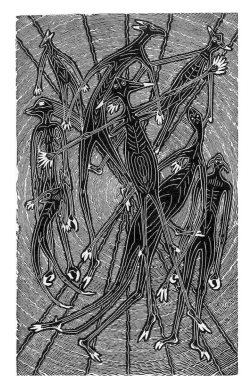

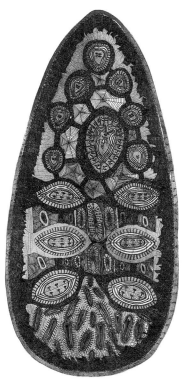

196. Pooaraar (Bevan Hayward), *Spirits of the Australian bushlands*, 1988

197. Treahna Hamm, *Rebirth II*, 1991

The work of urban and rural artists continues to refer to traditional forms and themes as part of the process of cultural enhancement. Rick Roser's *Jundal gianga* (*woman powerful*) 198 expresses the fecund power of this ancestor-being, who carries spirit children in her fighting-club leg and a bolt of lightning in her arms as she seeks a father for her children. The sculpture is made from native materials, various woods, cabbage-palm string, emu feathers and ochres, to emphasize links with tradition. In the Coorong, Ngarrindjeri men and women weave coiled bundles of sedge-grass into baskets and other functional items. These techniques are continued today by artists such as Ellen Trevorrow (born 1955) and Yvonne Koolmatrie. Koolmatrie adapts these techniques to produce innovative constructions such as *Bi-plane*. 199

198. Rick Roser, *Jundal gianga*
(woman powerful), 1990

199. Yvonne Koolmatrie,
Bi-plane, 1994

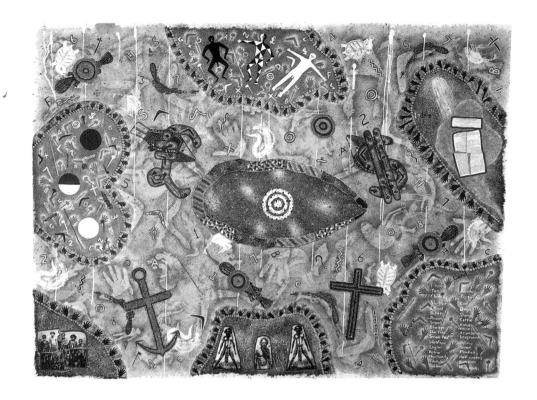

200. Richard Bell, *Crisis: What to do about this half-caste thing*, 1991

In *Crisis: what to do about this half-caste thing*, Richard Bell con- fronts the issue of racial prejudice in a bold and sardonic manner, with three figures, the black, the white and the harlequin half-caste in the upper central section of the painting. The work focuses on the historical treatment of Aboriginal people, in particular those of 'mixed blood', known by the derogatory term 'half-caste'. The painting juxtaposes symbols of Aboriginal and European civilizations: images of Aboriginal boys in European clothing, an elder in chains, a defiant Aboriginal warrior, and a page from a 1940s document on methods of controlling the 'half-caste problem'. In the bottom right corner is a shopping list of colonial imports. *Crisis: what to do about this half-caste thing* encapsulates many of the themes running through urban art, and displays a brash confidence in dealing with the issues Aboriginal people face today.

Recent developments
Toward the final years of the second millennium of the Christian era – or the fiftieth of indigenous Australia – the 'brash

You taught me language; and my profit on't is, I know how to curse.

Shakespeare
Caliban: *The Tempest*, I. ii.

201. Destiny Deacon, *Caliban*, 1996

202. Julie Dowling, *Her father's servant*, 1999

203. Leah King-Smith, *Patterns of connection; Untitled no. 3,* 1992

confidence in dealing with the issues faced by indigenous people today' as displayed by Richard Bell in *Crisis*, has become the leit- 200 motif in the work of many urban and rurally-based indigenous artists who have emerged in the last decade. Despite the social and political gains made by indigenous Australians, and the current populist movement towards reconciliation, there is a great deal of 'unfinished business' in terms of improving indigenous social conditions and official recognition of indigenous rights and history. Far from accepting the status quo, today's urban artists continue to use every means available to them to express contemporary realities through their art.

The photograph, in an era where images can be manipulated and enhanced digitally, continues to be a popular means of expression. Leah King-Smith produces large cibachrome photo- 203 graphs in which images of Aboriginal people from the turn of the twentieth century are superimposed and re-contextualized – in this case, a photograph of the artist William Barak. The

photographer and performance artist Destiny Deacon attacks 201
populist but denigrating expressions of Aboriginality through
the use of kitsch objects and tourist nick-nacks, or lampoons the
'civilizing' effects of colonization.

The processes of cultural renewal have become particularly
pertinent on the island of Tasmania after decades of denial and
suppression of indigenous culture. Artists such as Yvonne Kopper 204
and Lola Greeno (born 1946) have revived techniques of shell
necklace making and the use of dried bull kelp (a type of seaweed)
to produce sculptural utilitarian objects such as water carriers.

While many artists work in a range of media and forms, Julie 202
Dowling takes a decidedly painterly approach: she reinterprets
traditional European techniques of portraiture and the nature of
Aboriginal narrative within the framework of her family's his-
tory. On the other hand, indigenous male sexuality is explored in
Brook Andrew's (born 1970) electronic signs and billboards, and
in the performances of Clinton Nain (born 1971).

Not all the work of urban and rural artists is so politically and
socially charged. Their nineteenth-century forerunners, Tommy 172
McRae and others, provided commentaries on contemporary
life and portrayed traditional life for a non-Aboriginal public.
Similarly artists in the rural and urban areas of the country today
offer a variety of perspectives on a world with which much of its
audience has generally been unfamiliar. At the same time, by
implicitly questioning and challenging contemporary attitudes,
they articulate the concerns and aspirations of Aboriginal people
in modern society.

204. Yvonne Kopper, *Bull kelp
water carrier*, 1998

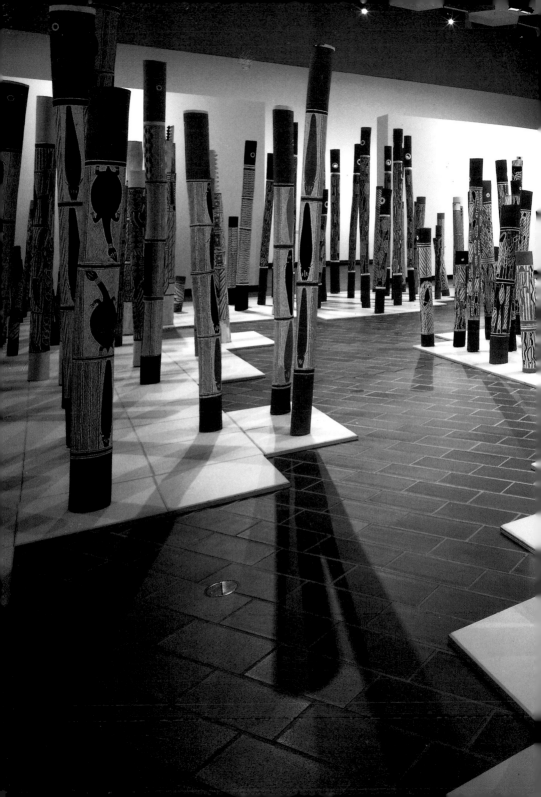

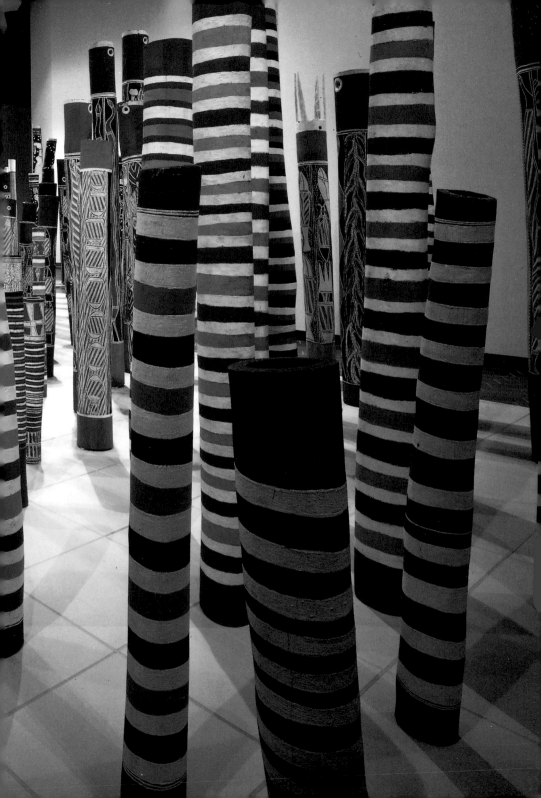

Conclusion

In 1988, when many Australians celebrated two centuries of European settlement, the Aboriginal community presented a varied response. Many Aboriginal people protested at the injustices of the past and the inequalities of the present; others saw the event as irrelevant, while some found cause to laud the benefits derived by Aboriginal society from European culture. Above all, Aboriginal people across the country celebrated the resilience of their culture in the face of great odds. A small group of artists in Ramingining in Central Arnhem Land, including Paddy Dhathangu, George Milpurrurru, Jimmy Wululu and David Malangi, decided to mark the event with a memorial to Aboriginal people past, present and future. The memorial took the form of two hundred hollow-log coffins or *dupun*, one to mark each year of settlement. The coffins, of the type used in reburial ceremonies throughout much of Arnhem Land, were painted with the clan designs and the major Dreamings of the artists. The *Aboriginal Memorial* project caught the imagination of artists in the local area until ultimately forty-three artists participated in its construction.

The form of the *Memorial* fulfilled the intentions of the artists to commemorate the thousands of Aboriginal people who had perished in the course of European settlement, and for whom it had not been possible to conduct appropriate mortuary rites. The *Memorial*'s relevance, however, is not confined to the past. It speaks of life, continuity, and a new beginning. An imposing forest of imagery, it confidently asserts a place for Aboriginal people in contemporary society. To fulfil its purposes, the artists intended the *Memorial* to be located in a public place where it could be preserved for future generations of Australians. One of the outstanding works of art to have been created in Australia, the *Aboriginal Memorial* is now permanently displayed in the National Gallery in Canberra.

The *Memorial* also symbolizes the significance of art to Aboriginal people today. On the one hand, it reflects traditional ceremonial and artistic activities which continue to be practised across the country, carrying the spiritual forces of the ancestral beings from one generation to the next. The recurring and

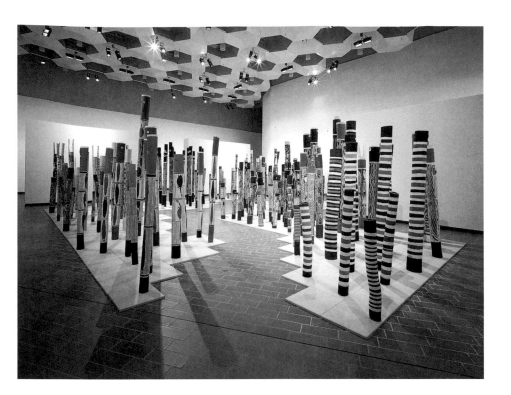

206. Ramingining artists,
The Aboriginal Memorial, 1988

inseparable themes of the land and the Ancestral Realm are as pertinent now as they ever have been through countless past generations. The creative dramas of the ancestral beings continue to provide the template by which Aboriginal society relates to the natural and spiritual environment. On the other hand, the *Memorial* signifies the important role of art in expressing Aboriginal values and perspectives to a world which, in many cases, continues to be hostile to Aboriginal aspirations. The vital nature of Aboriginal culture is evident in the ways in which artists are taking the traditions of Aboriginal art, with conviction and integrity, to the world at large.

Aboriginal art, once admired solely for its antiquity, has now staked its claim on the artistic map of the modern world, as being among the great expressions of the human spirit and human experience.

Note on Aboriginal names

The recording in writing of Aboriginal languages has only occurred since European colonization and there is no standardized orthography in use throughout Australia. Orthographies have changed over time, and vary not only from region to region, but often within a region and even within one language. Thus a Warlpiri-speaker living in or near Papunya, in the desert, might write his subsection name Tjakamarra, while a Warlpiri at Yuendumu would write Jakamarra, while yet a third may retain an earlier spelling, Jagamara. Most communities have adopted orthographic conventions, and where possible, these local conventions have been followed here.

Since this book was first published in 1993, the orthographies of a number of languages across Aboriginal Australia have been revised. Accordingly, changes to the spelling of artists' names and words have been incorporated in this edition.

In addition, as it is customary not to utter the names of the recently deceased, a number of artists have been recorded by researchers with mourning names that differ from their usual working names. Where the mourning names were used in the previous edition of this book, they have been replaced by the artists' working names, and cross-referenced in the index. Permission has been sought to use the working names of more recently deceased artists in this edition.

Aboriginal languages contain many synonyms, including those of the names of creator ancestors, supernatural beings, cosmological phenomena, natural species and material objects. The use of many names is restricted to specific contextual situations, or to those people of relevant status. The Aboriginal words used in this volume are those used in a general public context.

Acknowledgments

For their invaluable assistance in the preparation of this book, my gratitude goes to Kim Akerman, Susan Jenkins, Avril Quaill, Brenda L. Croft, Leanne Handreck, Michael Desmond, Djon Mundine and Daphne Wallace. Thanks also go to Banduk Marika, Margaret West, Luke Taylor, Diane Moon, Vivien Johnson, Christine Lennard, Steve Fox, Peter Sutton, Mrs P. Stanner, Peter Townsend, Joseph Caruana, and Betty Churcher, Brian Kennedy and the staff of the National Gallery of Australia. The photography department of the Gallery deserves a special mention; it includes Gordon Reid, Bruce Moore, Willi Kemperman, Richard Pedvin and Robert Patterson. I would also like to thank all the art centres, institutions and collectors who provided the illustrations, and those individuals whose assistance has been most valuable. They include Christopher Anderson and Kate Alport, Kathy Barnes, Ace Bourke, Anne Marie Brody, Tim Burt and Josephine Gwynne, Helen Campbell, Julia Clark, Carol Cooper and Valerie Chapman, Judith Graham, Christopher Hodges, David Kaus and David Andre, Duncan Kentish, Mary Lakic, Mary Macha, Peter McKenzie, Michael O'Ferrall, Judith Ryan and Philip Jago, John E. Stanton and Ross Chadwick, Grahame L. Walsh, Margaret Waugh, and ANKAAA, Desart, Aboriginal and Pacific Arts, Alcaston Gallery, Hermannsburg Potters, Gallery Gabrielle Pizzi, Injalak Arts, Jilamara Arts, Papunya Tula Artists, Short Street Gallery, Sotheby's Australia, Utopia Art Sydney, Warlyirti Arts, Warmun Arts, and William Mora Gallery .. I would like to make special mention of James Mollison and of the late Anthony Forge. Finally, my deepest appreciation goes to the artists who have contributed to this volume, and to Aboriginal and Torres Strait Islander artists across the country, for sharing their art and their knowledge with us.

Select Bibliography

Aboriginal Arts Board, *Oenpelli Bark Paintings*, Ure Smith, Sydney, 1979.

Akerman, K., with J. E. Stanton, *Riji and Jakuli: Kimberley Pearl Shell in Aboriginal Australia*, Northern Territory Museum of Arts and Sciences, Darwin, 1994.

Amadio, N., R. G. Kimber and B. Skipsey, *Wildbird Dreaming: Aboriginal Art from the Central Deserts of Australia*, Greenhouse Publications, Melbourne, 1988.

Bardon, G., *Papunya Tula: Art of the Western Desert*, McPhee Gribble, Ringwood, Vic., 1991.

Barnes, K., *Kiripapurajuwi (Skills of Our Hands): Good Craftsmen and Tiwi Art*, Kathy Barnes, Darwin, 1999.

Berndt, R. M., *Australian Aboriginal Art*, Ure Smith, Sydney, 1964.

Berndt, R. M., C. H. Berndt and J. E. Stanton, *Aboriginal Australian Art: A Visual Perspective*, Methuen Australia, Sydney, 1982.

Boulter, M., *The Art of Utopia: A New Direction in Contemporary Aboriginal Art*, Craftsman House, Roseville East, N.S.W., 1991.

Brandl, E. J., *Australian Aboriginal Paintings in Western and Central Arnhem Land: Temporal Sequences and Elements of Style in Cadell River and Deaf Adder Creek Art*, Australian Institute of Aboriginal Studies, Canberra, 1973.

Brody, A. M. and R. Gooch, *Utopia, A Picture Story: 88 Silk Batiks from the Robert Holmes à Court Collection*, Heytesbury Holdings, Perth, 1990.

Caruana, W. (ed.), *Windows on the Dreaming: Aboriginal Paintings from the Collection of the Australian National Gallery*, Australian National Gallery, Canberra, and Ellsyd Press, Chippendale, N.S.W., 1989.

Chaloupka, G., *Journey In Time, the World's Longest Continuing Art Tradition: The 50,000-Year Story of the Australian Aboriginal Rock Art of Arnhem Land*, Reed, Chatswood, N.S.W., 1993.

Cowan, J., *Wirrimanu: Aboriginal Art from the Balgo Hills*, Craftsman House, Roseville East, N.S.W., 1994.

Crawford, I. M., *The Art of the Wandjina: Aboriginal Cave Paintings in the Kimberley*, Western Australia, Oxford University Press, Melbourne, 1968.

Crocker, A. (ed), *Mr Sandman Bring Me a Dream*, Aboriginal Artists Agency, Sydney, and Papunya Tula Artists, Alice Springs, N.T., 1981.

Edwards, R., *Aboriginal Art in Australia*, Ure Smith, Sydney, 1978.

Eickelkamp, U., *'Don't Ask for Stories' : The Women from Ernabella and their Art*, Aboriginal Studies Press, Canberra, 1999.

Horton, D. (ed.), *The Encyclopaedia of Aboriginal Australia*, volumes 1 and 2, Aboriginal Studies Press, Canberra, 1994.

Hutcherson, G., *Gong-wapitja: Women and Art from Yirrkala, Northeast Arnhem Land*, Aboriginal Studies Press, Canberra, 1998.

Isaacs, J., *Thancoupie the Potter*, Aboriginal Artists Agency, Sydney, 1982.

_____, *Australia's Living Heritage: Arts of the Dreaming*, Lansdowne, Sydney, 1984.

_____, *Desert Crafts: Anangu Maruku Punu*, Doubleday, Sydney, 1992.

_____, T. Smith, J. Ryan et al., *Emily Kngwarreye Paintings*, Craftsman House, Roseville East, N.S.W., 1998.

_____, *Hermannsburg Potters: Aranda Artists of Central Australia*, Craftsman House, Roseville East, N.S.W., 2000.

Johnson, V., *Aboriginal Artists of the Western Desert: A Biographical Dictionary*, Craftsman House, Roseville East, N.S.W., 1994.

_____, *The Art of Clifford Possum Tjapaltjarri*, Craftsman House, Roseville East, N.S.W., 1994.

_____, *Michael Jagamara Nelson*, Craftsman House, Roseville East, N.S.W., 1997.

Kleinert, S. and M. Neale (eds.), *The Oxford Companion to Aboriginal Art and Culture*, Oxford University Press, Melbourne, 2000.

Kupka, K., *Dawn of Art: Painting and Sculpture of Australian Aborigines*, Angus and Robertson, Sydney, 1965.

_____, *Peintres aborigènes d'Australie*, Musée de l'Homme, Paris, 1972.

McLean, I. and G. Bennett, *The Art of Gordon Bennett*, Craftsman House, Roseville East, N.S.W., 1996.

Morgan, S., *The Art of Sally Morgan*, Viking, Ringwood, Vic., 1996.

Morphy, H., *Animals into Art*, Unwin Hyman, London and Boston, 1989.

_____, *Ancestral Connections: Art and an Aboriginal System of Knowledge*, University of Chicago Press, Chicago, 1991.

_____, *Aboriginal Art*, Phaidon, London, 1998.

_____, M. Smith Boles (eds.), *Art from the Land: Dialogues with the Kluge-Ruhe Collection of Australian Aboriginal Art*, University of Virginia, Charlottesville, VA, 1999.

Mountford, C. P., *Records of the American-Australian Scientific Expedition to Arnhem Land, volume 1: Art, Myth and Symbolism*, Melbourne University Press, Melbourne, 1956.

_____, *The Tiwi: Their Art, Myth and Ceremony*, Phoenix House, London, 1958.

_____, *Aboriginal Art*, Longmans, London, 1961.

Mulvaney, D. J. and J. Kamminga, *Prehistory of Australia*, Allen & Unwin, St Leonards, N.S.W., 1999.

Mundine, D., J. Rudder, B. Murphy et al., *The Native Born: Objects and Representations from Ramingining, Arnhem Land*, Museum of Contemporary Art, Sydney, 1999.

Munn, N. D., *Walbiri Iconography: Graphic Representation and Cultural Symbolism in a Central Australian Society*, University of Chicago Press, Chicago and London, 1986.

Ngarjno, Ungudman, Banggal, Nyawarra, with J. Doring (ed.), *Gwion Gwion: Dulwan Mamaa, Secret and Sacred Pathways of the Ngarinyin Aboriginal People of Australia*, Könemann, Cologne, 2000.

O'Ferrall, M. A., *Keepers of the Secrets: Aboriginal Art from Arnhemland in the Collection of the Art Gallery of Western Australia*, Art Gallery of Western Australia, Perth, 1990.

Pike, I. and M. A. O'Ferrall, *Jimmy Pike: Desert Designs 1981–1995*, Art Gallery of Western Australia, Perth, 1995.

Quaill, A., *Marking Our Times: Selected Works of Art from the Aboriginal and Torres Strait Islander Collection at the National Gallery of Australia*, National Gallery of Australia, Canberra, 1996.

Sayers, A., *Aboriginal Artists of the Nineteenth Century*, Oxford University Press, Melbourne, 1994.

Spencer, W. B., *The Native Tribes of the Northern Territory of Australia*, Macmillan, London, 1914.

Spencer, W. B. and F. J. Gillen, *The Native Tribes of Central Australia*, Macmillan, London, 1914.

Stanton, J. E., *Painting the Country: Contemporary Aboriginal Art from the Kimberley Region, Western Australia*, University of Western Australia Press, Nedlands, W.A., 1989.

Taylor, L., *Seeing the Inside: Bark Painting in Western Arnhem Land*, Clarendon Press, Oxford, 1996.

Ucko, P. J. (ed.), *Form in Indigenous Art: Schematisation in the Art of Aboriginal Australia and Prehistoric Europe*, Australian Institute of Aboriginal Studies, Canberra, 1977.

Walsh, G., *Australia's Greatest Rock Art*, E.J. Brill/Robert Brown & Associates, Bathurst, N.S.W., 1988.

Exhibition catalogues

Barou, J. P. and S. Crossman (eds.), *L'été australien à Montpellier: 100 chefs-d'œuvre de la peinture australienne*, Libération, Paris, and Musée Fabre, Montpellier, 1990.

Barney, J. and N. J. O'Neill, *Black Humour*, Canberra Contemporary Art Space, Canberra, 1997.

Berndt, R. M. and C. H. Berndt, *An Exhibition of Aboriginal Art: Arnhem Land Paintings on Bark and Carved Human Figures*, Western Australian Museum, Perth, 1957.

Brody, A. M., *Kunwinjku Bim: Western Arnhem Land Paintings from the Collection of the Aboriginal Arts Board*, National Gallery of Victoria, Melbourne, 1984.

_____, *The Face of the Centre: Papunya Tula Paintings 1971–84*, National Gallery of Victoria, Melbourne, 1985.

_____, *Contemporary Aboriginal Art: The Robert Holmes à Court Collection*, Heytesbury Holdings, Perth, 1990.

_____, (ed.), *Stories: Eleven Aboriginal Artists, Works from the Holmes à Court Collection*, Craftsman House, Roseville East, N.S.W., 1997.

Buku-Larrngay Mulka Centre, *Saltwater: Yirrkala Bark Paintings of Sea Country*, Buku-Larrngay Mulka Centre, Yirrkala, N.T., and Jennifer Isaacs Publishing, Neutral Bay, N.S.W., 1999.

Carew, M. and M. K. C. West, *Maningrida: The Language of Weaving*, Australian Exhibitions Touring Agency, South Melbourne, 1995.

Carrigan, B. (ed.), *Utopia: Ancient Cultures, New Forms*, Heytesbury and Art Gallery of Western Australia, Perth, 1998.

Caruana, W., S. Jenkins, D. Mundine, et al., *The Eye of the Storm: Eight Contemporary Indigenous Australian Artists*, Museum of Modern Art, New Delhi, and National Gallery of Australia, Canberra, 1996.

_____ and N. Lendon (eds.), *The Painters of the Wagilag Sisters Story, 1937–1997*, National Gallery of Australia, Canberra, 1997.

_____, S. Jenkins, D. Mundine et al., *Le Mémorial: un chef-d'oeuvre d'art aborigène*, Musée Olympique, Lausanne, Switzerland, 1999.

Cooper, C. et al., *Aboriginal Australia*, Australian Gallery Directors Council, Sydney, 1981.

Croft, B. L. (ed.), *Beyond the Pale: 2000 Adelaide Biennial of Australian Art*, Art Gallery of South Australia, Adelaide, 2000.

de Dardel, J. J. (ed.), *Art aborigène: jouvence millénaire*, Musée Olympique, Lausanne, Switzerland, 2000.

Dussart, F., *La peinture des aborigènes d'Australie*, Musée national des Arts d'Afrique et d'Océanie, Paris, 1993.

Eather, M. and M. Hall, *Balance 1990: Views, Visions, Influences*, Queensland Art Gallery, Brisbane, 1990.

Foley, F. and D. Mundine, *Tyerabarrbowaryaou II: I shall never become a white man*, Museum of Contemporary Art, Sydney, 1994.

Isaacs, J. (ed.), *Spirit Country: Contemporary Australian Aboriginal Art*, Hardie Grant, South Yarra, Vic., and Fine Arts Museums of San Francisco, San Francisco, CA, 1999.

Jenkins, S. et al., *Keeping Culture: Aboriginal Art to Keeping Places and Cultural Centres*, National Gallery of Australia, Canberra, 2000.

Johnson, T. and V. Johnson, *Koori Art '84*, Artspace, Sydney, 1984.

Johnson, V., *Australia: Art & Aboriginality 1987*, Aspex Gallery, Portsmouth, Great Britain, 1987.

_____, et al., *The Painted Dream: Contemporary Aboriginal Paintings from the Tim and Vivien Johnson Collection*, Auckland City Art Gallery, Auckland, New Zealand, 1990.

_____, *Copyrites: Aboriginal Art in the Age of Reproductive Technologies*, National Indigenous Arts Advocacy Association and Macquarie University, Sydney, 1996.

Jones, P. G., P. Sutton and K. Clark, *Art and Land: Aboriginal Sculptures of the Lake Eyre Region*, South Australian Museum and Wakefield Press, Adelaide, 1986.

Lüthi, B. (ed.), *Aratjara: Art of the First Australians: Traditional and Contemporary Works by Aboriginal and Torres Strait Islander Artists*, DuMont, Cologne, 1993.

Maughan, J. and J. Zimmer (eds.), *Dot and Circle: A Retrospective Survey of the Aboriginal Acrylic Paintings of Central Australia*, Royal Melbourne Institute of Technology, Melbourne, 1986.

Milpurrurru, G. with G. Getjpulu, D. Mundine, J. Reser and W. Caruana, *The Art of George Milpurrurru*, National Gallery of Australia, Canberra, 1993.

Moon, D., *Spinifex Runner: A Collection of Contemporary Aboriginal and Torres Strait Islander Fibre Art*, Campbelltown City Bicentennial Art Gallery, Campbelltown, N.S.W., 1999.

Morphy, H. and R. Coates (eds.), *In Place (Out of Time): Contemporary Art in Australia*, Museum of Modern Art, Oxford, Great Britain, 1997.

Mosby, T. and B. Robinson (eds.), *Ilan Pasin (This is Our Way): Torres Strait Islander Art*, Cairns, 1998.

O'Ferrall, M. A., *On the Edge : Five Contemporary Aboriginal Artists: Bede Tungutalum, Rover Thomas, Mandjuwi, George Milpurrurru, Trevor Nickolls*, The Art Gallery of Western Australia, Perth, 1989.

_____, *1990 Venice Biennale. Australia: Rover Thomas – Trevor Nickolls*, Art Gallery of Western Australia, Perth, 1990.

_____, *Tjukurrpa, Desert Dreamings: Aboriginal Art from Central Australia (1971–1993)*, Art Gallery of Western Australia, Perth, W.A., 1993.

Onus, L., M. Neale, M. Eather et al., *Urban Dingo: The Art and Life of Lin Onus, 1948–1996*, Craftsman House, Roseville East, N.S.W., in association with the Queensland Art Gallery, South Brisbane, 2000.

Perkins, H., *Aboriginal Women's Exhibition*, Art Gallery of New South Wales, Sydney, 1991.

Perkins, H. and H. Fink (eds.), *Papunya Tula: Genesis and Genius*, Art Gallery of New South Wales in association with Papunya Tula Artists, Sydney, 2000.

Perkins, H., B. L. Croft and V. Lynn, *fluent: Emily Kame Kngwarreye, Yvonne Koolmatrie, Judy Watson : XLVII esposizione internazionale d'arte, La Biennale di Venezia 1997*, Art Gallery of New South Wales, Sydney, 1997.

Ryan, J., *Mythscapes: Aboriginal Art of the Desert from the National Gallery of Victoria*, National Gallery of Victoria, Melbourne, 1989.

_____, *Paint Up Big: Warlpiri Women's Art of Lajamanu*, National Gallery of Victoria, Melbourne, 1990.

_____, *Spirit in Land: Bark Paintings from Arnhem Land in the National Gallery of Victoria*, National Gallery of Victoria, Melbourne, 1990.

_____ and K. Akerman (eds.), *Images of Power: Aboriginal Art of the Kimberley*, National Gallery of Victoria, Melbourne, 1993.

_____, *Ginger Riley*, National Gallery of Victoria, Melbourne, 1997.

_____, R. Healy and J. S. Bennett, *Raiki Wara: Long Cloth from Aboriginal Australia and the Torres Strait*, National Gallery of Victoria, Melbourne, 1998.

Sutton, P. (ed.), *Dreamings: The Art of Aboriginal Australia*, Viking, New York, and Ringwood, Vic., 1988.

Taylor, L. (ed.), *Painting the Land Story*, National Museum of Australia, Canberra, 1999.

Thomas, R. with K. Akerman, M. Macha, W. Christensen and W. Caruana, *Roads Cross: The Paintings of Rover Thomas*, National Gallery of Australia, Canberra, 1994.

West, M. K. C. (ed.), *The Inspired Dream: Life as Art in Aboriginal Australia*, Queensland Art Gallery, South Brisbane, 1988.

_____, *Rainbow, Sugarbag and Moon: Two Artists of the Stone Country, Bardayal Nadjamerrek and Mick Kubarkku*, Museum & Art Gallery of the Northern Territory, Darwin, 1995.

Williamson, C. and H. Perkins, *Blakness: Blak City Culture!*, Australian Centre for Contemporary Art, South Yarra, Vic., and Boomalli Aboriginal Artists Co-operative, Sydney, 1994.

List of Illustrations

The artist's language group and dates of birth and death follow the name. Avoidance of the spoken names of the recently deceased is customary in Aboriginal communities, and this custom should be respected. In some cases the biographical details are approximate, as indicated, or unknown due to the lack of records. Dimensions of works are given in centimetres and inches, height preceding width.

Abbreviations for the collections are:

AGNSW Art Gallery of New South Wales, Sydney
AGSA Art Gallery of South Australia, Adelaide
AGWA Art Gallery of Western Australia, Perth
AIATSIS Australian Institute of Aboriginal and Torres Strait Islander Studies Pictorial Collection, Canberra
AM The Australian Museum, Sydney
HàC The Robert Holmes à Court Collection
MAGNT Museums and Art Galleries of the Northern Territory Darwin
MOV Museum of Victoria, Melbourne. Reproduced with the permission of the Museum Council
NGA National Gallery of Australia, Canberra
NGA/AC National Gallery of Australia, Canberra. Purchased from Gallery admission charges
NGV National Gallery of Victoria, Melbourne
NMA National Museum of Australia, Canberra
SAM South Australian Museum, Adelaide
WU University of Western Australia, Berndt Museum of Anthropology, Perth
AAA Copyright: Aboriginal Artists Agency, Sydney

1 Jack Wunuwun (Djinang, 1930–90). *Barnumbirr the Morning Star*, 1987. Natural pigments on bark 178 × 125 (70 ⅛ × 49 ¼). NGA/AC.
2 Rock painting, Ubirr, Kakadu, Northern Territory. Photo Reg Morrison/Auscape.
3 Map drawn by Annick Petersen.
4 Rock engraving, c. AD 500 , Mount Cameron West, Tasmania. Photo Robert Edwards.
5 Rock painting of lightning figures, Katherine River, Northern Territory. Photo Grahame L. Walsh.
6 Hand stencil, 9–20,000 before present, Kakadu, Northern Territory. Photo Grahame L. Walsh.
7 Narrative rock painting, Musgrave Ranges, South Australia. Photo Grahame L. Walsh.

8 Gwion Gwion figures, Kimberley, Western Australia. Photo Grahame L. Walsh.
9 Rock drawing of kangaroos, Wilton, New South Wales. Photo Grahame L. Walsh.
10 George French Angus. *Native weapons and implements*, 1847. *South Australian Illustrated*, London 1847. NGA.
11 Najombolmi (Kunwinjku, c. 1895–1967). *Hunter*, 1960s. Rock painting, extended figure h. 142 (56). Djerlandjal site, Kakadu, Northern Territory. Photo Grahame L. Walsh.
12 Unknown artist. Gunbalanya, West Arnhem Land. *Mimi spearing a kangaroo*, 1912. Natural pigments on bark 127.5 × 80 (50 ¼ × 31 ½). MOV. Baldwin Spencer Collection.
13 Jimmy Midjaw Midjaw (Kunwinjku, 1897–c. 1985). *Nadulmi in his kangaroo manifestation, as Wubarr leader*, 1950. Natural pigments on bark 76 × 58 (29 ⅞ × 22 ⅞). WU.
14 Yirawala (Kuninjku, 1903–76). *Namanjwarre, the Mardayin Crocodile*, c. 1973. Natural pigments on eucalyptus bark; 115 × 58.5 (45 ¼ × 23) NGA. Collected by Sandra Le Brun Holmes.
15 Paddy Compass Namatbara (Iwaidja, 1890–1973). *Maam spirit*, c. 1963. Natural pigments on bark 58 × 35 (22 ⅞ × 13 ¾). NGA. Founding Donor Fund.
16 Bobby Barrdjaray Nganjmirra (Kunwinjku, 1915–92). *Kangaroo and crocodile*, 1984. Natural pigments on bark 151 × 88 (59 ½ × 34 ⅝). NGA.
17 Bruce Nabekeyo (Kunwinjku, b. c. 1949). *Yingarna, the Rainbow Serpent*, 1989. Natural pigments on bark 150.1 × 40.4 (59 ¼ × 15 ⅞). NGA.
18 Robin Nganjmirra (Kunwinjku, 1951–91). *Likanaya*, 1989. Natural pigments on bark 191 × 81 (75 ¼ × 31 ⅞). NGA.
19 Djawida (Kunwinjku, b. 1936). *Nawura, Dreamtime ancestor spirit*, 1985. Natural pigments on bark 156 × 68 (61 ⅝ × 26 ⅞). NGA.
20 Peter Marralwanga (Kuninjku, 1916–87). *Ngalyod, the Rainbow Serpent*, 1981. Natural pigments on bark 154 × 93 (60 ⅝ × 36 ⅝). NGA.
21 Crusoe Kuningbal (Kuninjku, 1922–84). *Mimi spirits*, 1979. Natural pigments on wood h. 216 (85) and 221 (87). NGA.
22 John Mawurndjul (Kuninjku, b. 1952). *Rainbow Serpent's antilopine kangaroo*, 1991. Natural pigments on bark 189 × 94 (74 ⅜ × 37). NGA.
23 Mick Kubarkku (Kunanjku, b. 1925), *Dird*, 1991. Natural pigments on bark 196.5 × 74 (77 ⅜ × 29 ⅛). NGA.
24 Wally Mandarrk (Dangbon, 1915–87). *Narrangem and Ngaldaluk, Lightning Spirits*, 1986. Natural pigments on bark 89.5 × 27 (35 ¼ × 10 ⅝). NGA/AC.
25 Ronnie Djambardi (Kurrkoni, 1925–94). *Wandurk and his two wives*, 1981. Natural pigments on bark 140 × 45 (55 ⅛ × 17 ¾). MAGNT.

26 England Banggala (Gun-nartpa, c. 1925–2001). *Modj (Rainbow Serpent)*, 1988. Natural pigments on bark 143.5 × 83.5 (56 ½ × 32 ⅞). NGA.
27 Dorothy Galaledba (Gun-nartpa, b. c. 1967). *Jin-gubardabiya (triangular pandanus skirt)*, 1989. Natural pigments on bark 168 × 92 (66 ⅛ × 36 ¼). NGA.
28 Lena Djamarrayku (Rembarrnga, b. 1943). *Djerrh, bush string carrying bag*, 1989. Fibres, natural dyes, feathers w. 49 (19 ¼). NGA.
29 Lena Yarinkura (Rembarrnga, b. 1948). *Yawk Yawk Spirits*, 1998. Pandanus, paper bark, feathers, natural pigments; h. 200 (78 ¾), 210 (82 ⅝). NGA. © DACS 2003
30 Jack Kala Kala (Rembarrnga, c. 1925–87). *Balangu, two sharks*, 1986. Natural pigments on bark 130 × 60 (51 ¼ × 23 ⅝). NGA.
31 Les Mirrikkuriya (Rembarrnga, c. 1943–96). *Digging sticks and sacred dilly bag at Ginajangga*, 1988. Natural pigments on bark 152 × 93.8 (59 ⅞ × 36 ¾). AGSA. Maude Vizard-Wholohan Art Prize Purchase Award 1988.
32 Paddy Fordham Wainburranga (Rembarrnga, b. 1938). *How World War II began (through the eyes of the Rembarrnga)*, 1990. Natural pigments on bark 65 × 135 (25 ⅝ × 53 ⅛). NGA.
33 Brian Nyinawanga (Rembarrnga, b. 1935). *Bones*, 1982. Natural pigments, wood, paperbark, cotton, string, size variable. MAGNT.
34 Tjam (Sam) Yilkari Kitani (Liyagalawumirri, 1891–1956). *Wagilag*, 1937. Natural pigments on bark 126.5 × 68.5 (49 ⅞ × 27). MOV. Donald Thomson Collection.
35 Dawidi Djulwarak (Liyagalawumirri, 1921–70). *Wagilag religious story*, 1965. Natural pigments on bark 84 × 46.5 (33 ⅛ × 18 ⅜). Private Collection.
36 Paddy Dhathangu (Liyagalawumirri, 1915–93). *The Wagilag Sisters story*, 1983. Natural pigments on bark; 60 × 133 (23 ⅝ × 52 ⅜). NGA/AC.
37 Peter Bandjuldjul (Djinang, 1942–95). *Djang'kawu creator ancestors and Gachalan the goanna at Mewrnbi*, 1983. Natural pigments on bark 127.5 × 90 (50 ¼ × 35 ⅝). NGA/AC.
38 Tom Djawa (Gupapuyngu, 1905–80). *Crabs*, 1969. Natural pigments on bark 101.5 × 50 (40 × 19 ⅝). NGA.
39 David Malangi (Manharrngu, 1927–99). *Gunmirringgu*, 1987. Natural pigments on bark 124.5 × 69 (49 × 27 ⅛). MAGNT. Groger–Wurm Collection.
40 Clara Wubugwubuk (Ganalbingu, b. 1950). *Walmi grass – munyigani edible tuber*, 1990. Natural pigments on bark 211 × 67 (83 ⅛ × 26 ⅜). John W. Kluge Collection.
41 Johnny Bulun Bulun (Ganalbingu, b. 1946). *Sacred waterholes surrounded by totemic animals of the artist's clan*, 1981. Natural pigments on bark 135.5 × 73

(53 ⅜ × 28 ¾). NGA.

42 Don Gundinga (Djinang, 1941–89).
Honey Dreaming at Walkumbimirri, 1984.
Natural pigments on bark 142.5 × 83 (56 ⅛
× 32 ⅝). NGA. Founding Donor Fund.

43 Jimmy Wululu (Daygurrgurr/
Gupapuyngu, b. 1936). *Niwuda, Yirritja
native honey*, 1986. Natural pigments on
bark 144 × 60 (56 ¾ × 23 ⅝). NGA.

44 George Milpurrurru (Ganalbingu,
1934–98). *Fire and Water Dreaming*, 1989.
Natural pigments on bark 200.5 × 76
(78 ⅞ × 29 ⅞). NGA.

45 Wandjuk Marika (Rirratjingu,
1927–87). *The birth of the Djang'kawu
children at Yalangbara*, 1982. Natural
pigments on bark 147.5 × 66 (58 × 26).
NGA/AC. (AAA).

46 Mick Daypurryun (Liya-gawumirri,
1929–94). *Sacred waterholes – the
Djang'kawu*, 1988. Natural pigments on
bark 173.7 × 67.3 (68 ⅜ × 26 ½). AGWA.

47 Mandjuwi (Galpu, b. 1934) with Kallie
Yalkarrawuy (Galpu, b. 1942). *The Morning
Star ceremony*, 1979 (installation). Natural
pigments on bark and wood, feathers, fibres,
string h. 209 (82 ¼). NGA.

48 Mawalan Marika (Rirratjingu, 1908–67).
Turtle Dreaming, c. 1963. Natural pigments
on bark 132 × 35 (52 × 13 ¾). NGA.

49 Banduk Marika (Rirratjingu, b. 1954).
Minyapa ga Dhanggatjirya, 1990. Linocut on
paper 61 × 117 (24 × 46 ¼). NGA. Gordon
Darling Fund 1991. (AAA).

50 Mathaman Marika (Rirratjingu,
c. 1920–70). *Wawilak ceremony*, 1963.
Natural pigments on bark 157.5 × 62.8
(62 × 24 ⅞). NGV. Donated by Mr James A.
Davidson 1967.

51 Dundiwuy Wanambi (Marrakulu,
1936–96). *Wuyal creation story with
Gundimulk ceremonial ground*, 1990. Natural
pigments on bark 183 × 64.5 (72 × 25 ⅜).
NGV.

52 Badangga (Wangurri, 1910–c. 1970)
and Waninyambi (Warramiri, b. 1902?)
Djirrban (Lany'tjung), 1960. Natural
pigments on wood, fibres h. 178 (70 ⅛). WU.

53 Birrikitji Gumana (Dhalwangu,
c. 1898–1982). *Lany'tjung story – the death of
Lany'tjung*, 1960s. Natural pigments on bark
135.8 × 63.8 (53 ½ × 25 ⅛). AGWA.

54 Yanggarriny Wunungmurra
(Dhalwangu, 1932–2003), *Minhala the
Long-Necked Tortoise on the sacred log*, 1990.
Natural pigments on wood, h. 132.5 (52 ¼).
NGA.

55 Munggurrawuy Yunupingu (Gumatj,
c. 1907–79). *Lany'tjung story number two*,
1959. Natural pigments on bark 193 × 73.7
(76 × 29). AGNSW. Gift of Dr Stuart
Scougall 1959.

56 Mutitjpuy Mununggurr (Djapu,
1932–93). *Dugong hunt*, 1967. Natural
pigments on bark 118 × 54 (46 ½ × 21 ¼).
NMA. Groger–Wurm Collection.

57 Wakuthi Marawili (Madarrpa, b. 1921).
Fire Dreaming with Dugong hunting story,
1982. Natural pigments on bark 139 × 47
(54 ¾ × 18 ½). NGA/AC.

58 Liwukang Bukurlatjpi (Warramiri,
b. c. 1927). *Mamu spirit boat*, 1982. Natural
pigments on bark 124.5 × 38 (49 × 15).
NGA/AC

59 Luma Luma Yunupingu (Gumatj,

1941–85). *The spirit's journey*, 1984. Natural
pigments on bark and wood painting 198 ×
80 (78 × 31 ½), sculptures h. 139 (54 ¾) and
147 (57 ¾). NGA. Founding Donor Fund.

60 Narritjin Maymuru (Manggalili,
1922–80). *Nyapililngu at Djarrakpi, c.* 1978.
Natural pigments on bark 158 × 60
(62 ¼ × 23 ⅝). NGA/AC.

61 Bill Namiayangwa (Anindilyakwa,
1923–68). *They surround a man and his five
wives, but he escapes, c.* 1955 (detail from the
series *An attack by war canoes*). Natural
pigments on bark 24 × 38 (9 ½ × 15). NGA.

62 Minimini Mamarika (Anindilyakwa,
1904–72). *Orion and the Pleiades*, 1948.
Natural pigments on bark 76 × 32 (29 ⅞ ×
12 ⅝). AGSA. Gift of the Commonwealth
Government 1957.

63 Attributed to Nandabitta (Anindilyakwa,
1911–81). *Macassan prahu and trepang curing,
c.* 1974. Natural pigments on bark 62 × 41
(24 ⅜ × 16 ⅛). NGA/AC.

64 George Jawaranga Wurramara
(Anindilyakwa, 1926–88). *Yinikarrka (the
Wind Spirit)*, 1984. Natural pigments on
bark 96 × 40 (37 ¾ × 15 ¾). NGA. Founding
Donor Fund.

65 Wilfred Ngalandarra (Rittharrngu,
b. c. 1940). *Fish and birds in the shallows*,
1989. Synthetic polymer on canvas 170 ×
181 (66 ⅞ × 71 ¼). Private Collection.

66 Ginger Riley Munduwalawala (Mara,
1937–2002). *My country*, 1988. Synthetic
polymer on canvas 178 × 247 (70 ¼ × 97 ¼).
Anthony and Beverley Waldegrave-Knight
Collection.

67 Willie Gudabi (Alawa, 1916–96).
Untitled, 1990. Synthetic polymer on canvas
173 × 110.9 (68 ¼ × 43 ⅝). NGA.

68 Amy Johnson Jirwulurr (Wagilak,
b. 1953). *Some animals have secret songs*, 1990.
Synthetic polymer on canvas 175 × 167
(68 ⅞ × 65 ¾). Anthony and Beverley
Waldegrave-Knight Collection.

69 Maloney Porkalari Marruwani (Tiwi,
1916–60). *The death of Purukuparli*, 1954.
Natural pigments on bark 89 × 24 (35 ×
9 ½). SAM.

70 Laurie Nelson Mungatopi (c. 1915–68),
Bob One Gala-ding-wama Apuatimi
(1925–76), Big Jack Yarunga (1905–73), Big
Don Burakmadjua (1925–95), Charlie Quiet
Kwangdini (1905–61) and one unknown
artist (Tiwi). *Pukumani poles*, 1958 (a group
of 17 graveposts from Milikapati, Melville
Island). Natural pigments on ironwood
h. 147.3–274.2 (58–108). AGNSW. Gift of
Dr Stuart Scougall 1958.

71 Bama Yu (Polly Miller) (Tiwi,
1921–89). *Jimwalini, Pukumani basket*, 1984.
Natural pigments on bark, fibre h. 65
(25 ⅝). NGA/AC.

72 Unknown artist (Tiwi). Bathurst Island,
Northern Territory. *Pamijini mourning band*,
pre-1912. Natural pigments, abrus seeds,
feathers, cane h. 83 (32 ⅝). MOV. Baldwin
Spencer Collection.

73 Enraeld Munkara (Tiwi, 1895–1968).
Purukuparli and Bima, c. 1955. Natural
pigments on ironwood h. 60 (23 ⅝) and
53 (20 ⅞). NGA/AC.

74 Paddy Henry Ripijingimpi (Tiwi,
1925–99). *Bird*, 1979 Natural pigments on
ironwood 103 × 16 × 20.5 (40 ¼ × 6 ¼ ×
8 ⅛). NGA.

75 Mani Luki (Harry Carpenter) (Tiwi,
c. 1914–80). *Bima carrying Jinani, c.* 1970
(detail from the installation *The Purukuparli
and Bima story*, by Mani Luki, Paddy Henry
Ripijingimpi and other artists). Natural
pigments on ironwood, fibres, max. h. 180
(70 ⅞). MAGNT. The Holmes Tiwi
Collection.

76 Nellie Wanterapila (Tiwi, 1905–79).
Coral, 1974. Natural pigments on bark
37.5 × 62 (14 ¾ × 24 ⅜). NGA.

77 Declan Apuatimi (Tiwi, 1930–85).
Clubs, c. 1984. Natural pigments on canvas
90 × 90 (35 ⅜ × 35 ⅜). NGA.

78 Bede Tungutalum (Tiwi, b. 1952), Tiwi
Designs (established 1969). *Yam design*,
1982. Screenprint on cotton; detail. Tiwi
Designs.

79 Kitty Kantilla (Tiwi, b. c. 1928). *Jurrah
c.* 1996. Natural pigments and gum on
canvas, 149 × 118 (58 ⅝ × 46 ½). NGA.

80 Thecla Puruntatameri (Tiwi, b. 1971).
Irramaru, 1991. Gouache on paper 56.3 × 76
(22 ¼ × 29 ⅞). NGA.

81 Charles Mardigan (Murrinh-Garr,
1926–86). *Billabongs*, 1961. Natural
pigments on bark 63.2 × 37.8 (24 ⅞ × 14 ⅞).
AGNSW. Gift of Dr Stuart Scougall 1961.

82 Simon Ngumbe (Murrinh-Patha,
b. 1911). *Rainbow Snake and children, c.* 1972.
Natural pigments on bark 62 × 24.6 (24 ⅜ ×
9 ⅜). AGWA.

83 Robin Nilco (Murrinh-Amor, b. 1956).
Water python and boomerangs, 1990.
Synthetic polymer on canvas 45 × 152.5
(174 ⅞ × 60). NGA.

84 Nym Bandak (Murrinh-Patha,
c. 1907–81). *Map of the Murrinh-Patha
countryside 1*, 1959. Natural pigments on
composition board 89 × 156 (35 × 61 ⅜).
Private Collection.

85 Paddy Jupurrurla Nelson (1920–98),
Paddy Japaljarri Sims (b. 1917), Paddy
Cookie Japaljarri Stewart (b. 1940), Neville
Japangardi Poulson (b. c. 1950), Francis
Jupurrurla Kelly (b. c. 1950) and Frank
Bronson Jakamarra Nelson (1948–98)
(Warlpiri). *Yarla*, 1989 (ground painting
in the exhibition *Magiciens de la terre*,
organized by the Centre Georges
Pompidou). Earth pigments, mixed media
4 × 10 m (13 × 33 ft). Photo Centre
Georges Pompidou, Paris.

86 Various artists (Diyari). Killalpaninna,
South Australia. *Group of toas*, 1904–5.
Natural pigments on wood, max. h. 57
(22 ½). SAM.

87 Angkuna Graham (Pitjantjatjara,
b. 1934), Ernabella Arts (established 1949).
Untitled, 1984. Batik on silk 93 × 376
(36 ⅝ × 148). NGA. Founding Donor Fund.

88 Unknown artist (Pitjantjatjara). Amata,
South Australia. *Animal carving*, 1977.
Wood, length 114 (44 ⅞). SAM.

89 Sadie Singer (Yankunytjatjara, b. 1950).
Summer landscape, 1988. Lithograph on
paper 66.8 × 52.4 (26 ¼ × 20 ⅝). NGA.
Gordon Darling Fund 1989.

90 Kay Tunkun (Pitjantjatjara, b. 1957).
Kipara (Wild Turkey) Dreaming, 1986–87.
Watercolour on paper 47 × 80 (18 ½ ×
31 ½). Private Collection.

91 Judith Pungarta Inkamala (Arrernte,
b. 1948). *Cockatiels*, 1996. Terracotta, h. 39
(15 ⅜), diam. 27 (10 ⅝). NGA.

92 Albert Namatjira (Arrernte, 1902–59). *Anthewerre, c.* 1955. Watercolour on paper 24.5 × 35.2 (9 ⅝ × 13 ⅞). NGA. Gift of Thomas William and Pamela Joyce (Joy) Falconer, Canberra. Reproduced by permission of Legend Press Pty. Ltd., Sydney, Australia.

93 Billy Stockman Tjapaltjarri (Anmatyerre/Arrernte, b. *c.* 1927), Long Jack Phillipus Tjakamarra (Warlpiri/ Luritja, b. *c.* 1932), Kaapa Mbitjana Tjampitjinpa (Anmatyerre/Arrernte, 1920–89), Mick Wallankarri Tjakamarra (Luritja/Warlpiri, *c.* 1914–96) and other artists. *Honey Ant Dreaming,* 1971 (mural at Papunya School). Photo H. Munro, Geoffrey Bardon Collection.

94 Billy Stockman Tjapaltjarri (Anmatyerre/Arrernte, b. *c.* 1927). *Yala (Wild Potato) Dreaming,* 1971. Synthetic polymer paint on composition board; 54.5 × 46 (21 ⅜ × 18 ¼). Private Collection. Photo Sotheby's.

95 Long Jack Phillipus Tjakamarra (Warlpiri/Luritja, b. *c.* 1932). *Children's Kadaitcha Dreaming,* 1972. Synthetic polymer on board 56 × 35 (22 × 13 ¾). Private Collection. (AAA).

96 Charlie Tjararu Tjungurrayi (Pintupi, b. 1921). *Mitukatjirri,* 1972. Gouache on composition board 32.8 × 65.1 (12 ⅞ × 25 ⅝). NGV. Presented by Mrs Douglas Carnegie OAM, 1988. (AAA).

97 Dinny Nolan Tjampitjinpa (Warlpiri, b. *c.* 1924). *Shield,* 1972. Natural pigments on wood h. 74.5 (29 ⅜). NMA. (AAA).

98 Johnny Warangkula Tjupurrula (Luritja, b. 1918). *Water Dreaming at Kalipinypa,* 1972. Synthetic polymer paint on composition board; 80 × 75 (31 ½ × 29 ½). Private collection. Photo Sotheby's.

99 Timmy Payungka Tjapangarti (Pintupi, *c.* 1940–2000). *Secret sandhills,* 1972. Synthetic polymer paint on composition board; 76 × 52 (29 ⅞ × 20 ½). NGA. From the Peter Fannin Collection.

100 Ronnie Tjampitjinpa (Pintupi, b. *c.* 1943). *Two Women Dreaming,* 1990. Synthetic polymer on canvas 150.2 × 182.4 (59 ¼ × 71 ¾). NGA. (AAA).

101 Uta Uta Tjangala (Pintupi, 1920–90). *The Old Man's Dreaming,* 1983. Synthetic polymer on canvas 242 × 362 (95 ¼ × 142 ½). AGSA. South Australian Government Grant 1985. (AAA).

102 Turkey Tolson Tjupurrula (Pintupi, b. 1938). *Straightening spears at Ilyingaungau,* 1990. Synthetic polymer on canvas 181.5 × 343.5 (71 ½ × 95 ⅛). AGSA. Gift of the Friends of the AGSA 1990. (AAA).

103 Anatjari Tjampitjinpa (Pintupi, 1927–99). *Ceremonial ground at Kulkuta,* 1981. Synthetic polymer on canvas 183.5 × 182 (71 ⅞ × 71 ⅝). NGA. (AAA).

104 Mick Namarari Tjapaltjarri (Pintupi, 1926–98). *Bandicoot Dreaming,* 1991. Synthetic polymer on canvas 182 × 150 (71 ⅝ × 59). MAGNT. (AAA).

105 Clifford Possum Tjapaltjarri (Anmatyerre/Arrernte, *c.* 1943–2002). *Yinyalingi (Honey Ant Dreaming story),* 1983. Synthetic polymer on canvas 244 × 366 (96 ⅛ × 144 ⅛). NGA/AC. (AAA).

106 Tim Leura Tjapaltjarri (Anmatyerre/ Arrernte, *c.* 1936–84). *Men's camps at*

Lyrrpurrung Ngturra, 1979. Synthetic polymer on canvas 218 × 260 (85 ⅞ × 102 ¾). NGA/AC. (AAA).

107 Long Tom Tjapanangka, (Pintupi-Ngaanyatjarra, b. *c.* 1930). *Mereenie Range, Mikarnta Spring, Ulampawarru,* 1995. Synthetic polymer paint on canvas; 153 × 283 (60 ¼ × 111 ⅜). The Kerry Stokes Collection, Perth.

108 Tim Leura Tjapaltjarri (Anmatyerre/ Arrernte, *c.* 1936–84) with Clifford Possum Tjapaltjarri (Anmatyerre/Arrernte, b. *c.* 1943). *Napperby Death Spirit Dreaming,* 1980. Synthetic polymer on canvas 213 × 701 (83 ⅞ × 276). NGV. Felton Bequest 1988. (AAA).

109 Mitjili Napurrula (Pintupi, b. *c.* 1945). *Uwalki: Watiya Tjuta,* 1998. Synthetic polymer paint on canvas; 198 × 183 (78 × 72). NGA.

110 Sonder Nampitjinpa (Warlpiri, b. 1956). *Pankalangu ceremonies at Yamunturnga,* 1987. Coolamon: synthetic polymer on wood, length 131.2 (51 ⅝). NGA/AC. (AAA).

111 Michael Jagamara Nelson (Warlpiri, b. 1949). *Five Dreamings,* 1984. Synthetic polymer on canvas 122 × 182 (48 × 71 ⅝). Gabrielle Pizzi Collection. (AAA).

112 Pansy Napangati (Luritja/Warlpiri, b. *c.* 1947). *Old Man at Ilpilli,* 1990. Synthetic polymer on canvas 90 × 137 (35 ⅜ × 53 ⅞). Private Collection. (AAA).

113 Maxie Tjampitjinpa (Warlpiri, *c.* 1945–97). *Flying Ant Dreaming at Wantungurru,* 1988. Synthetic polymer on canvas 233 × 213 (91 ¾ × 83 ⅞). NGA. (AAA).

114 Paddy Japaljarri Sims (Warlpiri, b. 1917). *Ngapakurlu (Rain),* 1983. Synthetic polymer on Yuendumu School door. SAM. Photo Gerry Orkin. AIATSIS.

115 Paddy Jupurrula Nelson (1920–98), Paddy Japaljarri Sims (b. 1917) and Larry Jungarrayi Spencer (1919–90) (Warlpiri). *Yanjilypiri Jukurrpa (Star Dreaming),* 1985. Synthetic polymer on canvas 372 × 171.4 (14 ½ × 67 ½). NGA/AC.

116 Darby Jampijinpa Ross (Warlpiri, b. *c.* 1910). *Emu Dreaming,* 1987. Synthetic polymer on canvas 121.1 × 91.5 (47 ⅝ × 36). NGV. Purchased from funds donated by Lauraine Diggins 1988.

117 Peggy Napurrula Poulson (b. *c.* 1935), Maggie Napurrula Poulson (b. *c.* 1935) and Bessie Nakamarra Sims (b. *c.* 1940) (Warlpiri). *Janganpa Jukurrpa (Possum Dreaming),* 1988. Synthetic polymer on canvas 210 × 91 (82 ⅝ × 35 ¾). Tim and Vivien Johnson Collection.

118 Liddy Napanangka Walker (b. 1930), Topsy Napanangka (b. 1924) and Judy Nampijinpa Granites (b. 1934) (Warlpiri). *Wakirlpirri Jukurrpa,* 1985. Synthetic polymer on canvas 124.6 × 123.8 (49 × 48 ¾). NGA/AC.

119 Jeannie Nungarrayi Egan (Warlpiri, b. 1948). *Jardiwampa Jukurrpa (Snake Dreaming),* 1989. Synthetic polymer on canvas 122 × 183 (48 × 72). NGA.

120 Uni Nampijinpa Martin (b. *c.* 1942) and Dolly Nampijinpa Daniels (formerly Granites, b. 1931) (Warlpiri). *Warlukurlangu (Fire Country) Dreaming,* 1988. Synthetic polymer on canvas 182.4 × 121.8 (71 ¾ × 48). NGV.

121 Clarise Nampijinpa Poulson (Warlpiri, b. *c.* 1954). *Pamapardu Jukurrpa (Flying Ant Dreaming),* 1990. Synthetic polymer on canvas 183 × 91 (72 × 35 ⅞). Collection of Dr Kingsley Gee.

122 Molly Napurrurla Tasman (Warlpiri, b. *c.* 1955). *Marsupial Mouse Dreaming at Marlungurru,* 1986. Mixed media on cardboard 83.8 × 58.8 (33 × 23 ¼). NGV. Purchased through The Art Foundation of Victoria from funds provided by CRA Limited, Fellow, 1989.

123 Abie Jangala (Warlpiri, 1919–2002). *Water Dreaming,* 1987. Synthetic polymer on canvas 122 × 92 (48 × 36 ¼). RHàC.

124 Peter Blacksmith Japanangka (Kartangarurru, *c.* 1918–91). *Snake Dreaming,* 1986. Synthetic polymer and house paint on canvas 210.4 × 10.5 (82 ⅞ × 43 ½). NGV. Purchased through The Art Foundation of Victoria from funds provided by CRA Limited, Fellow, 1989.

125 Jimmy Jampijinpa Robertson (Warlpiri, b. 1946). *Seed Dreaming,* 1986. Synthetic polymer on canvas 217.9 × 120.6 (85 ¾ × 47 ½). NGV. Purchased through The Art Foundation of Victoria from funds provided by CRA Limited, Fellow, 1989.

126 Edie Kemarre (Alyawarre, b. *c.* 1950), Utopia Women's Batik Group (established 1978). *Women sitting in groups painting each other for corroboree,* 1987. Batik on silk 113 × 386 (44 ½ × 152). NGA.

127 Sandra Holmes Kemarre (Alyawarre, b. *c.* 1955), Utopia Women's Batik Group (established 1978). *Morning Star Dreaming,* 1988. Batik on silk, approx. 120 × 240 (47 ¼ × 94 ½). RHàC.

128 Lyndsay Bird Mpetyane (Anmatyerre, b. *c.* 1953). *Utnea,* 1991. Synthetic polymer on canvas 150 × 250 (59 × 98 ⅜). Utopia Art Sydney.

129 Mavis Holmes Petyarre (Anmatyerre, b. *c.* 1947). *Untitled,* 1990. Synthetic polymer on car door h. 99 (39). NGA.

130 Emily Kame Kngwarreye (Anmatyerre *c.* 1916–96). *Untitled,* 1991. Synthetic polymer on canvas 250 × 150 (98 ⅜ × 59). NGA.

131 Lilly Sandover Kngwarreye (Alyawarre, *c.* 1937–2002). *Sandover River,* 1989. Synthetic polymer on canvas 126 × 125 (49 ⅝ × 49 ¼). RHàC.

132 Ada Bird Petyarre (Anmatyerre, b. *c.* 1930). *Sacred grasses,* 1989. Synthetic polymer on canvas 130 × 230 (51 ⅛ × 90 ½). NGA.

133 Peter Sunfly (Sandfly) Tjampitjin (Kukatja, b. *c.* 1916). *Sleeping at Naligudjana,* 1986. Synthetic polymer on canvasboard 50 × 60 (19 ¾ × 23 ⅝). AGWA.

134 Wimmitji Tjapangarti (Kukatja, *c.* 1924–2000). *The artist's country,* 1989. Synthetic polymer on canvas 90 × 120 (35 ⅜ × 47 ¼). NGA.

135 Donkeyman Lee Tjupurrula (Kukatja 1921–94). *Untitled,* 1989. Synthetic polymer on canvas 120 × 180 (47 ¼ × 70 ⅞). NGV.

136 Susie Bootja Bootja Napangarti (Kukatja, b. *c.* 1932). *Kutal soakage,* 1989. Synthetic polymer on canvas 159.5 × 80 (62 ¾ × 31 ½). RHàC.

137 Robert Ambrose Cole (1959–94). *Untitled,* 1994. Synthetic polymer paint on

paper on canvas; 136.5 × 91.5 (53 ¾ × 36). NGA. Purchased with funds from Leo Christie through the Aboriginal and Torres Strait Islander Fund of the National Gallery of Australia Foundation.
138 Patricia Lee Napangarti (Warlpiri b. 1960). *The death of the Tjamptjin fighting man at Tjunta*, 1989. Synthetic polymer on canvas 180 × 120 (70 ⅞ × 47 ¼). NGA.
139 Richard Tax Tjupurrula (Kukatja, b. 1938). *Tiddal in the Great Sandy Desert*, 1994. Synthetic polymer paint on canvas; 90 × 60 (35 ⅜ × 23 ⅝). Jean-Jacques de Dardelle Collection, Switzerland.
140 Ronta Lightning (Jaru/Walmajarri, b. c. 1920). *The Dingo and the Emu*, 1983. Natural pigments and ink on canvasboard 51 × 61 (20 ⅛ × 24). WU.
141 Jimmy Pike (Walmajarri, 1940–2002). *Jamirtilangu Parrija Purrku II*, 1987. Synthetic polymer on canvas 60.7 × 50.6 (23 ⅞ × 19 ⅞). RHàC.
142 Juwaliny, Mangala, Manjiljarra, Walmajarri and Wangkajunga people. *Maparngujanka Ngurrara (Painting this country)*, 1997. Synthetic polymer paint on rubberized canvas: 1000 × 800 (33 × 27 ft). Mangkaja Arts, Fitzroy Crossing.
143 Jarinyanu David Downs (Wangkajunga/Walmajarri, c. 1925–95). *Moses and Aaron leading the Jewish people across the Red Sea*, 1989. Synthetic polymer and ochre on canvas 198 × 137 (78 × 53 ⅞). NGA.
144 Peter Skipper (Juwaliny/Walmajarri, b. c. 1929). *Kurrkuminti Kurrkuminti*, 1987. Synthetic polymer on canvas 198 × 122 (78 × 48). RHàC.
145 Alex Mingelmanganu (Kulari/Wunambal, died 1981). *Wandjina*, 1980. Natural pigments and oil on canvas 159 × 139.5 (62 ⅝ × 54 ⅞). NGA.
146 Wandjina figures, Mandanggari, Gibb River, Kimberley, Western Australia. Photo Howard McNickle. AIATSIS.
147 Charlie Numbulmoore (Ngarinyin, c. 1907–71). *Wandjina-kaluru beings at Mamadai*, 1970. Natural pigments on bark 110 × 71 (43 ¼ × 28). NMA.
148 Unknown artist (Karajarri). Kimberley, Western Australia. *Pendant*, 1930s. Pearlshell, charcoal h. 17 (6 ¾). NMA. Elkin Collection.
149 Unknown artist (Bardi or Nyul Nyul). Lombadina, Western Australia. *Pendant: Min-nimb the whale*, 1988. Pearlshell, ochre, hairstring; pearlshell h. 17.5 (6 ⅞). NGA/AC.
150 Roy Wiggan (Bardi, b. 1930). *The voyage of my father: Cape Leveque lighthouse*, 1991. Synthetic polymer paint on wood, cottonwool, wool and metal; 61 × 81 (24 × 31 ⅞). NGA.
151 John Dodo (Karajarri, b. 1910). *Kungolo*, 1987. Natural pigments on stone 28 × 13 × 17.5 (11 × 5 ⅛ × 6 ⅞). NGA.
152 Paddy Jaminji (Kija, 1912–96). *Manginta the Devil Devil, c. 1977* (from the *Kurirr Kurirr* ceremonial series). Natural pigments on board 119 × 71.9 (46 ⅝ × 28 ¼). NMA.
153 Rover Thomas (Kukatja/Wangkajunga, 1926–98). *Cyclone Tracy*, 1991. Natural pigments on canvas 183 × 168 (72 × 66 ⅛). NGA.

154 Queenie McKenzie (Kija, c. 1930–98). *Kija country*, 1995. Natural pigments on canvas; 200 × 160 (78 ¾ × 63). NGA
155 Jock Mosquito Jubarljari (Jaru, b. 1951). *Kawarrin*, 1984. Natural pigments on board 90 × 180 (35 ⅜ × 70 ⅞). NGA/AC.
156 Jack Britten (Kija, c. 1924–2002). *Purnululu (Bull Creek country)*, 1988. Natural pigments on canvas 160 × 200 (63 × 78 ¾). NGA.
157 George Mung Mung (Kija, 1924–91). *Binoowoon country*, 1990. Natural pigments on canvas 80 × 160 (31 ½ × 63). NGA.
158 Freddie Ngarrmaliny Timms (Kija, b. 1946). *Blackfella, whitefella*, 1999. Natural pigments on canvas; 122 × 135 (48 × 53 ⅛). NGA.
159 Detail of a rock wall, Emu Gallery, Laura, Queensland. Photo Percy Tresize. AIATSIS.
160 Unknown artist. Cardwell River, Queensland. Shield, collected 1897. Natural pigments on softwood h. 91 (35 ⅞). AM. Photo Carl Bento.
161 Unknown artist. Cardwell River, Queensland. Basket, 19th century. Natural pigments on lawyer cane h. 81.5 (32). MOV.
162 Arthur Koo'ekka Pambegan senior (1895–1972) and Arthur Koo'ekka Pambegan junior (b. 1936) (Wik-Mungkan). *Kalben (Flying Fox Story Place)*, 1962. Natural pigments on wood, fibre h. 129 (50 ⅞). NMA.
163 Angus Namponan (Wik-Ngatharr, 1930–94) with Nelson Wolmby (Wik-Ngathan, b. 1951) and Peter Peemuggina (Wik-Ngathan, b. 1942). *Two Young Women of Cape Keerweer*, 1987. Wood, bark, natural pigments, nails, h. 70 (27 ⅝) and 73 (28 ¾). SAM.
164 Thancoupie (Thanaquith, b. 1937). *Garth Eran and Evarth Eran*, 1988. Stoneware h. 30.4 (12). NGA/AC.
165 Goobalathalbin (Dick Roughsey) (Lardil, 1924–85). *Rainbow Serpent, Thwaithu dance, Mornington Island*, 1972. Synthetic polymer on board 31 × 41 (12 ¼ × 16 ¼). NGA.
166 Kirk A. Watt (Lardil, b. 1960). *Two stories*, 1991. Natural pigments on bark 67 × 37.5 (26 ⅜ × 14 ⅞). Private Collection. Photo John Freund.
167 Unknown artist. East Torres Strait. *Krar (mask)*, 19th century. Turtleshell, hair, goa nuts, cassowary feathers, resin, fibres, ochres h. 47 (18 ½). AM. Photo John Fields.
168 Ken Thaiday senior (Erub, Torres Strait, b. 1950). *Beizam (shark) dance mask*, 1991. Enamel on plastic and plywood, steel wire, dyed feathers, cockatoo feathers h. 70 (27 ⅝). NGA.
169 Jenuarrie (b. 1944). *Our time has begun*, 1986. Batik on cotton 217 × 197 (85 ⅜ × 77 ⅝). NGA.
170 Denis Nona (Badu, Torres Strait, b. 1973). *Naath, c. 1995*. Hand-coloured linocut; 61 × 50.5 (24 × 19 ⅞). NGA. Gordon Darling Fund
171 William Barak (Wurundjeri, c. 1824–1903). *Corroboree, c. 1885*. Natural pigments and pencil on paperboard 56 × 75 (22 × 29 ¼). NGA/AC.
172 Tommy McRae (Kwatkwat, 1836–1901). *Page from a sketchbook, c. 1890*. Pen and ink on paper 20.2 × 16.2 (8 × 6 ⅜). NGA.

173 Kevin Gilbert (Wiradjuri, 1933–93). *My father's studio*, 1965, reprinted 1990. Linocut on paper 28.5 × 35.5 (11 ¼ × 14). NGA. Gordon Darling Fund 1990.
174 Avril Quaill (Nunukul, b. 1958). *Trespassers keep out*, 1982. Poster: colour screenprint on paper 48.7 × 72.1 (19 ¼ × 28 ⅜). NGA.
175 Alice Hinton-Bateup (b. 1950). *Dispossessed*, 1986. Poster: colour screenprint on paper 49.6 × 74.7 (19 ½ × 29 ⅜). NGA. Gift of Roger Butler 1985.
176 Trevor Nickolls (b. 1949). *Waterhole and trees*, 1986. Synthetic polymer on canvas 110.8 × 167.6 (43 ½ × 66). NGA. Philip Morris Arts Grant 1988.
177 Jeffrey Samuels (b. 1956). *This changing continent of Australia*, 1984. Oil on composition board 187 × 124 (73 ⅝ × 48 ⅞). AGNSW.
178 Mervyn Bishop (b. 1945). *Prime Minister Gough Whitlam pours soil into hand of traditional owner Vincent Lingiari, NT*, 1975. Gelatin silver photograph; 31 × 30.4 (12 ¼ × 12). NGA. © DACS 2003
179 Michael Riley (b. 1960). *Christina*, 1986. Gelatin silver photograph 50 × 60 (19 ⅝ × 23 ⅝). The artist.
180 Brenda Croft (Kurindji, b. 1964). *Michael Watson in Redfern on the Long March of Freedom, Justice and Hope, Invasion Day, 26 January 1988, Sydney, NSW*, 1988. Gelatin silver photograph 50.5 × 40.5 (19 ⅞ × 16). NGA. KODAK (Australasia) PTY LTD Fund 1988.
181 Fiona Foley (Badtjala, b. 1964). *Annihilation of the blacks*, 1986. Wood, synthetic polymer, feathers, hair, rope h. 210 (82 ⅝). NMA.
182 Bronwyn Bancroft (Bunjulung, b. 1958). *The marine cape*, 1987. Hand-painted cotton h. 140 (55 ⅛). AM. Photo Carl Bento.
183 Lin Onus (Yorta Yorta, 1948–96). *Dingoes; dingo proof fence*, 1989 (detail from the series *Dingoes*). Synthetic polymer on fibreglass, wire, metal h. 95.5 (37 ½). NGA.
184 Bluey Roberts (b. 1937). *River spirit*, 1992. Carved emu egg h. 13 (5 ⅛), NGA.
185 Arone Raymond Meeks (b. 1957). *Healing place*, 1988. Lithograph on paper 76 × 56.5 (29 ⅞ × 22 ¼). The artist.
186 Euphemia Bostock (Bunjulung, b. 1936). *Possum skin print*, 1990. Screenprint on cotton 329.4 × 102.4 (129 ⅞ × 40 ⅜). NGA.
187 Ellen José (Nurapai-Erub-Mer, Torres Strait, b. 1951). *In the balance*, 1993. Still from computer-animated video, 2 min 41 sec. NGA.
188 Sally Morgan (b. 1951). *Moon and stars*, 1987. Colour screenprint on paper 43 × 87.8 (16 ⅞ × 34 ⅝). The artist.
189 Byron Pickett (b. 1955). *Fellow Australian*, 1985. Colour screenprint on paper 55 × 51.2 (21 ⅝ × 20 ⅛). NGA.
190 Robert Campbell junior (Ngaku, 1944–93). *Aboriginal embassy*, 1986. Synthetic polymer on canvas 88 × 107.3 (34 ⅝ × 42 ¼). NGA.
191 Gordon Bennett, (b. 1955). *Outsider*, 1988. Oil and synthetic polymer on canvas; 290 × 180 (114 ⅛ × 70 ⅞). University of Queensland Museum of Modern Art, Brisbane.
192 Karen Casey (b. 1956). *Got the bastard*, 1991. Oil and mixed media on canvas

210 × 150 (82 ⅝ × 59). The artist.
193 Judy Watson (Waanyi, b. 1959).
Heartland, 1991. Powder pigment, pastel on
canvas 176 × 173.5 (69 ¼ × 68 ¼). NGA.
194 Ian W. Abdulla (Ngarrindjeri, b. 1947).
Sowing seeds at nite, 1990. Synthetic polymer
on canvas 100 × 100 (39 ⅜ × 39 ⅜). NGA.
Moët et Chandon Fund.
195 Ricky Maynard (b. 1953). *Jason
Thomas, Terry Maynard and David Maluga*,
1985. Gelatin silver photographs, each
image 30 × 19.2 (11 ¾ × 7 ½). NGA.
196 Pooaraar (Bevan Hayward) (b. 1939).
Spirits of the Australian bushlands, 1988.
Linocut on paper 56 × 30 (22 × 11 ¾).
NGA/AC.
197 Treahna Hamm (Yorta Yorta, b. 1965).
Rebirth II, 1991. Etching on paper 74.8 ×
34.2 (29 ½ × 13 ½). The artist.
198 Rick Roser (Jinibara, b. 1955). *Jundal
gianga (woman powerful)*, 1990. Natural

pigments and synthetic polymer on
driftwood, string, feathers h. 155 (61). NGA.
199 Yvonne Koolmatrie (Ngarrindjeri,
b. 1944). *Bi-plane*, 1994. Woven sedge grass;
50 × 113 × 135 (19 ⅝ × 44 ½ × 53 ⅛). NGA.
200 Richard Bell (Kamilaroi, b. 1953).
Crisis: what to do about this half-caste thing,
1991. Synthetic polymer and collage on
canvas 180 × 250 (70 ⅞ × 98 ⅜). NGA.
201 Destiny Deacon (Erub-Mer-Kuku,
Torres Strait, b. c. 1956). *Caliban*, 1996.
Colour bubble-jet print on paper 82.5 × 58.2
(32 ⅝ × 23). NGA. KODAK (Australasia)
PTY LTD Fund 1997. © DACS 2003
202 Julie Dowling (Yamatji-Badimaya,
b. 1969). *Her father's servant*, 1999. Synthetic
polymer paint, ochre, blood on canvas 100 ×
120 (39 ⅜ × 47 ¼). NGA. © DACS 2003
203 Leah King-Smith (Gamilaraay-Koamu,
b. 1957). *Patterns of connection; Untitled no. 3*,
1992. Direct positive colour photograph;

101 × 101 (39 ¾ × 39 ¾). NGA KODAK
(Australasia) PTY LTD Fund 1994.
Courtesy Gallery Gabrielle Pizzi,
Melbourne
204 Yvonne Kopper (Tasmanian
Aboriginal, b. 1951). *Bull kelp water carrier*,
1998. Bull kelp, ti-tree sticks, bush string
14 × 28 × 13 (5 ½ × 11 × 5 ⅛). NGA.
205 Detail of 206, below.
206 Paddy Dhathangu (Liyagalawumirri,
1915–93), David Malangi (Manharrngu,
1927–99), George Milpurrurru
(Ganalbingu, 1934–98), Jimmy Wululu
(Daygurrgurr/Gupapuyngu, b. 1936) and
other Ramingining artists. *The Aboriginal
Memorial*, 1988 (an installation of 200
painted hollow-log coffins). Natural
pigments on wood, from h. 40 (15 ¾) to
327 (128 ⅜). NGA. Purchased with the
assistance of funds from Gallery admission
charges and commissioned in 1987.

Glossary

Main text references follow definitions
Numbers in *italic* refer to illustrations.

Ancestral Realm See Dreaming.
Awelye Women's designs and ceremonies (in the Anmatyerre language, spoken in the desert). 147, 150
Bradshaw figures See Gwion Gwion.
Coolamon Wooden carrying dishes used in the desert. 101, 117, 120, 129, 136, 151; *110*
Dhulang Painted patterns or designs in North East Arnhem Land (see also *miny'tji, rarrk*). 25
Dhuwa Name for one of the two complementary social and religious categories (moieties) in central and eastern Arnhem Land (see also Yirritja). 25, 41, 48, 50, 51–2, 54, 60, 64
Digging stick Long wooden stick used by women to gather roots and root vegetables. 32, 44, 60, 63, 64, 75, 103, 108, 136, 151; *31*
Dilly bag Small bag, woven from natural fibre string, used in northern Australia for carrying food and personal possessions, and used in ceremonies. 14, 28, 43, 44, 54, 60, 63, 64, 75, 108; *31*
Dirmu Vibrant patterns found in nature and made in painting (in the Murrinh-Patha language, spoken in the Wadeye region). 98
Dreaming Term commonly used in Aboriginal Australia to refer to Aboriginal cosmology, encompassing the creator and ancestral beings, the laws of religious and social behaviour, the land, the spiritual forces which sustain life and the narratives which concern these (also called the Dreamtime). 10, 15, 21, 22, 47, 76, 85, 98, 101, 103, 111
Dupun A Yolngu term for the hollow-log coffin (see below).
Gwion Gwion The Ngarinyin name for dynamic, naturalistic human figures painted on rock walls in the Kimberley. Previously known as 'Bradshaw figures' after the explorer Captain Joseph Bradshaw, the first European to record such paintings in 1892. 169; *8*
Hollow-log coffin Coffin made from a prepared and painted hollow log used in reburial ceremonies in Arnhem Land (the coffins are often called *lorrkon* in western Arnhem Land). 53, 68, 75, 226; *205, 206*
Jukurrpa Dreaming (in Warlpiri, one of the languages spoken in the desert). 101, 132
Kirda Among the Warlpiri and related desert groups, those with primary, usually patrilineally inherited rights in ceremonies, Dreamings, designs and so on (see also *kurdungurlu*). 104, 135, 136
Koori Generic term for the Aboriginal people of the south eastern part of Australia (see also Murri, Nunga, Nyoongah). 194, 201
Kurdungurlu Among the Warlpiri and related desert groups, those with secondary, usually matrilineally inherited rights in ceremonies, Dreamings, graphic designs and so on (see also *kirda*). 104, 135, 136
Kuruwarri Men's designs and ceremonies (in the Warlpiri language). 103, 108
Macassans Fishermen and traders from Sulawesi in Indonesia, who visited the

northern shores of the continent until the early twentieth century. 21, 23, 68, 70, 73, 76, 78–9; *63*
Mimi Spirit figures that appear depicted on the rock walls of West Arnhem Land and Kakadu. Also refers to a style of painting which incorporates images of these spirits. 22–3, 27–8, 38, 47, 169; *12, 21*
Miny'tji Painted clan patterns or designs in central and north eastern Arnhem Land. 25
Moiety One of a pair of complementary social and religious categories (see also Dhuwa and Yirritja). 15, 25, 41, 48, 49, 54, 56, 68, 104
Murri Generic term for the Aboriginal people of Queensland and northern parts of New South Wales. 194
Nunga Generic term for the Aboriginal people of the southern part of South Australia. 194
Nyoongah Generic term for the Aboriginal people of south-western Australia. 194, 208
Outstations Camps or settlements established by Aboriginal people on their traditional lands. Also known as homeland stations. 22, 102, 147, 150
Palga Narrative dance cycle in the eastern Kimberley, in which performers carry painted boards or threaded-string constructions. 175–6
Pukumani State of mourning imposed upon the kin of a deceased person, and the name of the funeral ceremony among the Tiwi of Bathurst and Melville Islands. 85–9, 90, 93; *70–2*
Rainbow Serpent The name common in much of Aboriginal Australia for several supernatural beings in their manifestations as snakes (Wititj the Great Python etc.). 10, 22, 30–2, 34, 48–50, 81, 84, 98, 128, 158, 171, 174–6, 211; *17, 20, 22, 26, 82, 83, 111, 165, 188*
Rarrk Cross-hatched clan patterns in western Arnhem Land (see also *dhulang, dirmu*, and *miny'tji*). 25, 26, 30, 32, 34, 38, 39, 41, 42, 44, 46, 186
Tingari Commonly described as a group of ancestral beings, with one or more dominant men or women, who brought law and culture to the peoples of the western desert region. 10, 117, 120, 155, 162–4
Wandjina Generic term for a group of ancestral beings in the Kimberley, who control the elements and maintain fertility in humans and other natural species. 10, 162, 169–71, 174, 176, 182; *145–7*
Yawulyu Women's designs and ceremonies (in the Warlpiri language). 103, 108, 109, 136, 139, 147
Yirritja Name for one of the two complementary social and religious categories (moieties) in central and eastern Arnhem Land (see also Dhuwa). 25, 40–1, 52, 54–6, 68
Yolngu Generic term for the Aboriginal people of central and eastern Arnhem Land. 26, 48, 54, 56, 60, 76, 84

Index

Numbers in *italic* refer to illustrations

5 General